D0524878

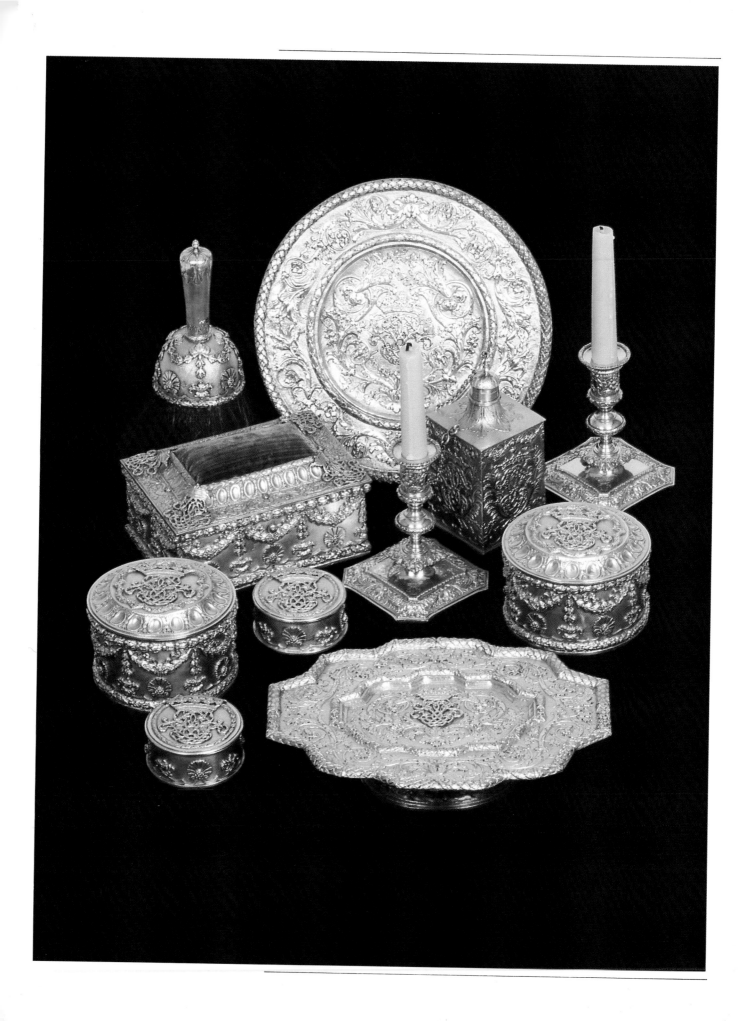

French Connections

SCOTLAND & THE ARTS OF FRANCE

EDINBURGH

HER MAJESTY'S STATIONERY OFFICE

ROYAL SCOTTISH MUSEUM

© Crown copyright 1985
First published 1985

Designed by HMSO Graphic Design: R. Burnett
Printed in Scotland for HMSO. Dd 762096
ISBN: 0 11 492433 3

Frontispiece
Items from the Lennoxlove Toilet Service made in Paris between 1661 and 1677.

Cover
The Lennoxlove Toilet Service made in Paris between 1661 and 1677.

Inside covers
Front and back views of the marble bust of the *Emperor Napoleon apotheosized*
by Bertel Thorvaldsen. Thorvaldsen Museum, Copenhagen.

Rear cover
Lid of the silver-gilt "Mary Queen of Scots casket". Made in France in the 15th or early 16th century.
Collection of the Duke of Hamilton, Lennoxlove.

CONTENTS

Preface 7

Introduction 9

 I Alliance with France 11

 II The French Queens 29

 III "Distracted Tymes" 43

 IV Culture and Conflict 55

 V The Great Collections 71

 VI A Touch of Class 103

Acknowledgements 121

Photographic Acknowledgements 123

Major Scottish Collections, Houses and Monuments Open to the Public 125

Bibliography 129

Index 137

Exhibition Checklist 141

PREFACE

My family has enjoyed a long personal connection with France. One ancestor, the 2nd Earl of Arran, held a French title in the 16th century; another, the 10th Duke, who lived in the 19th century, was a fervent admirer of Napoleon and an enthusiastic collector of French art. This involvement makes a book on the arts of France in Scotland, and the associated exhibition in the Royal Scottish Museum, doubly welcome. It gives me great pleasure to see such attention being given to this aspect of the culture and development of Scotland, and to see so many beautiful works of art which once belonged to my family reunited in these pages. The book and the exhibition are a wonderful opportunity to enjoy some of the fruits of the long and creative relationship between France and Scotland, and I am happy to give both my support.

Duke of Hamilton
5th April 1985

Lennoxlove,
Haddington,
East Lothian.

INTRODUCTION

Over the centuries the histories of Scotland, a small and often struggling country, and France, large and politically and culturally powerful, have intermeshed. The "Auld Alliance", the formal friendship between the two countries, came to an end in the sixteenth century, but the effect of several hundred years of close contact went much deeper than political expediency. Scotland absorbed language, customs and tastes from France which have made a lasting impact. Scots also brought home fine works of art from the country that was for substantial periods regarded as the major creative force in Europe.

It is with the tangible evidence of this long association between Scotland and France that this book is concerned. The Scots who visited France as statesmen, churchmen, academics, soldiers, artists and sometimes as exiles, returned not only with ideas but with objects— furniture, books, paintings, sculpture, gold and silver. They were also influenced by France in their choice of designs for their houses, and in fashion and textiles. French artists and craftsmen were brought to Scotland to work on medieval churches and abbeys, on palaces, and on the fine houses of later periods.

France, for centuries, possessed an unrivalled reputation in Europe for fine works of art. A large country with an extensive population, France was able to provide the necessary preconditions for such production: substantial markets for the sale of goods, and urbanization capable of sustaining workshops and factories. The most important centre for the manufacture of luxury products was Paris which by the early fourteenth century had a population of about 200,000 including some wealthy royal and ecclesiastical inhabitants. The patronage of the French royal family and of the aristocracy were of cardinal importance in the development of luxury goods workshops in Paris, in the medieval period and under Louis XIV and his successors. An example of this was the acquisition by Colbert, Louis XIV's minister, of the Gobelins factory, intended to produce tapestries, but soon expanded to include workshops for cabinet makers, goldsmiths, painters, sculptors, mosaicists, engravers, founders and chasers. The Parisian workshops supplied thousands of pieces of furniture and other items to the palaces of Louis XV and Louis XVI. After the Revolution Napoleon became the premier patron of this luxury industry. The scale of demand can be illustrated by noting that Napoleon's goldsmith, Martin-Guillaume Biennais

(1764-1843), who was in business between 1789 and 1819, was said to have had 600 people in different workshops working to fill his orders and stock his shelves.

Small wonder then that Scots with wealth and cultural aspirations travelled to France, or sent agents on their behalf, to purchase the most fashionable pieces from the best craftsmen they could afford. Many works were acquired from the French royal palaces or the *châteaux* of the aristocracy when their contents were sold on a huge scale after the Revolution. As a result, a number of fine collections of French furniture and the decorative arts are to be found in the small palaces and country houses of Scotland, whilst several impressive Scottish buildings demonstrate the extent of the influence of French architectural styles.

The Royal Scottish Museum in Edinburgh possesses a large and representative collection of French works of art including the splendid seventeenth century Lennoxlove toilet service and one half of the magnificent silver-gilt tea service made for Napoleon by Biennais, once owned by the 10th Duke of Hamilton, but now sold and divided between the Royal Scottish Museum and the Musée du Louvre in Paris.

In August 1985 an exhibition, "French Connections: Scotland and the Arts of France", was mounted in the Royal Scottish Museum based on this material, some key items associated with the 10th Duke of Hamilton from foreign museums, as well as a selection of the best pieces from all the outstanding Scottish collections. Many of the objects described and illustrated here were included in the display. This book aims to enlarge upon the exhibition and, in its exploration of the background and context of France in Scotland, provides evidence of a rich and intriguing cultural relationship.

ALLIANCE WITH FRANCE

The Norman Conquest begun in 1066 by William, Duke of Normandy, not only brought Saxon England under French rule, but transformed the history and culture of Scotland. The southern kingdom provided the Conqueror and his followers with more than sufficient lands and William was prepared to ignore Scotland, provided the Scots showed respect and left him in peace. The Normans had enough to do consolidating their victory in England, colonizing the country and suppressing revolts without embarking upon the conquest of the far-off, comparatively barren land of Scotland. The attention of the Normans was first drawn to Scotland by the actions of the Scottish King Malcolm III (1057-93), who invaded Teesdale in 1070 and probably shortly afterwards married the future St Margaret, who was Princess of the Wessex royal house. William reacted to this threat of Scottish intervention in English affairs by bringing his army north in 1072 and, at Abernethy, Malcolm "came and made peace . . . and gave hostages and was his man". On three subsequent occasions Malcolm invaded England; he was killed in 1093 fighting in Northumbria. Malcom's successors were far more ready to co-operate with the Normans than he had been, and Duncan II and Edgar received support from and did homage to William II (1087-1100). A number of important marriages were arranged to seal the new relationship. Henry I of England (1100-35) married Malcolm III's elder daughter Matilda in 1100 and Alexander I of Scotland (1107-24) received the hand of an illegitimate daughter of Henry I. These unions brought the two courts closer and increased the rate of Anglo-Norman penetration of Scotland.

Alexander I died childless in 1124 and was succeeded by his brother David (1124-53), the youngest son of Malcolm III and Queen Margaret. It was David who was chiefly responsible for the Normanization of Scotland. The new king was born about 1080-85 and grew to manhood at the court of Henry I, who employed him as a justice. In 1113-14 Henry arranged that David should make an advantageous marriage with Maud, daughter of the Earl of Northumbria. She was also the widow of Simon de Senlis and brought with her the earldom of Huntingdon and extensive estates in the Midlands. The new king of Scotland was therefore a Norman baron, with large estates in the heart of England and a claim to the earldom of Northumbria. He spurred on the pace of Normanization in Scotland. He wanted things run in the most efficient, internationally accepted manner—that is to say, in the Norman manner—and desired to have friends and other individuals of similar outlook

in his company and councils. He invited Normans and other Anglo-French, chiefly from his estates in England, to settle in Scotland. Among those who came north were Robert de Brus (who was given land in Annandale) and Hugh de Moreville (who received Cunningham and Lauderdale). Anglo-Norman and Anglo-French settlement took place in the south of Scotland and spread northwards during the reign of David and, more significantly, during the reigns of his grandsons Malcolm IV (1153-65) and William the Lion (1165-1214). King David also invited churchmen and religious orders to Scotland, founding about a dozen monasteries and priories. He established and developed Anglo-Norman institutions and systems of central and local government which he had seen working in England and had come to admire, and entrusted important offices in the state and in the church to Anglo-Normans and Anglo-French.

Scotland, it can be claimed, became a Norman state in the twelfth century, although Norman influence did not of course make a uniform impression. It was most keenly felt at court and in the south of Scotland, where the Anglo-Normans and Anglo-French were concentrated, and it was comparatively little felt in the Highlands. Nevertheless, Scotland ceased to be insular and became part of the European feudal community. Her rulers, nobles and churchmen sought to keep abreast of international affairs and paid great heed to what was happening in England and in France, where the Anglo-Normans held important territories.

The Anglo-Norman Scots identified with the Anglo-Normans and with the French. It would have been surprising if they had done otherwise: they

1. Holyrood Abbey Church, Interior of the Nave, South Side, 13th century. Holyrood demonstrates the transmission of architectural layouts and styles from England to Scotland. The model for the first church was Merton Priory, Surrey, the home monastery of the Augustinian canons who were brought to Holyrood by King David in 1128. The interior of the new, cathedral-sized church, begun shortly before 1200, was influenced by work at Lincoln Cathedral.

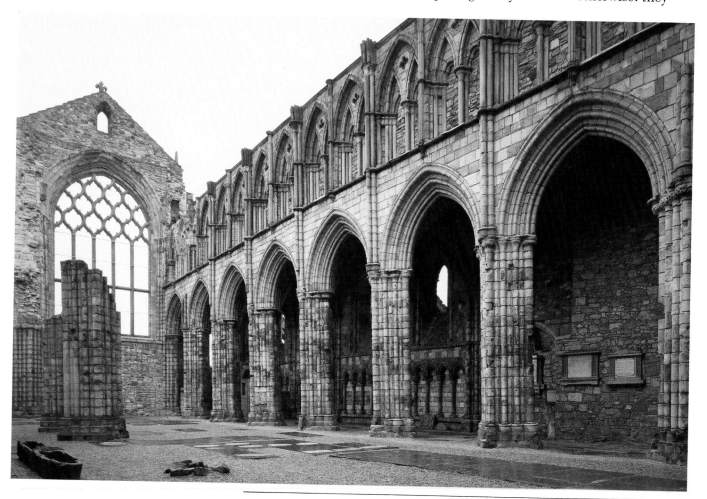

shared the same language, the same interests and the same tastes. Writing at the end of the thirteenth century, Walter of Coventry stated:

> "the more recent kings of Scots profess themselves to be rather Frenchmen, both in race and in manners, language, and culture; and, after reducing the Scots to utter servitude, they admit only Frenchmen to their friendship and service".

Walter exaggerates the servitude of the Scots, but he is certainly correct in representing the Scottish kings and the barons and knights as a French-speaking caste.

Much of the material culture of the years 1100 to 1286, before the Scottish Wars of Independence, has been destroyed, but what remains reveals that the Anglo-Norman Scots and those whom they influenced built motte and bailey castles (see in particular the mounds in Galloway) and later stone castles, as in England. Churches and monastic buildings were also modelled on English and French prototypes (Fig. 1). Most of the architectural ideas seem to derive from works in the north of England, from Durham, York and the Cistercian settlements in Yorkshire. The northern centres were probably also important for the supply of manuscripts, although they were certainly not the only source. Pottery was later shipped from Yorkshire, including the well-known Scarborough ware. There was direct contact with France and some French luxury goods and other items were imported. However, the main impact of France was experienced through the medium of England (Fig. 2).

2. The Whithorn Crozier. English, late 12th century. Champlevé enamel on copper. 19.3 x 9 cms. National Museum of Antiquities of Scotland, Edinburgh. Found inside the wooden coffin of an unidentified bishop in the church of the Premonstratensian Priory of Whithorn, Galloway. Whithorn was under the jurisdiction of the metropolitan see of York.

The most interesting connections with France in the period 1100 to 1286 relate to the establishment of monastic foundations in Scotland. It was inevitable that a good Norman like King David, with the power to grant lands and rights, would encourage monastic foundations and highly probable that he would favour the new ascetic orders. The number of his foundations and his clear preference for the ascetic orders demonstrate the extent to which the King was indeed a Norman and a leading figure of the time. David's first foundation was made before he became king. In 1109 Bernard of Poitiers had founded the Tironensian order, which aimed at a simpler kind of cloistered life based upon a literal observance of the Rule of St Benedict, the reinstatement of manual labour and private meditation, and seclusion from the outside world. Four years after the foundation of this order, David brought monks from Tiron to Selkirk. In 1116 he himself visited Tiron intending to see the founder, only to find that Bernard had died. Some twelve years later, the King moved the Tironensians from Selkirk to Kelso, near to the sheriff, castle and royal burgh of Roxburgh. The Tironensians made little progress in England, but went on to establish other colonies in Scotland at Arbroath, at Kilwinning, and Lesmahagow. Tironensians became the Bishops of Glasgow and St Andrews; the second and third abbots of Tiron came from Scotland.

The best known of the ascetic orders is the Cistercian. This was a revival of primitive Benedictine observance which was established in the "desert which is called Cîteaux" by a group of rigorists who had withdrawn from the Abbey of Molesme in 1098. Bernard of Clairvaux sought admittance to the order in 1112 and by the year of his death in 1153 there were 343 Cistercian monasteries throughout Europe. The Cistercian ideal exerted a tremendous attraction in the first half of the twelfth century, partly as a result of Bernard's immense personal charisma and brilliant advocacy. Like many other rulers, King David encouraged such fervour and devotion. When he died in 1153, the same year as St Bernard, there were four Cistercian houses in Scotland: Melrose (founded in 1136), Newbattle, near Edinburgh (1140), Dundrennan in Galloway (1142), and Kinloss in Moray (1150).

King David also supported the Canons Regular, a hybrid order of priest-monks who observed the Rule of St Augustine. The movement had begun in northern Italy and in southern France and by 1107 was established in England. David's brother-in-law, Henry I, and his sister, Matilda, were both enthusiastic patrons of the order and it spread rapidly across England, becoming the largest in the country, with 274 houses. Augustinian canons were brought to St Andrews and Scone by Alexander I, and David continued this patronage inviting canons from Merton in Surrey to found the Abbey of the Holy Rood at Edinburgh in 1128. Another community, Jedburgh (1138), appears to owe its origin to the importation of canons from Beauvais by King David and John, Bishop of Glasgow. It is interesting to see that the King again supported an ascetic form of observance, the austere life of strict enclosure and separation from the world followed by the Arrouaisian order of Augustinian canons. The order takes its name from the Abbey of Arrouaise in Picardy where the Abbot Gervase (1121-47) modelled the practice of the community upon the severe customs of the Cistercians. These observances were adopted at David's Cathedral at Carlisle and the King made gifts to Arrouaise. An Arrouaisian community, the future Abbey of Cambuskenneth, was in existence near Stirling by 1147.

One of David's Norman barons, Hugh de Moreville, supported another

3. Double Miniatures. Psalter. French (Paris), 1240s. 14 x 10 cms. Bodleian Library, Oxford (Ms. Douce 50, fo.XVII r). The Scottish and Irish saints in the calendar and litany suggest a connection with Ardchattan in Argyllshire, founded about 1230, and one of three Valliscaulian priories in Scotland directly dependent on Val des Choux near Langres in France. An erased inscription at the end of the text, "... Liber ... lis/prioris ... cha ...", may confirm this theory.

strict Augustinian observance: the Premonstratensians. They were founded by Norbert, the son of a baron in the duchy of Cleves, and derive their name from the first foundation, Prémontré in the forest of Coucy. Norbert envisaged the Premonstratensians as a preaching order, but the general chapters or assemblies of 1131-35 set the order on a different course, modelled on Cistercian lines. The Premonstratensians or White Canons came to England about 1143, when Peter of Goxhill, a minor baron of Lincolnshire, endowed the Abbey of Newhouse and imported canons from the county of Guines to start the community. In 1150 Hugh de Moreville brought canons from Alnwick to Dryburgh and the settlement became an abbey in 1152. Alnwick had been colonized from Licques, Pas-de-Calais. The Premonstratensians who later came to St Ninian's Priory, founded by Fergus of Galloway at Whithorn, came directly from Prémontré.

The religious orders were international networks of communities and there was a good deal of communication with abbots making visitations, checking that the rules were being obeyed, and monks and canons moving from one community to another and engaging in trade. The general chapters were of considerable importance for the dissemination of information and ideas. The most significant was the Cistercian general chapter, which was held at Cîteaux on the vigil of the Holy Cross (13 September) each year, when all abbots were obliged to attend. Because of the distance and the potential danger of long periods of absence from their communities, Scottish abbots were granted permission to attend personally once in every four years and to send a representative in other years. This international assembly acted as a gigantic clearing house for information, and it would be quite wrong to think of Melrose and other communities as isolated and unaware of what was happening in Europe.

Scotland now felt itself to be politically as well as ecclesiastically part of Europe. The outstanding consequence of this wider political outlook was the "Auld Alliance" between France and Scotland which lasted, though not continuously or in exactly the same form, for over 250 years. The "Auld Alliance" came into being as a result of the death of a Scottish king without adult male issue, of rival claimants to the throne and the intervention of the English king, and of strained relations and warfare between England and France.

Scotland's years of peace ended on the stormy night of 19 March 1286, when Alexander III was thrown to his death as he was riding near Kinghorn in west Fife. The King's two sons had died in 1281 and 1284, his daughter Margaret in 1283. She had married Eric II of Norway and their daughter, Margaret, the Maid of Norway, was the intended successor to the Scottish throne. Various Scots made claims to the throne after Alexander's death and an embassy was sent to Edward I of England to request his assistance in resolving the problem. On the face of it, the request was reasonable: the Scots had acknowledged the sovereignty of the King of England in the past and many of the leading magnates owned lands in England. Moreover, Edward had acquired a reputation as an honest broker. Even before his accession in 1272, the King of Cyprus had asked him to arbitrate in a dispute between himself and his barons, and in the 1280s Edward was working hard to resolve the conflict between the Aragonese and the Angevins. However, the appeal could only lead to trouble. Edward was a crusader, an expansionist king and an impatient man easily moved to violence. His record should have warned the Scots. In the two Welsh Wars of 1277 and 1282-83, he defeated

the Welsh and consolidated his victories by raising a semi-circle of great fortresses across North and Central Wales—Flint, Rhuddlan, Conwy, Caernarfon, Beaumaris, Criccieth, Harlech, Aberystwyth and Builth—to keep the Welsh in check. It was folly to invite such a man to intervene in the affairs of Scotland, although undoubtedly Edward would have become involved, with or without an invitation. His solution was to recognize the Maid of Norway as the successor and to propose that she should be married to his heir, the future Edward II, but the child died *en route* from Norway to Scotland in 1290. It was then agreed that Edward should decide upon the rival claims to the throne. In November 1292 he judged John Balliol (the grandson of the eldest daughter of David, Earl of Huntingdon, the brother of Malcolm IV and William the Lion) to be the rightful heir, rather than Robert Bruce (the son of David's second daughter). Once Balliol was king, Edward tested his overlordship. He summoned Balliol to appear before him at Westminster to explain his failure to do justice, and in 1294 he summoned him and other Scottish magnates to perform military service in Gascony. In his absence, a council of twelve seized power from Balliol in 1295.

England and France had gone to war in 1294 and on 5 July 1295 Scottish envoys were sent to France to see if an alliance could be made against England. A defensive and offensive alliance directed against England was drafted on 23 October and was ratified by the Scots at Dunfermline on 23 February 1296. Thus began the "Auld Alliance".

Edward responded to these developments with the campaign of 1296, which was a campaign of conquest, as the removal of the so-called Stone of Destiny (part of the king-making ceremony of the kings of Scotland) from Scone to Westminster indicates. The English succeeded in defeating the Scots but had insufficient resources to consolidate their success as they had done in Wales. Robert Bruce rebelled and was crowned King of Scotland at Scone in March 1306. King Edward died in July 1307 on the march up to Scotland and the campaign was abandoned, but the war left the Scots determined to remain independent. They were alienated by the English victories and by the Scottish deaths and angered by Edward's acts, most notably in 1306 when he ordered the executions of members of Bruce's family and supporters and the imprisonment of Robert Bruce's sister Mary and the Countess of Buchan in "cages" in Roxburgh and Berwick Castles. Edward was succeeded by his incompetent son, Edward II, who took up his struggle against the Scots and was soundly defeated at Bannockburn in 1314.

Edward II's abysmal reign gave the Scots additional resolve but the ignominy of defeat also made it inevitable that the English would attempt to regain ascendancy over the Scots. Scottish antagonism to the English is superbly reflected in the magnificent words of the Declaration of Arbroath of 1320:

> "As long as a hundred of us remain alive, we will never on any conditions be subjected to the lordship of the English. For we fight not for glory, nor riches, nor honours, but for freedom alone, which no good man gives up except with his life."

To retain their independence, the Scots needed help and the French were their obvious allies.

The Scots were able to enter into alliances with France from 1295 to 1492 because of English possessions in France or English designs to retrieve lost territories. The king of England was also Duke of Aquitaine and held Aquitane or Gascony as the vassal of the king of France. Sovereign in

England, the king of England was a subject in France. It was an impossible arrangement. There were conflicting interests and several incidents led to war. In 1294 naval war between English and Norman sailors, involving Gascons, provided Philip IV of France with the opportunity to summon Edward I to appear before the parlement of Paris. In 1324 a dispute over the construction of a new fortified town on the Gascon border at St Sardos sparked off further conflict.

This unstable situation was exacerbated by the appearance on the scene of two expansionist kings, Philip VI of France and Edward III of England. Both had claims to the throne of France when Charles IV, the last Capetian king of France, died in 1328. Edward was the nephew of Charles (his mother, Isabella, was Charles' sister), while Philip was Charles' cousin. Philip became regent at Charles' death and was able to ascend the throne after Charles' widow had given birth to a daughter. (Salic law prevented inheritance by females.) Edward may have had the better claim, but he was not present when Charles died, and furthermore he was only 15 at the time (Philip was 35) and was still under the domination of Isabella and Mortimer, who had deposed and murdered his father. Philip was anxious to increase his territories and had drawn up a plan for an elaborate invasion of Gascony in 1329. Edward, whose personal rule began in 1330, was no less aggressive and the two kings prepared for war. It was in Philip's interests, as it would be in the interests of future French kings, to have the Scots invade England at the same time as the French engaged the English on the continent. If England had to fight wars on two fronts, she could not marshal all her men and resources against France. This was the key to the continuation of the "Auld Alliance".

In August 1336 Philip announced his intention to assist the Scots. On 24 May 1337 he declared the lands of "the King of England, Duke of Aquitaine, Peer of France, Count of Ponthieu" to be confiscate, thus beginning the Hundred Years War. At a great ceremony in Ghent on 26 January 1340, Edward in his turn assumed the title of King of England and France, quartered the arms of France and dated his documents "in the fourteenth year of our reign in England and the first in France". From then on both the English and the French were engaged in warfare, interspersed by periods of truce. The campaigns during the reign of Edward III produced the great English naval victory of Sluys in 1340 and the brilliant defensive battles, fought by retreating English armies, of Crécy and Poitiers in 1346 and 1356 respectively. Henry V's reign saw campaigning in Normandy and was distinguished by the famous victory at Agincourt in 1415. Despite these victories the English possessions were slowly reduced and in 1453 Bordeaux, the main port of Gascony, fell to the French. The Hundred Years War was over, but the English had not accepted the loss of Aquitaine, nor surrendered their other claims. Subsequent decades witnessed Edward IV's invasion of 1474, English intervention in Brittany in 1488 and Henry VII's invasion of 1492. On 3 November 1492 the Peace of Étaples was concluded. This crucial treaty was important because it was a peace, rather than a truce, and laid the foundations for a more permanent settlement. However, Calais only ceased to be English in 1558 and the claim to the throne of France was only allowed to lapse in 1802, with the Peace of Amiens.

The Franco-Scottish alliance (or series of alliances from 1295 to 1512) needs to be seen against this background of Anglo-Scottish and also Anglo-French conflict. The alliance was mutually convenient. It was not

unbroken, nor were the separate treaties identical. Generally speaking, more was expected from the weaker signatory than from the stronger. The principal advantage of the alliance to Scotland was that it made the King of England reluctant to concentrate all his resources in the north. He had to keep troops and individuals he could trust in the south to guard against French invasion. It was not, however, the Franco-Scottish alliance but the priority given by the English to the lands in France that deflected English attention from Scotland and preserved the independence of the northern nation. Shortage of resources and civil strife in England were also important factors in reducing the likelihood of the conquest of Scotland.

Scotland received little material assistance from France between 1295 and 1492, and such aid as she did receive was largely motivated by French self-interest. The two most important instances were in 1355 and 1385. In 1355 King John of France ordered the Sire de Garencières to lead 50 men-at-arms to Scotland and to take with him 40,000 *deniers d'or à l'escu* "to be given among the prelates and barons of Scotland upon condition that they should break their truce with the King of England and make war upon him". The result was the Franco-Scottish sack of Berwick, but the French withdrew before Edward III arrived to take the town. Much of the period between 1380 and 1415 on the continent was taken up with uneasy truce, and garrison warfare from frontier posts and piracy in the Channel were the chief forms of military activity. In this context, the French King agreed in August 1383 to send troops, money and arms to Scotland in the event of Anglo-Scottish war. An expeditionary force under Jean de Vienne, Admiral of France, landed at the end of May 1385. It is said to have numbered 26 bannerets, 50 knights and 1,050 men-at-arms and they brought 50,000 gold francs, together with 80 suits of armour and 80 lances. This force, however, was insufficient to enable the Franco-Scottish army to oppose the English, who turned out in large numbers to honour the young Richard II's first major campaign, and the Scots were forced to retreat, wasting the land behind them. This scorched earth policy allowed little place for the French and there was also considerable resentment at their presence. The Scottish attitude to the French in Scotland always tended to be ambivalent; the Scots were pleased to receive French assistance at first and then became less cordial and increasingly hostile to their allies, whom they generally regarded as arrogant. Some of the pages in Vienne's force were killed by Scots as they foraged for food and the French were not allowed to depart until they had paid for damages they were alleged to have caused. The Admiral himself was obliged to remain as a hostage until the necessary money was sent from France.

It was more valuable for Scots to be able to go to France than it was for them to receive assistance from the French. In 1334 Philip VI invited the young David II and his Queen to take shelter from Edward III, installing them at Château-Gaillard on the Seine until 1341. France increasingly became a country where Scots could serve as professional soldiers. There were Scots serving in France in the fourteenth century, but the major period of involvement was the first half of the fifteenth century, when civil war in France together with the English campaigns provided Scots with splendid opportunities for service. Among those who were attracted to France were Lindsay, 1st Earl of Crawford and Admiral of Scotland, who entered the service of the Duke of Orléans in January 1402, and Alexander Stewart, Earl of Mar, who commanded the rearguard of the Duke of Burgundy when he put down the revolt of the citizens of Liége in 1408.

In April 1413 Archibald, 4th Earl of Douglas, alias Archibald the Tyneman (the Loser), made a treaty with the Duke of Burgundy. A Scottish expeditionary force was sent to aid the Dauphin in 1418. It was commanded by the Earl of Buchan, accompanied by the Tyneman's heir, the Earl of Wigtown. The two earls then recruited reinforcements and returned to France where a Franco-Scottish victory was won at Baugé in March 1421. The Earl of Buchan was made Constable of France, while Sir John Stewart of Darnley was granted the lordship of Concressault. In 1424 Archibald the Tyneman and the Earl of Buchan recruited a fresh Scottish expeditionary force, and Charles VII rewarded the Tyneman with the duchy of Touraine and his son, the Earl of Wigtown, with the lands of Dun-le-Roi in Berry. However, the French and their allies suffered a major defeat at Verneuil on 17 August. The Tyneman, his second son, Sir James Douglas, and his son-in-law, the Earl of Buchan, were amongst those killed. Sir John Stewart of Darnley continued in the service of Charles VII and met his death at Rouvray on 12 February 1429. In 1455 Charles founded the *garde écossaise*, the elite guard of Scots, as the senior household company of the French monarchy. The time was past when large contingents of Scots fought alongside the French army, but the Scots guard continued to provide openings for Scots of good birth who were attracted to the well-paid service of the French king.

The most important role of France, however, was as the educator of Scots. Until 1410 there was no university in Scotland and Scots were obliged to go abroad in order to get a university education. Warfare between Scotland and England made attendance at Oxford or Cambridge either impractical or undesirable and Scots generally went to France. Paris was pre-eminent for teaching, particularly in theology and philosophy, while Orléans was "the one great and famous law school of northern Europe". A Scottish "nation" or student association had been in existence in Orléans since 1336. An analysis of 400 Scots who graduated in the period 1340-1410 reveals that 230 studied at Paris, 55 at Orléans and 34 at Avignon; 90 were granted English safe-conducts to study at Oxford or Cambridge, but there is only evidence to show that 11 definitely did so. Most of the eminent churchmen, including the founders of the Scottish universities and the lecturers, had attended French universities. The foundation of St Andrews University, and of Glasgow University and of King's College, Aberdeen, in the fifteenth century naturally reduced the number of Scots educated in France, but French universities continued to be attractive to Scottish students especially for second degrees.

With this continuous traffic between the countries, many French works of art were imported into Scotland during the period of the "Auld Alliance". By about 1240 Paris was established as the intellectual and artistic capital of Europe, and exquisite objects were produced for the court circle of Louis IX (1226-70) and his successors. France, and especially Paris, was the place to obtain top-quality, fashionable work.

One of the earliest major imports was the tomb to mark the burial place in Dunfermline Abbey of Robert the Bruce who died on 7 June 1329. This was made of alabaster by Thomas de Chartres and was imported from Paris by way of Bruges in 1329. The monument was subsequently destroyed, but ten fragments are preserved in the National Museum of Antiquities of Scotland, Edinburgh.

Members of the Scottish royal families, nobles and churchmen bought

manuscripts and silver in Paris and the other centres of production in France over a period of more than three centuries. Almost all the silver was melted down and many manuscripts have perished, perhaps most notably in the sacking of the Royal Library at Holyrood and the border abbeys in the 1540s. It is impossible to know the scale and quality of French manuscripts in Scotland, but sixteenth century visitors were impressed by what they saw.

Marcus Wagner, a book hunter acting for the German Protestant controversialist and church historian Flacius Illyricus, visited Scotland in the early 1550s. He acquired manuscripts from Arbroath, Coupar Angus and St Andrews and is recorded as having visited Dundee, Perth, Scone, Cambuskenneth, Edinburgh and Leith. He maintained that "neither Germany, Italy, nor Denmark can boast of such manuscripts as are to be found at Scone, Cambuskenneth, Edinburgh, and St Andrews". One of the most fascinating survivals from the fourteenth century was acquired by Wagner from the Prior of St Andrews in 1553. It is a small music book, measuring only 15 x 21.5 cms, which preserves or reflects compositions of the two great twelfth century masters of the Notre Dame school, Leoninus

4. Limoges-style Enamels excavated in Scotland (from left to right): Dagger Pommel, late 14th century, unearthed in a garden at Fortingall, Perthshire, 2.7 x 3.2 x 1.2 cms; Crucifix, 13th century, discovered in the churchyard at Ceres, Fife, 17 x 13.3 cms; and Plaque depicting Christ blessing, from the reverse of a cross, 13th century, found on a body buried in the church of the castle, Borve, Benbecula, 6.1 x 6.1 cms. All three enamels are in the National Museum of Antiquities of Scotland, Edinburgh. Other Limoges-style enamels in the National Museum include a pricket candlestick found in digging the foundation of the parish church of Kinnoul, near Perth; another candlestick from Bothwell Castle, Lanarkshire; and a hasp found in the bank of Beck's Burn, near Wauchope Castle, Langholm, Dumfriesshire.

5. Plaque depicting the Crucifixion. French, c. 1325. Champlevé enamel on copper. 15.1 x 3.8 cms. Said to have been found during repairs at Dunkeld Cathedral in 1818. Collection of the Duke of Atholl, Blair Castle.

and his successor, Perotinus. The manuscript is now in the Ducal Library, Wolfenbüttel, near Hannover in West Germany (Codex Helmstadiensis 628). An inscription, "*liber monasterii S. andree apostoli in scocia*", on fo.64 reveals that it belonged to the Augustinian Priory of St Andrews and analysis of the handwriting suggests that it was there by about 1350. There are at least three other marginalia which establish that the manuscript was in Scotland in the fourteenth century. An intriguing passage on fo.172 reads, in translation: "to the venerable and discreet James, clerk of St Andrews, Johannes Molindinarius send affectionate greetings. I gladly beg of you [to receive] Thomas Bell, the bearer of this letter". It is tempting to link this Thomas Bell with a man of the same name, described as a citizen of St Andrews, who witnessed a charter of John, Prior of St Andrews, at some time between 1326 and 1328 and then two more charters, granted by Duncan, Earl of Fife, between 1328 and 1332. It would seem likely that the presence of the music book at St Andrews is connected with the years of great activity when Bishop William Lamberton (1297-1328) was pouring money and effort into the diocese. The bishop built or rebuilt a number of episcopal residences, renovated the priory, constructed a new chapter house, and erected ten new churches. More importantly, he completed the cathedral (begun in 1159), decorated it and provided splendid new vestments for the canons. The cathedral was dedicated on 5 July 1318 in the presence of Robert the Bruce and a large assembly of dignatories. During his visit to the priory, Wagner also removed another music manuscript, which contains Latin motets. It too is at Wolfenbüttel (Codex Helmst. 1099). The contents and notation suggest that it was probably copied in or near Paris towards the middle of the thirteenth century.

A number of French and French-style enamels have been discovered in Scotland (Figs. 4 and 5). Colourful French enamels were probably being imported into Scotland from the twelfth century. Limoges, the chief centre of production, belonged within the Angevin domains from 1152, the time of the marriage of Eleanor of Aquitaine to Henry II, and Limoges enamels were imported into England from about this period. However, the surviving examples found in Scotland date from the thirteenth and fourteenth centuries. French ceramics were imported in connection with the wine trade and recent excavations at Perth and Aberdeen have produced a few fragments of Rouen, Saintonge and other French wares.

Scottish literature, and in particular court verse, was much influenced by French works. Froissart actually visited Scotland in 1365 and on his return composed the romance *Meliador*, which tells the mythical tale of rival contenders for the hand of the king of Scotland's only daughter. Two interesting French-related works date from the fifteenth century. The first, *The Avowis of Alexander*, is a Scots translation of a late version of the *Roman d'Alixandre, Les Voeux du Paon*, composed by Jacques de Longuyon around 1310. It is preserved in the work now known as *The Buik of Alexander* (printed by Alexander Arbuthnet, Printer to the King's Majesty, about 1580, although the colophon proves that the translation was in existence by 1438). The second piece is the anonymous *Lancelot of the Laik*, a long fragmentary romance based on parts of the anonymous thirteenth century French prose *Lancelot del Lac*. Textual evidence suggests that it was in existence during the reign of James III (1460-88) and that the lady's name, Margaret, is not unconnected with Queen Margaret of Denmark, whom James III married in 1468.

A wide range of French works and Scottish works in the French style have survived from the fifteenth century. At least one master mason of French origin was working in Scotland in the early fifteenth century. A badly-weathered panel set into the west wall within the south transept of Melrose Abbey once read:

"John Morrow sum tym callit was I,
And born in Parysse certanly,
And had in kepyng al mason werk
Of santandroys ye hye kirk
Of Glasgw, Melros, and Paslay,
Of Nyddysdayll and of Galway.
I pray to God, and Mari bathe,
& swete Sanct Johne, to kepe
This haly kirk fra skathe".

Close to the panel, on the lintel of the doorway giving access to a stair leading up to the clerestory and the tower, was another inscription:

"Sa ye compas gays even about
Sa trouth and laote shall do but diute
Bahalde to ye hende qo John Morvo".

The first two lines of the verse are placed on either side of a panel which contains the arms of Morvo: a shield charged with three trefoils and two compasses set saltierwise.

Melrose Abbey (Fig. 6) had been destroyed by the troops of Richard II in 1385. Four years later, the English King gave compensation to the monks.

6. Melrose Abbey, South Side, early 15th century. The tracery in the transept window and in some of the chapels is attributed to the French-born master mason John Morrow.

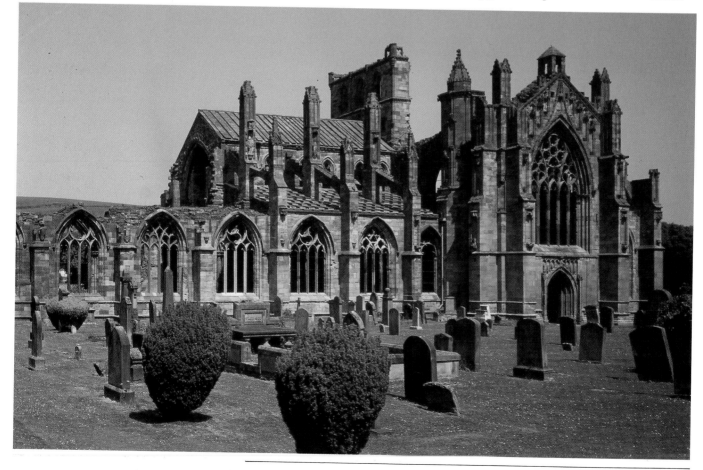

The first phase of work, the choir, is essentially English and is connected with projects undertaken in Yorkshire. The details of the transept, however, reveal the hand of a master mason from another background. The position of the inscription suggests that the new man was Morvo or Morrow. Stylistic analysis indicates that he was not simply Paris-born, but an active importer of French ideas. A recent author (Richard Fawcett) has drawn attention to the spherical triangles in the tracery of the windows of the south transept and chapels on the south of the nave and has related them to the preference of many French masons of the late fourteenth century for spherical forms within curvilinear tracery, as for example in the Lagrange chapel added to Amiens Cathedral in about 1373.

Morrow's activity at the other churches named in the larger inscription is still not clear, although Paisley ("Paslay") and Lincluden (in Nithsdale or "Nyddsdayll") both have windows which are almost identical to an example at Melrose. An interesting aspect of Morrow's work is his apparent knowledge of Central European (Prague) as well as French architecture. It would seem likely from their name and their work that a family of master masons called Franch had links with France. John Franch died in 1489 and was buried at Linlithgow. He may have been involved with the church and with the windows in the south transept and the nave. His son, Thomas, worked on Falkland Palace in the 1530s.

French silver was imported into Scotland in the fifteenth century. Some items would have been for secular use and some for religious purposes. The fifteenth century and the first half of the sixteenth century witnessed the proliferation of altars in the burgh churches, and these would have had crucifixes, altar plate and other silver. Linlithgow is said to have had 26 altars, Perth 37, Aberdeen 38 and Edinburgh 44. Such figures are suspect, but nevertheless indicate the presence of many altars in the burghal churches. This century and a half also saw the foundation of three dozen collegiate churches. Surviving inventories suggest that some of the religious plate came from abroad, but it is seldom possible to establish the origins of individual items or to apportion the percentage of French, English, Flemish and other imports.

Fortunately, three important maces have survived which have a claim to be French. Two belong to the University of St Andrews and the other to the University of Glasgow. The earliest of the maces at St Andrews (Fig. 7) is decorated with six shields bearing the arms of Scotland, of Bishop Henry Wardlaw, the founder of the University (1403-40), of Alexander Stewart, Earl of Mar (d. 1435), of Archibald, 4th Earl of Douglas (d. 1424), and of Robert, Duke of Albany, Regent of Scotland (d. 1420). The sixth shield, a later addition, is that of John Spotiswood, Archbishop of St Andrews (1615-39). Although no mark can be distinguished, the mace would appear to be French. This attribution is supported by our knowledge that the founder of the university, Bishop Wardlaw, had graduated in arts at Paris, studied civil law at Orléans and attended the papal university at Avignon, while all the earliest lecturers at St Andrews had gone to French universities. It would seem likely that the mace was acquired soon after the foundation of the university. The first university lectures took place after Whitsunday 1410, and Bishop Wardlaw issued a charter on 28 February 1411. Pope Benedict XIII confirmed the foundation on 28 August 1413, and the papal bull arrived at St Andrews on 3 February 1414.

There is no inscription on the mace to indicate to which faculty it

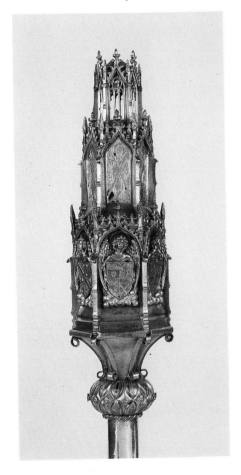

7. Head of a Mace identified as the Mace of the Faculty of Canon Law, University of St Andrews. French, c. 1410-18. Silver-gilt. 128.3 cms. University of St Andrews.

belonged. However, an inventory of about 1461 records that both the Faculty of Canon Law and the Faculty of Arts owned maces, presumed to be this mace and another similar mace at St Andrews. The latter appears to have been made in Scotland. The papers of the Faculty of Canon Law have not survived, but the Proceedings of the Faculty of Arts do exist and reveal that it was resolved to lay aside money for a mace on 17 January 1414 and on 21 May 1415, that the order had been placed by 9 August 1418, and that the mace had probably been completed by 9 December 1419. There is no description of the mace, but there is a clue to its identity. On 9 August 1418 the faculty requested the goldsmith to come to St Andrews to complete the job, or, if he was unwilling to do this, to send the mace with their messenger. It would be a mistake to make too much of this, but the entry suggests a local rather than an international expedition. This would imply that the Faculty of Arts owned the Scottish mace and the Faculty of Canon Law the French mace. Some support for the identification of the French mace as the mace of the Faculty of Canon Law may be found in the fact that no fewer than four of the first eight teachers at St Andrews lectured in the Faculty of Canon Law: Richard Cornell, Archdeacon of Lothian; John Litstar, Canon of St Andrews; John Scheves, Official of St Andrews; and William Stephen, afterwards Bishop of Dunblane. The similarity of the Scottish mace to the French mace suggests that it may have been modelled on the latter. If this identification is correct, it would imply that the French mace would have been at St Andrews by August 1418, by which date the Arts mace had definitely been ordered and was probably being made.

The other French mace at St Andrews (Fig. 8) belongs to St Salvator's College and is an extremely fine piece of goldsmith's art. St Salvator's, the College of the Holy Saviour within the City and University of St Andrews, was founded by James Kennedy, Bishop of St Andrews (d. 1465), on 27 August 1450. The church was consecrated in October 1460. A silver-gilt medallion attached to the shaft of the mace is engraved with a Latin inscription, which translates:

> "James Kennedy, the illustrious archbishop of St Andrews and founder of the College of St Salvator to which he gifted me, had me made in Paris in the year of the Lord 1461".

The information is corroborated by the subject-matter of the tabernacle head, the arms of Bishop Kennedy on one of the three shields and the spiral bands of chasing on the staff which repeat the letters "IK" (for James Kennedy) linked by a cord and surmounted by a crown. Another inscription, on a disc inserted between the bottom of the staff and the moulded terminal, records:

> "John Maiel govldsmche and verlete off chamber til ye Lord ye Dalfyne hes made yis masse in ye toune of Paris ye zer of our Lorde MCCCCLXI".

The maker, Jean Mayelle, was clearly an important goldsmith whose ability is evident from the mace. He was one of six wardens of the Incorporation of Goldsmiths of Paris in 1460 and produced work for the Dauphin. The intricate hexagonal head of the mace takes the form of a shrine and shows Christ, the Holy Saviour, to whom the college was dedicated, on the upper of two tiers with angels bearing three instruments of the Passion: the column, the cross and the spear. Christ's torso is exposed and the reference is clearly to his suffering, crucifixion and death. The grotesques or devils below, the

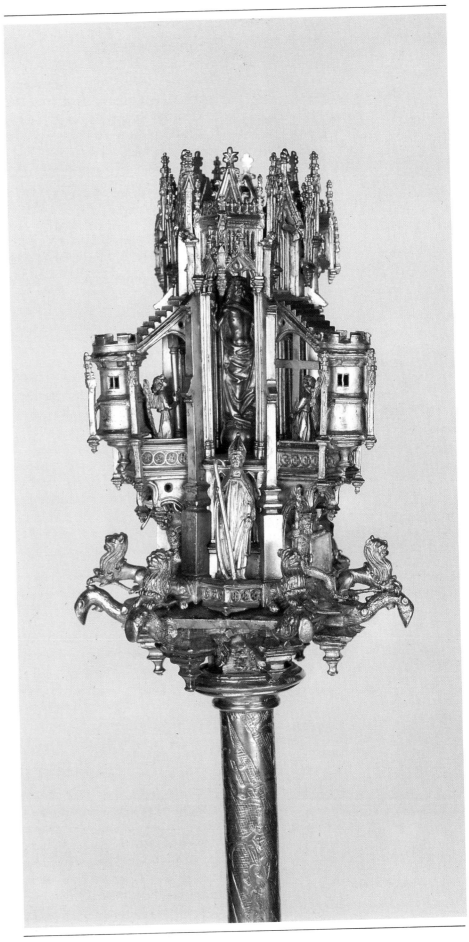

8. Head of the Mace of St Salvator's College.
St Andrews, by Jean Mayelle. French
(Paris), 1461. Silver-gilt. 116.2 cms.
Commissioned by James Kennedy, Bishop
of St Andrews (d. 1465). University of
St Andrews.

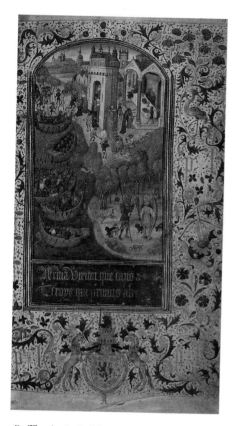

9. The Arrival of Aeneas at Carthage. *Works of Virgil* written by the Florentine scribe Florius Infortunatus and decorated in the style of William Vrelant. French (Paris), c. 1460. 22.4 x 13.8 cms. Edinburgh University Library (Ms. 195, fo.65r). The Royal Arms of Scotland beneath the miniature reveal that the manuscript was produced for a member of the Scottish royal house. The initials "PL" are believed to refer to the Princess Leonora or Eleanor.

placing of Christ on a globe to symbolize his dominion over the world, and his hands raised in benediction refer to his resurrection and the salvation of mankind. A king, a bishop and what may be taken to be a member of Kennedy's new college occupy alternate places on the lower tier. The staff is adorned with pulpit-like projections and figures.

Glasgow University's mace is similar to the mace of the Faculty of Canon Law at St Andrews. Unfortunately, the former has had its coats of arms re-engraved or replaced and the little plaques on the second level appear to have suffered a similar fate. The University of Glasgow was founded by William Turnbull, Bishop of Glasgow, in January 1451. Some details are known about this mace's acquisition. David Cadzow, Canon of Glasgow and the first rector of the University, was re-elected Lord Rector on 25 October 1460, and gave twenty gold nobles as a subscription towards a mace. In 1465, a committee was appointed to collect funds for the completion of the mace, by taxing the "nations", or student associations. A reference in the University Minutes of 1469 suggests that the mace was in use. Glasgow had strong connections with France and with Paris, and Paris is the likeliest source of the mace. An inscription on the mace reveals that it was taken to France for safe-keeping in 1560 at the time of the Reformation, and was brought back in 1590.

Bishop Kennedy's commission of a mace from Jean Mayelle in Paris suggests that he may have acquired other items of plate from France. Evidently there was a large amount of silver for the altars and the celebration of mass at St Salvators in the 1460s, and some could have been French purchases. The most magnificent items are referred to in the inventory: "ane gret ymage of syluyr of our Saluiour with ane louss diadem set with preciouss stanis closyt with ane pyn of siluer"; a "gret cruss gylt with ane crucifix Mare and John and the tuelf Apostolys about standand apon a gret futh closit with a pyn of syluer"; and "ane gret *Agnus dei* with relikis about Sant Saluatoris hals siluer and our gylt".

During this period illuminated manuscripts were also imported from France. A number of these are likely to have been acquired by the royal family. One manuscript which was clearly owned by the royal family is the *Virgil Manuscript*, now in Edinburgh University Library. This was written in Paris by a Florentine scribe and decorated in the style of the Flemish artist William Vrelant. It contains the royal arms and the initials "PL" (Fig. 9), which suggests that it was prepared or finished for Princess Leonora or Eleanor, daughter of James I. Churchmen also acquired French manuscripts, of which the most interesting survival is the prayerbook of Robert Blackadder, Bishop and subsequently the first Archbishop of Glasgow (d. 1508). In this manuscript, commissioned and carried out in Northern France between 1483 and 1492, Blackadder is depicted kneeling before a crucifix on fo.47 (Fig. 10). On fo.41 is the prayer "*Libera me domine, Robertum famulum tuum, ab omni malo*". Blackadder's involvement with Glasgow is reflected in the prominence given to St Kentigern in the calendar and litany, the importance given to the dedication of Glasgow in the calendar, and the presence of a number of saints from the Lennox district of the diocese of Glasgow. He had been Bishop of Aberdeen and this association is reflected in the appearance of the dedication of Aberdeen in the calendar. The prayerbook contains historiated initials of the Scottish saints Margaret and Ninian.

For those who could not afford such de-luxe works, there were the less expensive, middle-range lines. The manuscript workshops of Rouen, in

10. Blackadder before Crucifix. Prayerbook of Robert Blackadder, Archbishop of Glasgow (d. 1508). Northern French, 1483-92. 19 x 13 cms. National Library of Scotland, Edinburgh (10271, fo.47v).

Northern France, assembled books of hours for Scottish customers (Fig. 11). Many Scots arrived in France by travelling up the Seine to Rouen, which was a large town by the standards of the day, and a major trading port. It was also a major centre for book production, with a flourishing book trade. Its workshops produced texts which followed the *British Use of Sarum* (the order of religious worship used at Salisbury from the eleventh century and copied in England and Scotland up to the Reformation), as opposed to their own *Use of Rouen*, and illustrated these with the standard Rouen treatments of religious subjects, labours of the month and signs of the zodiac. Such texts could have been sold to any English or Scottish customer. To give them particular relevance to Scotland, the workshops prepared separate calendars of saints which included and gave prominence to Scottish saints. These calendars were bound at the beginning of the books. Among such books of hours intended for Scottish customers are the *Yester Hours* (Magdalene College, Cambridge, Pepys Library, Ms. 1576), the *Playfair Hours* (Victoria

and Albert Museum, L.475-1918), Edinburgh University Library, No. 43, and the *Farmor Hours* (Koninklijke Bibliotheek, The Hague, Ms. 133D16). These manuscripts date from around the 1480s. The *Yester Hours* was owned by Lord Hay of Yester and records his death in 1508. The early histories of the other manuscripts are not known. From about 1470, when printing was introduced in Paris, Scots acquired French printed books.

11. **The Mass of St Gregory.** Book of Hours. French (Rouen), late 15th century. 20 x 13.3 cms. Edinburgh University Library (Ms. 43, fo.117r). The presence of Scottish saints in the calendar indicates that the manuscript was produced or completed for a Scottish customer.

THE FRENCH QUEENS

The most fascinating period of the "Auld Alliance" was during the sixteenth century. Scotland moved closer to France in order to receive assistance against England, yet in so doing sacrificed her independence and finally revolted against French domination.

The century began with the signing of a perpetual peace with England in 1502 and the marriage of James IV to Henry VII's daughter, Margaret, in August 1503. Unfortunately, the peace was not perpetual. The Franco-Scottish alliance, which had been renewed in 1492, was confirmed once more in 1512. The following year Henry VIII invaded France and James led his army over the border to draw off some of the English troops from the invasion. James was killed at the Battle of Flodden on 9 September, along with his son Alexander Stewart, the young Archbishop of St Andrews, two dozen earls and nobles, four bishops and abbots and several thousand of his army. The Scots prepared to continue the fight.

The new king, James V, was only 17 months old and Scotland was faced with another minority. John, Duke of Albany (1481-1536), son of James II's brother Alexander and his French wife, heir-presumptive to the throne of Scotland after James V and his brother (d. 1515), was invited to come from France, where he had been born and raised, to act as governor of Scotland. Albany's military experience and the belief that he would be able to obtain French military assistance were perhaps not unimportant considerations in inviting him to come to Scotland. France decided upon peace with England at this point, and Albany was not allowed to leave the country until the spring of 1515. He finally arrived in Scotland in May and although he could speak only French and was not fully conversant with Scottish affairs, Albany governed the country well until 1524, when he returned to France. He sought to govern fairly and to avoid opening up divisions. In the first of several attempts to obtain French support Albany visited France in 1517 and concluded the Treaty of Rouen, which laid down that France and Scotland should act jointly and give mutual assistance in the event of an English attack on either, and held out the prospect of a French bride for James V. Despite Albany's efforts to sustain concerted action between France and Scotland he was not always successful. Eventually in 1524 while Albany was in France, Archibald Douglas, 6th Earl of Angus, who had married Margaret Tudor, widow of James IV, with others took advantage of his absence and invested James V with the symbols of sovereignty, so bringing Albany's

governorship to an end. Douglas became the young King's guardian in 1526 and shared out offices amongst his family. James managed to escape from his protectors in 1528, and the Douglases fled or were forced into exile in England.

That James V was inclined to seek alliance with France was understandable. The English had killed his father, together with many Scottish nobles, and James himself had been confined by the Douglases, the principal supporters of the English. He may also have reacted against his unstable English mother and have looked back upon the pro-French administration of Albany, considering it preferable to the "jobs for the family" government of the Douglases. The Treaty of Rouen had held out the prospect of a French bride for James. In 1520 Francis I's wife, Claude, had given birth to another daughter, Madeleine, and a marriage was suggested on various occasions, but the French repeatedly negated the idea: the child was too young and too frail. By the end of 1534 Francis was offering James the hand of Mary, daughter of the Duke of Vendôme, with a dowry of 225,000 livres. After seeing a portrait of the girl, James asked for more: a pension of 20,000 livres, the order of St Michael, the surrender of Dunbar, and the extension to other ports of the privileges enjoyed by the Scots at Dieppe. A Scottish commission was appointed to treat for the marriage in July 1535, Francis confirmed the settlement in March 1536, and James arrived in France in September. Mary was inspected and rejected and finally Francis agreed to the marriage of Madeleine and James, which took place in Paris on 1 January 1537. James waited until the winter weather had improved before returning to Scotland with his Queen in May but, unfortunately, Francis had been all too correct in his judgement. The frail Madeleine died seven weeks later on 7 July 1537.

James obviously wanted another French marriage and it is clear that his religious advisers were also keen for him to marry a French Catholic. Less than a year later, on 9 May 1538, Robert, Lord Maxwell, stood proxy for James at his marriage to Mary of Guise (1515-60), the daughter of the Duke of Guise, and widow of Louis, Duke of Longueville. Both these marriages brought James great wealth as well as strengthening the alliance with France. Madeleine's dowry took the form of 100,000 livres and also provided 125,000 livres in annual rent. She is said to have brought plate, apparel and jewels worth more than 225,000 livres together with two great ships and munitions. Mary of Guise's dowry consisted of a payment of 100,000 livres and an annuity of 20,000 livres.

James had already started to build, reconstruct and improve his palaces before his marriage to Madeleine. The wealth provided by his marriages, added to the normal revenues of the crown, enabled him not only to continue building, but to become more innovative and to build in the French style. The King's principal projects were the "greit towre" at the north end of the main west facade of Holyroodhouse (1528-32); parts of Linlithgow Palace, probably including the outer and inner courts (1534-36); the west and south quarters of the principal quadrangles at Holyroodhouse (1535-36) now swept away or transformed by the great re-building of 1671-79; the new gateway and reconstruction of the east and south quarters of Falkland Palace (1537-41); and the new Palace block at Stirling (1540-42). This sustained programme of royal building is on a scale unparalleled in Scottish architectural history. It began with the King's assumption of power in 1528 at the age of 16, and continued until his death in 1542, at the age of only 30.

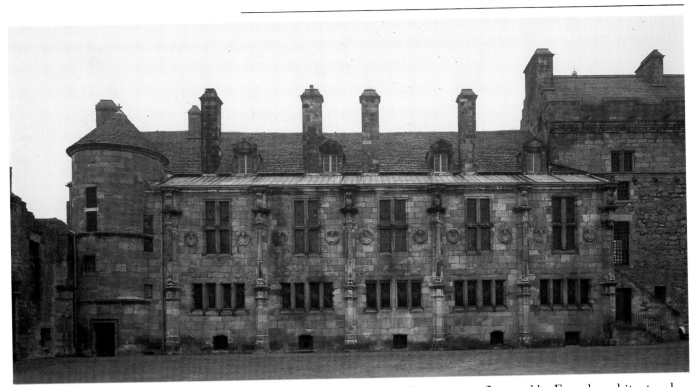

12. The South Range of Falkland Palace. Two French master masons, Moses Martin and Nicholas Roy, worked on Falkland Palace between 1537 and 1541.

There can be no doubt that James was influenced by French architectural patronage and French architecture from the time of his visit to France to marry Madeleine, but it is worth considering whether this sustained programme was inspired by news of developments in France before that date. What, for example, did Albany tell James about the *châteaux* of the Loire and other buildings in France? And how much did James know about the extensive architectural patronage of Francis I before 1536? Francis was about 18 years older than James and had been king for 13 years before James began his personal rule. From the very first he had been a great builder: his earliest works include the palaces of Amboise, Romorantin, Blois, and Chambord. Francis also built the Château of Madrid (now destroyed) in the Bois de Boulogne in Paris (1528-70), Fountainebleau (apparently commissioned in 1528), the Château of Villers-Cotterêts to the north-east of Paris (begun about 1533), and the Château of Saint-Germain-en-Laye (begun in 1539). Not only was Francis a great spender, but du Cerceau says that he was also very knowledgeable about architecture, and his example can be assumed to have inspired others, including James V.

There had been French craftsmen in Scotland prior to the King's marriage to Madeleine. James IV and Albany had employed French experts, and in 1532, for example, we find Edinburgh town council commissioning John Mayser and Bartrahame Foliot, Frenchmen, to pave the streets of the town. The royal marriages brought a greater number of French craftsmen to Scotland. Whilst at Orléans in December 1536, James V appointed Moses Martin, Frenchman, and sometime master mason at Dunbar Castle, as master mason to the crown. In April 1539 Nicholas Roy received a similar appointment. It would seem likely that Roy was recruited by Mary of Guise's mother, for the Duchess wrote to her daughter in March 1539 informing her that she had found "*ung masson que l'on estyme des biens bons*" who, together with another mason, would be able to leave for Scotland before Easter. The royal accounts also reveal the arrival three months later of six French masons.

French influence is most apparent in the courtyard facades of the south and east quarters of Falkland Palace (Fig. 12), which have been described as "a display of early Renaissance architecture without parallel in the British Isles". The building records reveal that both Martin and Roy worked on this project. French sources for the simple, dignified proportions of the bays, the buttresses incorporating classical columns and the medallions are to be found in the Loire and the Île-de-France. The simplicity of the elevations reflects the work under way at Fountainebleau since 1528 and on some other contemporary French schemes. The elements are derived in their turn from Italian sources, probably from Bramante and other Milanese architects, whose work became known in France as a result of Charles VIII's and Francis I's campaigns in Italy in the late fifteenth and sixteenth centuries. Besides the French architectural influence, it is also interesting to note the presence of a French tennis court, a *jeu quarré* court, at Falkland, which is believed to have been built in this period.

French influence is also discernible in the new palace block at Stirling, in the simple courtyard elevations and in the more elaborate external elevations, which are symmetrically divided into series of boldly recessed bays, each containing a sculpted figure set upon an ornamental baluster. Some of the figures, however, are derived from engravings by the German artist Hans Burgkmair. Regrettably, the building records for Stirling do not survive and it is not known who was involved with this undertaking. In all probability, some of the workers at Falkland would have been moved on to Stirling.

Other French craftsmen besides masons were employed by James V. One of the most interesting was Andrew Mansioun, described as a carver, wright and gunner. An early first reference appears to be in 1536 when an Andrew Mason or Mansioun entered into a contract with Robert Moreau, a Paris-born sculptor living in Antwerp, to make with him a marble monument with brass inlay for George Crichton, Bishop of Dunkeld. In 1539 Mansioun was responsible for the construction of the royal apartments and for other carved decoration on the "littil new bark" [ship] being built for the King. Following the birth of the King's first son, James, in May 1540, Mansioun undertook to carve "my lord prince cradyll". In 1542 he engraved coats of arms upon pieces of royal artillery, and after the King's death in December 1542, he carried out ornamental work and an engraved inscription in Roman letters, totalling 5.5 metres, on the King's tomb. Ten years later, he was employed by Edinburgh town council to erect new choir stalls in St Giles Church; and in 1562 he was appointed master wright and gunner-ordinary to Mary Queen of Scots.

Surviving works of sixteenth century sculpture which are influenced by French art include the ornate stone fountain in the inner court of Linlithgow, which probably dates from the latter part of James V's reign. The design is basically Gothic, but the work includes such Renaissance details as medallions, and is said to have borne the royal arms of Scotland and France. A number of French-influenced wooden sculptures or carvings are associated with James V's reign and the minority of Mary Queen of Scots. The most important scheme is the "Stirling heads", the oak medallions which decorated the ceiling of the King's Presence Chamber in Stirling Castle. The ceiling suffered a partial collapse in 1777 and was dismantled: but thirty-eight medallions or parts of medallions have survived and the majority are on display in Stirling Castle. Careful comparison suggests that

the medallions are not all by one individual, and two carvers have been postulated. The leading candidates appear to be John Drummond of Milnab, master carpenter and master gunner to James V and Mary Queen of Scots; Robert Robertson, carver; and Andrew Mansioun. Of the three, Mansioun is the most likely, although the building records for Stirling have not survived and the lack of documented works by these craftsmen prevents any attributions on stylistic grounds.

Armourers were among the other French craftsmen whom James employed. A harness or armour mill had been set up in Edinburgh for a French armourer called Passing and his colleagues under James IV in 1502, but Passing had died soon afterwards. In 1531, another armour mill manned by Frenchmen was set up at Holyrood Palace, but the records do not reveal how long it was in operation. Both undertakings reflect the expansion of iron making and working in France: over 400 of the 460 iron forges in France around 1542 had come into existence during the previous 50 years. The mills reflect the development of the French armaments industry to meet the demands of the Italian and Imperial Wars, especially after France was denied access to the previous suppliers. Artillery was also produced in Edinburgh with the help of foreigners, including Frenchmen. The pieces would have been made of cast bronze and pre-dated the establishment of the great forge at Breteuil for the manufacture of iron cannon. James also received some French assistance in 1539 to work the Crawfordmuir goldmine. The Duchess of Guise helped to recruit these French miners, but their stay in Scotland was no more than a few months. Two other Frenchmen should not be overlooked: one Gilzeame, described as a *tapistre* (tapestries and hangings), who came from France in 1538, and the head gardener who was at Stirling Palace in the 1530s.

Scottish craftsmen naturally learned from these experts and a few Scots were privileged enough to be sent to France. John Drummond, the master carpenter and master gunner, for example, visited France in 1538. Another Scottish craftsman who went to France was the royal goldsmith and jeweller John Mossman, whom Mary of Guise dispatched to buy 50 pounds' worth of goldwork. Mossman, it can be assumed, would have developed a knowledge of French silver and jewellery and in particular Parisian work. One of the commissions he received was for the making of a gold crown, using 35 ounces of gold, and a silver sceptre, to be gilded with four rose nobles, for Mary's coronation on 22 February 1540.

The Stewart royal family clearly owned a large number of high-quality French items, including many pieces of silver and jewellery, costume and textiles. The most important articles probably belonged to Madeleine who, as already noted, is said to have brought plate, apparel and jewellery to Scotland, but James I and his second wife, Mary of Guise, would have owned similar items appropriate to their position. A contemporary source refers to the "gold and silver, all kinde of riche substance, quhairof [James V] left greyt stoir and quantyte in all his palices at his departing". Much of the plate was used to pay the soldiers during the minority of Mary and the regency of her mother but, even after Mary of Guise's death on 11 June 1560, there remained a considerable quantity. An entry in the royal accounts lists the sale for £2,646 of silver vessels weighing 9 stones which belonged to the late Queen Regent. James V and his wives owned various tapestries and hangings which were made or acquired in France. These would have been moved from palace to palace as the court travelled around, and provided

colourful decoration on the walls and frames of furniture, as well as reducing draughts and acting as a simple form of insulation. The royal accounts note that a tapestry of the *Story of the Trymphand Dames* was bought in Paris in 1538. Netherlandish tapestries were much in favour at the French court in this period, and Francis I seems to have owned several. James V also acquired Netherlandish tapestries, and George Steel, who appears in the royal accounts between 1527 and 1542, is known to have been sent to Flanders in 1538 to bring home tapestries.

The leading nobles and churchmen probably owned some French luxury items, and a major opportunity for purchases and gifts was provided in 1536-37 when James V took a party of earls, barons and bishops to France to attend him at his first marriage. One such owner and patron of works in the French style was Cardinal David Beaton. He had finished his education in Paris, served as an ambassador to France, was made Bishop of Mirepoix in 1537 for his services to France, and was the principal architect of the Franco-Scottish alliance during the reign of James V. When Beaton was translated to the Archbishopric of St Andrews, he undertook the building of St Mary's College, St Andrews. This incorporates Franco-Italianate details and the Archbishop may well have obtained the services of craftsmen who had been working on Falkland Palace. Cardinal Beaton also commissioned the carved oak "Beaton panels" (National Museum of Antiquities of Scotland) which represent the Annunciation, the Tree of Jesse, the arms of the Passion, the royal arms, and those of the patron and his parents. The Tree of Jesse is related to French illustrations of the same subject, and the panels incorporate some Renaissance forms and details. After the Cardinal's murder in May 1546 the college was continued by his successor, John Hamilton, a strong supporter of the Franco-Scottish alliance whose half-brother, the 2nd Earl of Arran, was created Duke of Châtelherault by the French. It can be reasonably assumed that the Cardinal and Archbishop Hamilton owned French silver and manuscripts. Many churchmen owned French printed books, and a large number have survived which can be linked to original or early owners. Although French religious music was probably well known in this period little has survived. The large choirbook from Scone, known as the *Scone Antiphonary* (National Library of Scotland, Adv. Ms. 5.1.15), includes Dufay's *Missa L'homme armé* (fos.26-42). The *Missa L'homme armé* by the Scottish composer Robert Carver (1491-c. 1550) in the same manuscript is modelled on Dufay's work. (The choirbook also contains works by four English composers: William Cornyshe Junior, Robert Fayrfax, Walter Lambe and Nesbett.)

In England, by 1540, Henry VIII had almost carried through the so-called Henrician Reformation, which placed the king and not the pope at the head of the English Church and transferred much of the wealth of the church to the crown. Henry had been anxious to gain James' acceptance of his "reformation" and the two should have met at York in September 1541, but fearing that he might be kidnapped, James' advisers would not permit him to go south. Henry was incensed, tension increased, and an English force was mobilized. The campaign which James led was not merely in support of the "Auld Alliance" but in support of the papacy against the schismatic Henry. The Scots however were already deeply divided on the religious issue and some were also out of sympathy with their extravagant king. The disastrous defeat which they suffered at Solway Moss on 24 November 1542 was almost inevitable in these circumstances. James died in deep depression at Falkland

on 14 December and was succeeded by his daughter Mary, who had been born six days previously at Linlithgow. James V's death led to a radical change in the nature of the Franco-Scottish relationship and spelt the end of a strong royal lead in the patronage of the arts.

Scotland was once more faced with a minority. Henry with characteristic opportunism decided that Mary should marry his five-year-old son, Edward. There was already a pro-English current of opinion in Scotland, partly because of the conversion of Scots to Protestantism, partly through dislike of the French, and Henry sought to exploit this. He released Scottish prisoners from Solway Moss on condition that they furthered the marriage. The Douglases were also briefed and returned to Scotland from their exile. Largely as a result of these English machinations, Scottish commissioners were appointed to negotiate a treaty with England and a marriage between the infant Mary and the child Edward. In the Treaties of Greenwich, concluded on 1 July, it was agreed that the marriage should be contracted by proxy before Mary reached the age of ten, when she would be brought to England. Reaction set in however and the Scottish parliament denounced the treaties and renewed the alliance with France. Henry responded with the invasions of 1544 and 1545 commanded by the Earl of Hertford (later the Duke of Somerset). These are referred to as the "Rough Wooing" of Scotland and were intended to chastize and thoroughly intimidate the Scots.

The only way of preserving Scottish independence in the face of such aggression, and the incompetence and unreliability of the Scottish magnates, was to forge stronger links with France and secure French military help. At the beginning of September 1547 Somerset crossed over the border at the head of an army of 16,000 men and won a victory at Pinkie, near Musselburgh, in which thousands of Scots were killed. The English began to establish themselves in various strongholds dominating the Forth and Tay estuaries and in the spring of 1548 they took possession of Haddington, enabling them to intimidate the Lothians and Edinburgh. The French had already mounted an operation to take the Castle of St Andrews from the murderers of the pro-French Cardinal Beaton, but the price of further large-scale military support was to be the marriage of Mary Queen of Scots to the Dauphin. The vacillating Earl of Arran, heir-presumptive to the throne, was bribed with the offer of the French duchy of Châtelherault, which he received in February 1549, to agree to the marriage. Henri II of France made preparations to evict the English occupation force. Between 5,000 and 10,000 troops under the command of André de Montalembert, Seigneur d'Essé, arrived in Scotland in June 1548 aboard 120 vessels including 16 galleys. A joint Franco-Scottish force laid siege to Haddington and a treaty was drawn up at a nearby nunnery on 7 July, whereby the Scots agreed that Mary should marry the Dauphin, while Henri promised to maintain Scottish freedom, liberties and laws. Mary set sail for France on 29 July 1548. In September 1549 the English evacuated Haddington, partly as a consequence of French action against Boulogne.

During the 1550s Mary of Guise emerged as the major figure in the administration, becoming Regent in April 1554. Her chief adviser was the French ambassador D'Oysel, and she employed Frenchmen in various posts: Villiemore, a member of the dowager's household, became Comptroller; Bonot became Bailie of Orkney; and Jean Roytell was appointed Master Mason. French troops were present in some force, garrisoning Scottish fortresses, and there was the usual resentment at their presence. As early as

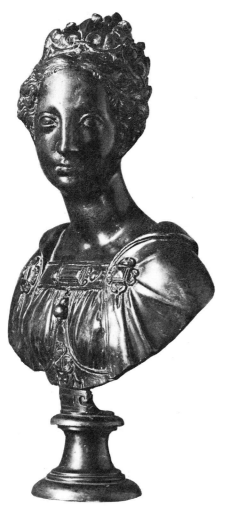

13. Mary Queen of Scots (1542-87) attributed to Ponce Jacquio. French, late 16th century. Bronze. 27 cms. Scottish National Portrait Gallery, Edinburgh.

1555, there was an official warning against "speaking evil of the queen's grace and of Frenchmen".

By the late 1550s the Reformation had begun to make a considerable impact and more and more Scots were becoming Protestant. Fear of French domination was also increasing. The Dauphin and Mary were married on 24 April 1558, Henri II died on 10 July 1559 and Francis and Mary were proclaimed King and Queen of France and Scotland. It looked as though Scotland would become an offshore possession of France. Eventually, the pent-up forces of the Reformation and the fear of domination by France combined to produce the revolt of 1559-60. But to eject the French, the Scots had to turn to England, their old enemy, for assistance. Late in June 1559 the Scottish reformers entered Edinburgh. Their leaders, the so-called "Lords of the Congregation", withdrew after a short time, but agreed to reassemble their forces in September. In the meantime, the government fortified Leith (the port of Edinburgh), and in August and September 1,800 French troops arrived in Scotland to bring the French complement up to at least 3,000. The reformers re-occupied Edinburgh in mid October, with the Duke of Châtelherault at their head, and declared Mary of Guise to be suspended from the regency. Their assault on Leith failed however, and the reformers again left Edinburgh in November. The French then took the initiative, but late in January 1560 an English fleet appeared in the Forth, cutting French lines of communication and forcing them to retreat. The reformers secured full English support with a treaty signed at Berwick on 27 February, by which England agreed to intervene for the preservation of the Scots "in their old freedom and liberties". An English army under Lord Grey entered Scotland at the end of March and beseiged Leith. Even before the death of Mary of Guise on 11 June 1560, French envoys were negotiating a settlement and the Treaty of Edinburgh was concluded on 6 July between France and England. Nearly all the English and French troops, except 60 in Inchkeith and 60 in Dunbar, were to withdraw and leave the Scots to settle their affairs. A parliament was to be called and a council nominated to govern Scotland.

Before moving on to the tragedy of Mary Queen of Scots, it is worth looking at Franco-Scottish cultural links in the period of Mary's minority and the regency of Mary of Guise. Obviously, the death of James V and the succession of a minor meant the end of the great programme of royal building and patronage of the arts. The royal revenues declined and there were crises when plate had to be released to pay for troops. It was a period of retrenchment, with the minority and regency regimes propped up by French troops, artillery and money. Mary of Guise did, however, make a visit to France between September 1550 and October 1551 taking with her a large entourage of nobles, who were thus exposed to French persuasion and flattery and bought off with French pensions and gifts. The Queen and her nobles probably acquired clothes, plate and other luxury items during the visit. The person who seems to have been most inspired by the visit was George, 4th Earl of Huntly (d. 1562), a nephew and a great favourite of James V. Huntly was the most powerful of the Catholic magnates. He had succeeded Beaton as chancellor in 1546 and had been captured at the Battle of Pinkie in 1547. A great fuss was made over Huntly when he was in France, and he received the Order of St Michael. It is probable that he bought fine furnishings during the visit. Immediately upon his return from France he was moved to rebuild Huntly Castle from the ground floor up

between 1551 and 1554. Mary of Guise stayed at the new Huntly Castle in 1556 and was royally entertained. The French ambassador was so impressed that he advised her to "clip" her host's wings, and an envoy wrote in 1562 that the Castle was "the best furnished of any house I have seen in the country". The inventory of loot taken after the defeat, death and forfeiture of Huntly in 1562 includes elaborate tapestries, beds covered with velvet and hung with fringes of gold and silverwork, plate, vessels of gilded and coloured glass, and figures of animals. The taste for French items in this period is reflected in surviving French books and in Scottish carved woodwork, as, for example, the oak panelled door and surround decorated with arabesques and medallions in the National Museum of Antiquities of Scotland, which is said to have come from Mary of Guise's house in Leith.

The Scottish coinage in these years also reflects the strong influence of France. The designs of the first gold coinage of Mary Queen of Scots is clearly based on the French *écu au soleil*, and there is a very interesting reference in the *Archives Nationales* in Paris, relating to the *Cour des Monnaies*, which records that:

> "This day, 21 October 1553, John Acheson, die-sinker at the Scottish mint, has been permitted to cut piles and trussels having portraits of the Scottish queen as shown by him to the said court, with the duty of making patterns at the Paris mint, and, when struck, have these taken to the said court by one of the wardens."

It is not clear for what coins, jettons or medalets Acheson was making these dies. It used to be thought that some of the Scottish coinage was actually minted in Paris at the new mint, which was set up in 1551 and was in regular use for the production of both gold and silver coins using a screw press from 1552, but there is no evidence to support this theory. Coins were produced at the Edinburgh mint and the testoons thought to have been made using a screw press can, in fact, be seen to be slightly double-struck, that is to be hammered coins. There are Latin references on later coinage which refer to Mary's marriage to the Dauphin ("Francis and Mary, by the Grace of God King and Queen of Scotland, Dauphin and Dauphiness of Vienne", and "He has made both one" or "They are now not twain but one flesh") and to their reign over the two kingdoms ("Francis and Mary, by the Grace of God King and Queen of France and Scotland"). The designs on these coins include crowned cyphers consisting of an "F" and an "M", the impaled arms of Scotland and France, crowned fleur de lys and thistles, and crosses of Lorraine. The legend on the reverses of the testoons of 1560 and 1561 and half testoons of 1560, "VICIT·LEO·DE·TRIBV·IVDA" ("The lion of the tribe of Judah has triumphed"), clearly refers to the Protestant victory, and presumably places such coins after the Treaty of Edinburgh (1560). A very interesting French medal was prepared to commemorate the wedding of Mary and the Dauphin, on which profile busts of Mary and Francis are shown facing one another, with a French crown with fleur de lys and crosses alternately around the circlet above their heads. The dies of this medal were discovered at the Hôtel des Monnaies at Paris about 1840 and impressions in silver and copper made from them.

Mary Queen of Scots' husband, Francis II, died on 5 December 1560, after a reign of only 17 months. There was no place for the 18-year-old dowager queen at the French court and Mary returned to Scotland on 19 August 1561. She came as a Catholic queen to a country which was rapidly becoming

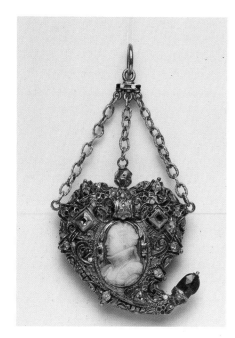

14. Locket with a Cameo Portrait of Mary Queen of Scots (1542-87). The cameo possibly French, mid 16th century. Gold, enamel and onyx cameo. 5.9 x 5.4 x 1.8 cms. National Museum of Antiquities of Scotland, Edinburgh.

Protestant. Her sympathies lay with France, at a time when her people were glad to have rid themselves of French rule. The Treaty of Edinburgh had ended the Franco-Scottish alliance and the fall of the Guise family in France made it doubly unlikely that Mary would be able to obtain aid from France. Mary's reign in Scotland lasted only six years ending with her surrender at Carberry on 15 June, and abdication on 24 July 1567. During these years the Queen had few friends and alienated potential support by her Catholicism, by the presence of French men and women in her household, by her indiscretions and by her unfortunate marriages. Mary probably could not have averted tragedy, but she appears to have had a talent for inviting disaster. Much of her life after 1561 has little to do with France, but she did bring many French works of art with her to Scotland and attempted to establish a small French cultural "cell" at court.

The important thing to bear in mind is that Mary had been Queen of France, if only for a short time, and that her French possessions would necessarily have been of the highest quality. Mary had been obliged to return the French royal jewels, but nevertheless she came back to Scotland with splendid jewels and plate. An inventory suggests that some of these were spectacular and a contemporary noted her "faire jewels, pretious stones and pearles as wer to be found in Europe". Mary is later recorded as having stated that many of the jewels had been given to her by Henri II and by her husband. Catherine de' Medici is known to have given her a superb set of pearls, which Brantôme described as "*les plus belles perles du monde*". The Regent Moray took possession of most of Mary's jewels in 1567, which "colded many stomachs among the Hamiltons". He gave some to his wife and sold a number to Queen Elizabeth in April 1568, including this set of pearls.

Mary also possessed important pieces of French silver. Some of these are recorded as having been melted down for coin and most of the pieces probably suffered this fate. A coach for her use was brought from France in 1561, together with elaborate tapestries and velvet hangings with friezes of gold and silverwork. She owned many French books and "delighted in poetry and poets, and most of all in M. de Ronsard, M. du Bellay and M. de Maisonfleur". A poet, Châtelard, and the chronicler, Brantôme, came with her when she returned to Scotland. One of her chief loves was music: she played the lute and the virginals and is said to have had "a charming soft singing voice". The songs of Clément Marot were apparently great favourites. Her household included musicians, just as Mary of Guise's had done (the 1550 lists, for example, refer to "certane Franchmen that play . . . on the cornettis"). These musicians provided entertainment for the Queen and music for dances and also for services in the Queen's private chapel. A number of secular Franco-Scottish songs have survived, including *Support your servand*, a formal translation of Marot's *Secourez-moi, ma dame par amours*, which was probably in the repertoire of Mary's court "stand" of voices. Another Franco-Scottish piece is *Richt soir opprest*, which was inspired by the work of composers active in Paris in the second quarter of the century.

Most of Mary's splendid possessions have disappeared, the plate and jewels having been melted down or refashioned. One surviving item which is associated, rightly or wrongly, with Mary is the beautiful silver-gilt casket owned by the Duke of Hamilton and now at Lennoxlove (Fig. 15). The simple dignified shape and naturalistic style decoration on the lid suggest that it was made in the fifteenth or early sixteenth century, before the craftsman

came under the full classicizing influence of the Italian Renaissance. The piece bears only one mark (although it is struck with it more than once): a crowned fleur de lys above a little design rather like a letter "ʙ" lying horizontally with a small cross connected beneath it. Very little is known about the marks on French silver of the fifteenth and sixteenth centuries, so that it is not possible to come to any definite conclusions about this particular mark. Briefly, a crowned fleur de lys was used as the upper half of Paris goldsmiths' marks from at least 1379. In 1493 Charles VIII ordered that all provincial goldsmiths should have their own marks. The goldsmiths of Paris were greatly disturbed by this development, fearing that their work would become confused with items of lower quality, and they deputized the wardens and some senior members of the guild to meet with the Premier Président of the parlement of Paris, the Advocate Général and the Général des Monnaies and find a solution. At the meeting it was decided that the goldsmiths of Paris should use punches incorporating two dots or *grains*— the two *grains de remède*, which refer to the allowance in the standard of silver—between the foot of the fleur de lys and the maker's letters or device, to distinguish their products. This decision does not mean that all plate

15. Casket. French, 15th or early 16th century. Silver-gilt. 10.8 x 21.5 x 14.4 cms. Collection of the Duke of Hamilton, Lennoxlove. The casket is reputed to have belonged to Mary Queen of Scots and to have contained the "Casket Letters". The arms are those of Anne, Duchess of Hamilton (d. 1716).

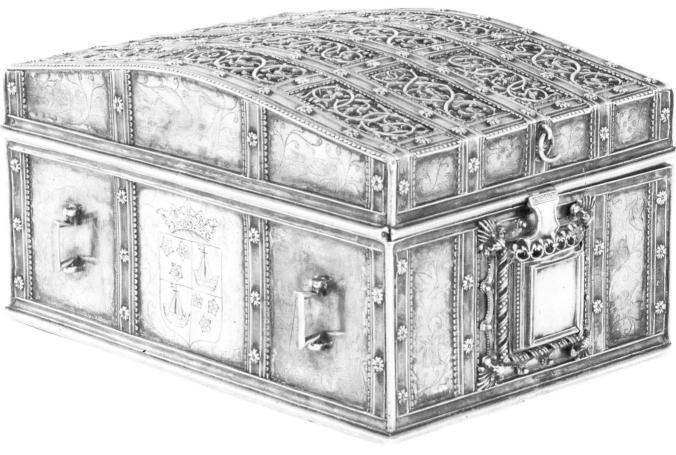

produced after 1493 was stamped with a mark incorporating two *grains*: punches with *grains* would have made their appearance gradually as goldsmiths adopted them and as old punches wore out and were replaced. Nevertheless the changeover must have been completed fairly soon after 22 November 1506, when Louis XII ordered all the goldsmiths in Paris to take out new punches. One reading of the mark on the Lennoxlove casket would therefore be that it is a Paris maker's mark which should have been superseded between 1493 and about 1510. The little device can be read as a steel or tinderbox and interpreted as a representation of the maker's name, possibly standing for Briquet, Fusil or something along these lines. However, the mark could equally be a provincial maker's mark, imitating the respected makers' mark of the Parisian goldsmiths. It may be relevant to note that a steel or tinderbox was one of the principal devices of the Dukes of Burgundy.

A manuscript which was once in the casket offers the following information on the casket's history:

> "This silver box guilded and carved with the arms of Her Grace Anne, Dutches of Hamilton on it, was the box that carryed letters and tokens by messengers to and againe between Queen Mary of Scotland and the Earle of Bothwell, which my Lady Marquis of Douglas mother to William, Duke of Hamilton bought from a papist having then the Queen's arms upon it and put her own arms theron, and afterwards having left all her Exẽre to her son Lord James, Her plate was all sold to a goldsmith, and the Dutches of Hamilton being told by my Lady Marquis that the said box did once belong to the Queen Her Grace bought the same from the goldsmith, and att the Dukes desire putt out my Lady Marquis arms and put her own arms on the same.
> The box had two keys whereof the Queen kept one and the E of Bothwell the other, but her grace only received one of them and beleives my Lady Marquis had never the other."

The account is slightly confusing. Setting aside for a moment the claim that the casket is associated with Mary Queen of Scots, what the writer is trying to tell us is that the casket was bought from a papist by the mother of William, Duke of Hamilton. This lady was Mary, the daughter of the 1st Marquess of Huntly and the second wife of William, 11th Earl of Angus and 1st Marquess of Douglas (d. 1660). The contract of Mary's marriage to the Earl (he became 1st Marquess of Douglas in June 1633) is dated 12 August 1632, and she gave birth to her first son, William, Earl of Selkirk and afterwards Duke of Hamilton, two years later. William married Anne, Duchess of Hamilton in her own right, on 29 April 1656. Lady Douglas died in 1674, and the casket was presumably purchased by Anne, Duchess of Hamilton, around this time. Certainly, this casket would appear to be synonymous with the "guilded silver box which was Queen Mary's of Scotland" included in a list of silver drawn up in 1705 that the Duchess intended to leave to her son, James, the future 4th Duke of Hamilton.

The statement that the casket belonged to Mary Queen of Scots and is actually the casket which contained the so-called "Casket Letters" has yet to be proved. The story is that the casket was seized from under the bed of George Dalgleish in the Potterow in Edinburgh in June 1567 and was found to contain letters which implicated Mary in the murder of Darnley. The casket which was produced at the hearing of evidence as to Mary's possible guilt is described in the Minutes of the Session of Commissioners at

Westminster for 7 December 1568 as a "small gilded coffer not fully one foot long. being garnished in many places with the Roman letter F. set under a royal crown". Another contemporary source, Buchanan, describes the casket containing the letters as "the silver casket, covered with inscriptions which had once belonged to the French King Francis". Neither reference accurately describes the casket now at Lennoxlove. However it is possible that earlier engraving has been erased and that the piece was re-engraved. Fifteenth century French items were decorated with pricked, naturalistic decoration, but the decoration on the Lennoxlove casket appears to be too crude to be French and has some parallels with Scottish seventeenth century incised and engraved decoration on silver and powder horns. It is interesting to see that in addition to the cinquefoils on the coats of arms there are no fewer than seven cinquefoils on the sides of the casket. However the real importance of the casket lies not in its possible association with Queen Mary, but in its excellence as a piece of goldsmiths' art and as one of the few surviving, top quality examples of French fifteenth and early sixteenth century secular plate.

Despite the Protestant victory of 1560 which severed the traditional alliance with France and led to the alignment of Scotland with Protestant England, the element of continuity and of the ongoing influence of France persisted. George Buchanan (1506-82), for instance, the tutor of James VI, and an acknowledged Latin scholar, had been educated at St Andrews and at Paris under John Major and had spent most of his adult life before 1560 in France. Principal Andrew Melville (1545-1622) of Glasgow University had been a student at St Andrews, Paris and Poitiers. A surprising number of architectural projects of the late sixteenth century reflect French influence. The portcullis gateway at Edinburgh Castle, built by the Regent James, Earl of Morton, in 1574, and the Regent's castle at Aberdour both echo French work, and the plan of the Earl's great tower house at Drochil, erected about 1578, with rooms arranged about central corridors, was probably based on a French publication, such as du Cerceau's *Livre d'Architecture* (1559). Between 1597 and 1606 George, 5th Earl and 1st Marquess of Huntly, rebuilt the upper parts of Huntly Castle with oriel windows inspired by Blois, and the Earl's Palace at Kirkwall, erected soon after 1600 by Patrick Stewart, Earl of Orkney, has carved decoration derived from French late Gothic (and Elizabethan) sources. There was a French painter at the Scottish court in 1573, and French sources have been suggested for two surviving painted ceilings. The remains of a scheme of ceiling decoration at Kinneil Castle, started by the Duke of Châtelherault in 1553, have been linked with French tapestry designs. The painted decoration on a ceiling dated 1581, discovered at Prestongrange in 1962 and subsequently transferred to Merchiston Castle, includes grotesque figures apparently drawn from the *Songes drolatiques de Pantagruel*, a book of 120 engravings published in Paris in 1565. Books and luxury items continued to be imported from France after 1560.

"DISTRACTED TYMES"

On the death of Queen Elizabeth in 1603, James VI of Scotland succeeded to the English throne becoming the first of the Stuart monarchs, James VI and I. Scotland remained independent, with its own parliament, law courts and church, but the process of incorporation with England had begun. With the court now based in London, Scottish magnates and leading administrators were obliged to make periodic journeys to London to maintain contact with the King and to keep abreast of political developments. London became, as it was to remain, the seat of government and the centre of patronage and preferment.

From the seventeenth century onwards sustained exposure to English culture naturally affected the Scots. Partly through involvement with England, and partly through direct contact, Scots continued to develop links with Holland, the Baltic countries, Germany and Flanders. Although the "Auld Alliance" between France and Scotland had ended in 1560, a special relationship still existed. Scotland continued to trade with France exchanging wool, linen cloth and salt fish for wine (estimated at half a million gallons a year), furniture, weapons and musical instruments and such delicacies as prunes, walnuts and chestnuts. Gradually, as a result of the conflicts of the seventeenth century which involved most European countries, France began to pursue a more protectionist policy. There was no longer any obvious political advantage to be gained by favouring Scotland, and Scottish trading privileges with France were confirmed for the last time in 1646 and abolished in 1663. However, Scots were still recruited in large numbers to serve the French king. Sir John Hepburn had a warrant to enlist 1,200 men in 1633, and in 1642 the Earl of Irvine was seeking no fewer than 4,500 men for the same purpose. Soldiering clearly provided one of the best opportunities of becoming wealthy and rising in station, and Scots served not only in France but in many countries in Europe in the seventeenth century.

The importance of education in the continuation of the special relationship between France and Scotland in this period should not be underestimated. A sizeable number of Scottish teachers, tutors, ministers and university professors were educated in France, while many others were attracted by France and French culture. Some schools in Edinburgh and Aberdeen offered instruction in French and a small number of French students attended Scottish universities. The statutes (1653) of King's College,

Aberdeen, permitted students to converse in French "on account of the ancient alliance". Many of the sons of wealthier Scots were sent to France to "finish" their education. An English visitor to Scotland in 1617 acidly remarked:

> "as soon as they fall from the breast of the beast their mother, their careful father posts them away for France, which as they pass, the sea sucks from them that which they have sucked from their rude dams; there [in France] they gather new flesh, new blood, new manners; and there they learn to put on their cloaths, and then return into their country to wear them out: there they learn to stand, speak, discourse and congee, to court women, and to compliment with men."

Protestant students went to the French Reformed Colleges, where there were a number of Scottish teachers, while Catholics were enrolled at the Scots College in Paris and other seminaries. The Kerrs provide a good example of three generations of one family visiting France as part of their education. Fortunately many of their letters survive and provide a fruitful source of information. Sir Robert Kerr (1578-1654), later 1st Earl of Ancram, spent some of his youthful years in France, and his son, William Kerr (c. 1605-75), visited Paris. He, in turn, sent his eldest sons, Robert, Lord Kerr (1636-1703), and William, to Holland and France in the custody of their tutor, Michael Young. Robert and William Kerr were just a few of the many Scots who attended Saumur, one of the French Reformed Colleges. During their stay in France the brothers learned to ride and dance in the fashionable manner and also had their portraits painted by Louis Ferdinand Elle. Like many others, they returned with books (some of which are still in the possession of the Kerr family), clothes and an assortment of easily transportable luxuries, including saddle pistols, a table book of ivory covered with shagreen and silver, and a hundred engravings of famous Frenchmen.

As a result of the religious and political upheavals of the seventeenth century many Scots were forced to flee to France. In the 1640s and 1650s royalists and Catholics escaped from Puritan persecution and, after 1688, with the Protestant succession to the throne established, Jacobites and Episcopalians found it expedient to spend time in France. But it was not essential for Scots to go to France to be exposed to French influence. The courts of Charles I and Charles II were imbued with French culture, and many Scots developed a taste for this through visiting or residing in London.

At this time the influence of France can be discerned in most areas of Scottish life, not least in matters of religion and theology which dominated the age. The Protestant Church in Scotland received elements of its organization and doctrine through the French Reformed Church; Geneva, where Calvinism originated, was a long way from Scotland, and the north of France offered more immediate contact. The regulations for the new chair of divinity at King's College, Aberdeen, in 1619, were modelled by Bishop Patrick Forbes on the practice of the French Reformed Church. Scottish concern for the French kirk was demonstrated in 1622 when money was collected throughout Scotland for the benefit of the Huguenot congregations. These congregations had been established by the Edict of Nantes in 1598, and when that edict was revoked in 1685 more than 250,000 Huguenots were forced to leave France, some coming to Scotland. A Huguenot congregation was established in Edinburgh, and the communion cups, made in Edinburgh by James Penman in 1685-86, are on display in the National Museum of

16. Folio from a Bound Volume of Engravings of Flowers, hand-coloured in watercolours. 17th century. 33.7 x 22 cms. National Library of Scotland (Adv. Ms. 23.1.8, fo.7r). Deleted inscriptions "Paris 26 April 1670" and "Pa Moray" on the first and last folios. Acquired by Patrick Murray of Livingston during a botanical expedition to France shortly before his death.

Antiquities of Scotland.

There were areas of Scotland, especially the Highlands and Islands, where the Reformation made little impression. During the Counter-Reformation, Jesuit priests from the Scottish College at Douai in northern France, travelled to the north and west of Scotland confirming the people in their Catholic faith. Barra, South Uist, Glenmoriston, Abertarff and Glen Garry, for instance, have remained predominantly Catholic. The Scottish Catholic aristocracy were confirmed in their belief and practice by French theologians such as Bishop Bossuet of Meaux, who corresponded with James Drummond, Lord Chancellor of Scotland in the reign of Catholic King James II.

In the more secular areas of Arts and Humanities the influence of France was apparent in the seventeenth century. Scottish university libraries still contain many French books from this period, and surviving private libraries such as those of the Marquesses of Lothian at Monteviot and the Earls of Traquair at Traquair House reflect contemporary taste for French editions of classical literature and contain books on history, philosophy, geography and travel. Rabelais, the popular French author, was known in Scotland at an early date, and his works were translated by Thomas Urquhart of Cromarty. Descartes was also read, although his ideas were disseminated through the work of the English philosopher Hobbes. In the field of music the principal survivals are the Panmure Music Books (now in the National Library of Scotland, Mss. 9447-9476), some of which were collected by the wife of the 2nd Earl of Panmure, Lady Jean Campbell. Lady Jean played the lute and her books contain collections of pieces by the lute composers active at the court of Louis XIII. The other books were collected by her sons, James and Harry, and include volumes of instrumental music by Lully, Marais and de St Colombe. The Lully scores are particularly interesting for they contain virtually all his ballets and operas composed between 1657 and 1677. It is recorded that in November 1680 Harry paid for the shipping of a box of four viols from Paris to Leith, and he and his brother would also seem to have been accomplished musicians.

Throughout Europe this was a time of great advances in the sciences, medicine and mathematics. The interest of individuals and the establishment of new forums of scientific enquiry, such as the Royal Society in London and the Académie Royale des Sciences in Paris, resulted in considerable correspondence and controversy in which several Scots participated. The statesman Sir Robert Moray (1608-73), who had distinguished himself in the service of Louis XIII and Cardinal Richelieu, played a pivotal role in the early Royal Society and was its principal link with the French philosophers.

For the aspiring physician contact with France was likely to be particularly necessary. He could gain the certificate required for medical practice at certain English and Scottish universities, but it was only by travel to the continent that he could obtain adequate medical training until the establishment of the Edinburgh Medical School in the 1720s. It was the French schools, and later the Dutch Protestant universities, that dominated medical education, and Scots frequently went to France for their training. Robert Morison, who was born in Aberdeen in 1620, took a medical degree at Angers and was Director of Gardens to the Duke of Orléans at Blois in the 1650s, before becoming Director of the Royal Gardens after the restoration of Charles II and the first Professor of Botany at Oxford in 1669. Andrew Balfour (1630-94) studied at St Andrews and spent ten years abroad in the

pre-eminent medical and botanical centres of France. He acquired a medical degree at Caen and visited Blois in 1651. Balfour also enjoyed royal patronage in London after the Restoration before returning to St Andrews in 1667. He subsequently moved to Edinburgh with what was said to have been the best library in Scotland, rich in books on medicine and natural history, and pooled his botanic collection with that of his kinsman, Robert Sibbald, to form the Edinburgh Physic Garden—only the second public botanic garden in Britain—in 1670. Robert Sibbald (1641-1722) attended Edinburgh University before studying abroad at Leyden, Paris, and then Angers, where he received a Doctorate of Medicine. On returning to Edinburgh, Sibbald established a successful medical practice. The need to have access to medicinal plants led to his founding the Edinburgh Physic Garden with Balfour. Sibbald was a man of the widest culture with interests ranging from archaeology to zoology. Sibbald's and Balfour's zoological specimens were the basis of Edinburgh University's Natural History Museum. Patrick Murray of Livingston, a friend of Balfour and of Sibbald, travelled abroad and assembled a collection of over a thousand plants which formed the major early contribution to the Edinburgh Physic Garden. One of Murray's last purchases made in France just before his death was a volume of engravings of flowers, hand-coloured in watercolours (Fig. 16).

17 Courtyard of the Palace of Holyrood (1670s) by Sir William Bruce (1630-1710). Bruce was influenced by French architecture and French architectural treatises. The courtyard at Holyrood was probably influenced by the Gaston d'Orléans wing at Blois.

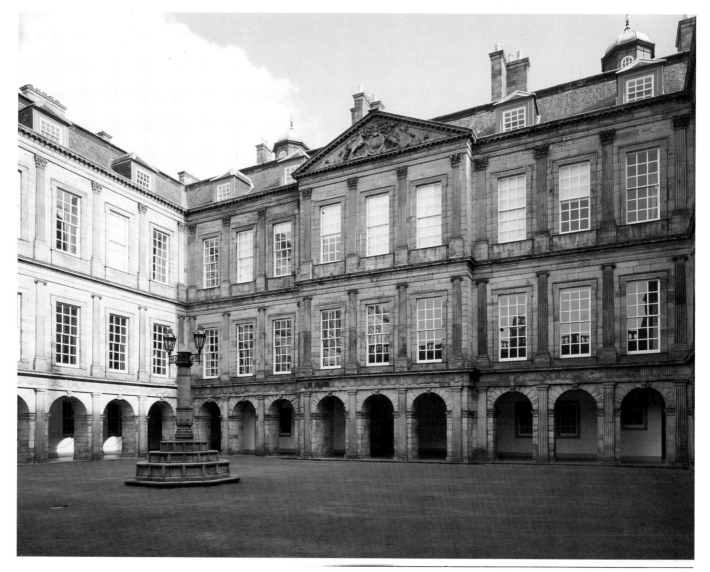

Some outstanding Scottish buildings of the second half of the century reflect the strong influence of contemporary French architecture. Sir William Bruce (1630-1710), who became Surveyor General of the King's Works in Scotland, visited France in 1663 and his principal buildings reveal an indebtedness to French models. Holyrood Palace (Fig. 17) is clearly influenced by French prototypes exemplified by the symmetrical ordered effect, the steep mansart roofs (inspired by Jean Mansart), and the relationship of the courtyard to the Gaston d'Orléans wing at Blois. It has been suggested that Bruce owned French architectural treatises, and indeed the second edition of Le Muet's *Manière de bien bastir* includes at least one set of engravings incorporating all the main features of Holyrood. At Hopetoun House, French influence is also discernible in "the overall horizontal rustication of the principle facade and the bold semi-circular pediment of the garden front" (John Dunbar). Bruce's own house, Kinross, begun in 1689, could be mistaken for a French *château*, and had a formal garden based on French designs which was stocked with plants especially imported from France. James Smith, the leading architect of this period, was also influenced by French architecture in his designs for Drumlanrig Castle. The courtyard at Drumlanrig (about 1679-90) is a concept adopted from France. The combination of the terrace with the arcade beneath it, and the wonderful double staircase leading up to the porch on the north front, may well be inspired by the famous horseshoe staircase at Fountainebleau.

Scots who acquired French works of art in the seventeenth century were usually politicians and courtiers who maintained a presence in the capital, in close contact with the English court. A natural consequence of this was that they invested more money in the interior decoration and furnishings for their London houses than in their homes in Scotland. Patronage was dispensed by Scottish Restoration politicians such as John Maitland, 1st Duke of Lauderdale (1616-82), who was Charles II's chief adviser on Scottish affairs, a member of the so-called "Cabal Cabinet", and Secretary of State for Scotland until 1680. In 1672 Lauderdale married Elizabeth, Countess of Dysart, and they began to extend and refurbish Ham House at Richmond in Surrey, commissioning a new suite of rooms along the south front to designs by William Samwell. The rooms were fitted with French sash windows and some of the ceilings in the principal rooms were painted by Antonio Verrio, an Italian who had been employed on French royal commissions and was familiar with the work of the French court painter Charles Le Brun. The Duke and Duchess spent a great deal of money on the interiors, furnishings and furniture, and the diarist John Evelyn described Ham in 1678 as "furnished like a Great Prince's". During the 1670s the Duke of Lauderdale also decided to enlarge and decorate his principal Scottish seat, Thirlestane Castle (built in the 1590s). His wife's cousin was Sir William Bruce, who provided designs for the project, and the decorative scheme was English in style with magnificent plaster ceilings by the English plasterer George Dunsterfield.

English influence was obvious in the interiors of Scottish houses, as was the influence of the Dutch. Silver and furniture were imported from Holland throughout the century and Dutch painters and craftsmen worked in Scotland. For example, the enlargement of Holyrood involved Dutch craftsmen and the Dutch painter Jacob de Wet. De Wet's surviving work includes the series of royal portraits in the Long Gallery at Holyrood (contract dated 1684), and the paintings on the life of Christ, based on

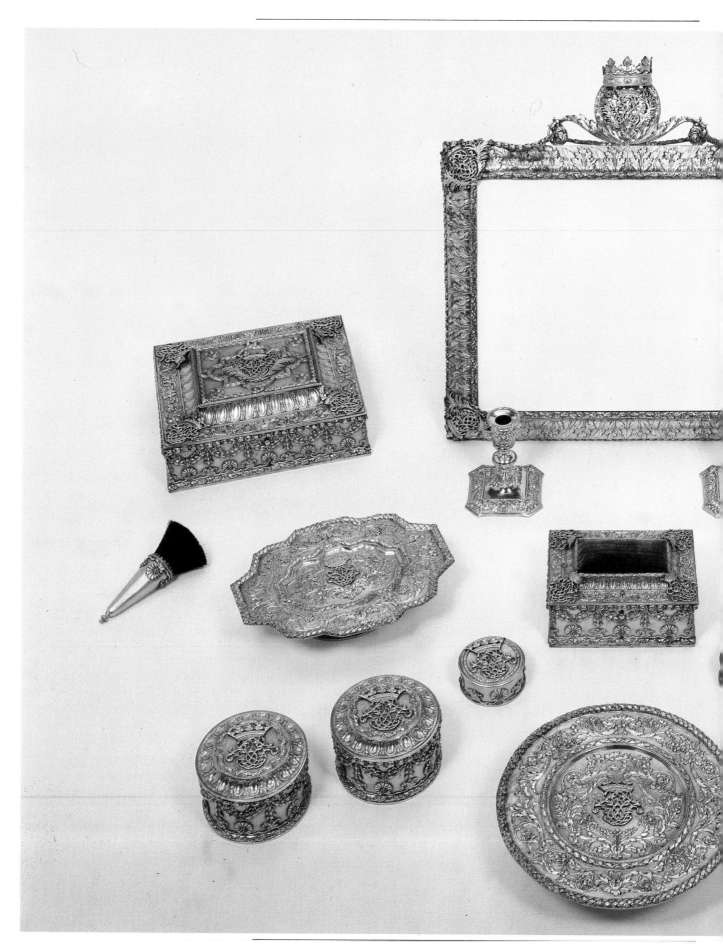

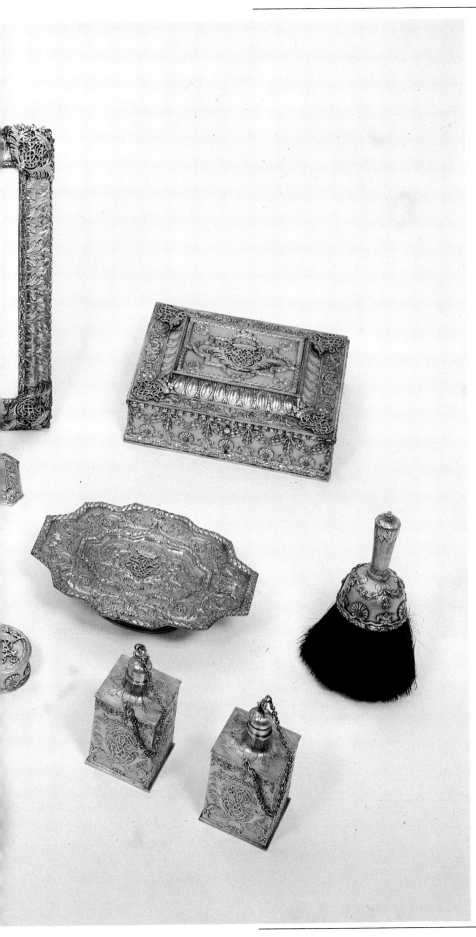

18. The Lennoxlove Toilet Service, owned by Frances Teresa Stuart, Duchess of Richmond and Lennox (1647-1702). French (Paris), 1661-77. Silver-gilt. Royal Scottish Museum, Edinburgh. Fourteen of the seventeen items are struck with the maker's mark of crowned fleur de lys, two dots and the initials "PF" separated by a flame which suggests the name Pierre Flamand or Flament. The smaller of the two brushes does not bear a maker's mark, but is attributed to the same maker on stylistic grounds. The two candlesticks are stamped with the maker's mark of a crowned fleur de lys, two dots and the initials "PM" separated by crossed maces, which appears to be a punch of Pierre Masse, who became a master of the Paris guild of goldsmiths in 1639 and was a warden of the guild in 1661, 1662 and 1673. Details about individual items will be found in the Checklist.

engravings by or after Boetius a Bolswert in the chapel of Glamis Castle. In the late seventeenth and early eighteenth centuries, imports of high quality Flemish and Dutch linen were much in evidence, and these were copied by Scottish linen weavers. William Mackintosh observed in 1729: "Where I saw the Table serv'd in *Scots* clear fine Linen, I see now *Fleemish* and *Dutch* Diaper and Damask".

French hangings were coveted possessions. In the 1630s the Earl of Haddington owned "ane grein French cloath bed with rich lace and fringe", and an entry in the 1685 Holyrood inventory refers to "ane sute of fyne Bruxells hangings containing seven pieces wherein is described the history of Diane". These may be the six tapestries depicting the story of Diana which are still at Holyrood. They are not, in fact, Brussels tapestries, but French tapestries woven in Paris after designs attributed to Toussaint Debreuil.

Without question the finest piece to be associated with a Scot in this period is the Lennoxlove toilet service (Fig. 18), which is also one of the few major examples of French seventeenth century secular plate to survive. An enormous quantity of exquisite silver was produced in Paris during the reign of Louis XIV, the "Sun King", but most of it was melted down to meet the costs of the King's wars and as a result very little French seventeenth century secular silver has been preserved in France. Almost all the important examples which do remain were exported and so avoided the melting pot.

The Lennoxlove toilet service consists of 17 items of silver-gilt together with 16 leather-covered cases (the two candlesticks fit into one case) and an impressive travelling chest made of oak, veneered in walnut and decorated with silver-gilt mounts. The pieces of silver-gilt were made in Paris over a period of at least 14 years. Nine items bear clear wardens' marks, indicating that they were approved by the wardens of the Paris guild of goldsmiths as being of acceptable standard. The candlesticks are not of the same design as the rest of the service and bear the earliest wardens' mark, an "R", showing that they were made between 30 December 1661 and 27 June 1663. Five of the most impressive articles—the pair of large caskets, the pair of shaped salvers and the circular salver—are struck with the letter "X" and were assayed between 21 June 1666 and 8 June 1667. The mirror bears the letter "H" and was approved between 16 July 1676 and 15 July 1677. The latest visible wardens' mark, the date-letter "I", used from 15 July 1677 to 18 June 1678, is on one of the large circular boxes. At least three other pieces bear poorly struck wardens' marks, but these do not appear to represent letters used after 1677-78. All 17 articles are struck with the mark of the tax collector Vincent Fortier, which was valid from 12 October 1672 to 5 August 1677. The presence of Fortier's mark on all 17 pieces, together with the wardens' marks, is evidence that they were made by 5 August 1677. The choice of items and the addition of ducal coronets and cyphers would have awaited the wishes of the purchaser.

Work from two goldsmiths' workshops is included in the Lennoxlove toilet service. The candlesticks are struck with a maker's mark which is probably the mark of Pierre Masse. Of the remaining 15 pieces 14 are struck with a mark consisting of a crowned fleur de lys, two dots, and the initials "PF" separated by a flame. On this evidence it can be suggested that the maker of the majority of pieces in the service was one Pierre Flamand or Flament. The smaller of the two brushes lacks a visible maker's mark but can be attributed to the same goldsmith on stylistic grounds. The coronets with strawberry leaves attached to the majority of items indicate that the service

was owned by a Duchess. The monogram on the pieces is open to different interpretations, but taken with the Lennoxlove provenance there is a clear link with Frances Teresa Stuart, Duchess of Richmond and Lennox.

Frances Teresa Stuart (Fig. 19) was the elder daughter of Walter Stuart, third son of the 1st Lord Blantyre, and his wife, Sophia. As a result of the Civil War, the family fled to France in 1649, and found refuge at the court of Queen Henrietta Maria where Frances became a favourite of the widowed Queen and of Charles II's sister, the Duchess of Orléans. After the Restoration, in 1662, she returned to England and was appointed a maid of honour to the Queen, Catherine of Braganza. Frances made a considerable impact on the court: in 1663 the diarist Samuel Pepys described her as "the greatest beauty I ever saw I think in my life". Charles II was also smitten by Frances and it was soon alleged by many that she was his mistress. However, there are grounds for believing that the King did not succeed in making Frances his mistress, Pepys notes "how the King is now become besotted upon Mrs Steward. . . But yet it is thought that this new wench is so subtle that she lets him not do anything more than is safe to her". In the summer of 1665, Sir Peter Lely painted her as the chaste goddess Diana. The young Frances was probably unsophisticated, frivolous and provocative, but it seems that she was also virtuous and was looking for a husband rather than a lecherous lover. Pepys subsequently remarked that Frances had confessed she was "willing to marry any gentleman of £1,500 a year who would have her in honour".

Early in 1667 she accepted a proposal of marriage from Charles Stuart, 3rd Duke of Richmond and 6th Duke of Lennox. The King was enraged when he learned of the marriage and threatened never to allow the couple to

19. **Frances Teresa Stuart, Duchess of Richmond and Lennox** (1647-1702), by Sir Peter Lely (1618-80). English (London), c. 1670. Oil on canvas. 255 x 125 cms. Collection of the Duke of Hamilton, Lennoxlove.

return to court. The Queen, however, intervened on their behalf and the King relented. Shortly afterwards Frances suffered an attack of smallpox, the King visited her during her convalescence and was soon "more assiduous than ever". The Duke was sent to Scotland in 1670 and in 1672 was dispatched as ambassador to Denmark, where he died. Frances continued to live at Whitehall and the King provided her with an income, but after the Revolution of 1688 she withdrew from society and led a very secluded life until her death in 1702.

The bedchambers of the leading ladies of the Restoration court were superbly furnished and most of the ladies had impressive toilet services as a visible sign of their status. By the late 1670s it had become customary for the most powerful ladies of the English court to own Paris-made toilet services. The Lennoxlove toilet service is a reflection of this lavish expenditure on bedchamber furnishings and possessions and the contemporary taste for French work. The most impressive surviving French toilet service, made by Pierre Prévost in Paris in 1669-71 and now at Chatsworth, bears the arms of William of Orange (later William III) and the Princess Mary, the elder daughter of the Duke of York, and was probably given to Mary by William at the time of their marriage in 1677.

There is a tradition that the Lennoxlove service was given to Frances by Charles II although no documentation has yet come to light which confirms this. Charles obviously admired the Duchess, he was a lavish giver of plate, and it is known that he gave jewels to Frances before her marriage. On the other hand it is not at all obvious why Charles should have made Frances the recipient of such a splendid gift in 1677 or shortly afterwards since the period of the King's infatuation with her had been a decade earlier. In 1675

20. Frances Teresa Stuart, Duchess of Richmond and Lennox, as Athene attributed to Henri Gascars (1634/5-1701). French (London), c. 1675. Oil on canvas. 240 x 137 cms. Collection of the Duke of Richmond and Gordon, Goodwood House. Gascars was a French artist who worked in London between about 1672 and 1677.

the Duchess of Portsmouth's son was created Duke of Richmond and Lennox and there is the possibility that the service could have been a gesture of apology to Frances for this use of her husband's titles, but this is not particularly convincing.

Two events in Frances's life in 1677 may have a bearing on the acquisition of the service. She agreed to sell her life interest in Cobham Hall to her brother-in-law for £3,800, and she disposed of her rights in the duchy of Aubigny to the King in return for an annuity of £1,000. It is possible that Charles II could have given the Lennoxlove toilet service to Frances as a reward for her co-operation in this matter, but taking everything into account the most likely explanation is that Frances was simply investing her new wealth in a beautiful possession which would provide her with both status and enjoyment.

Only four French seventeenth century toilet services have survived intact: the Chatsworth service is the most important, followed by the Lennoxlove service, the Chatsworth-Stonor service, and the service in Rosenborg Castle in Copenhagen. The design of the Chatsworth-Stonor service (Fig. 21) is clearly related to the design of the Lennoxlove service. It consists of 15 totally unmarked pieces of silver-gilt but there are no brushes and the travelling chest is missing. The two large boxes, pin-cushion casket, two shaped salvers and two pairs of circular boxes are of very similar design to their counterparts in the Lennoxlove service. The Chatsworth-Stonor service does not seem for technical reasons to have been produced in the same workshop as the majority of pieces in the Lennoxlove service. The Lennoxlove service was made between 1666 and 1678, and the Chatsworth-Stonor service is believed to have been completed in the 1680s. It is clear that both services represent a standard popular line which was available over a comparatively long period.

Frances left the bulk of her estate to her cousin, Walter Stewart, who became the 6th Lord Blantyre in 1704. After bequests to her mother and her cousin, she directed in her will that: "All the rest, residue and remainder of

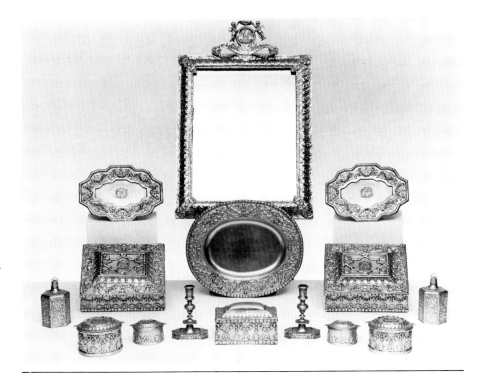

21. The Chatsworth-Stonor Toilet Service. French (Paris), 1680s. Silver-gilt. Private Collection. This service is very closely related in design to the Lennoxlove service and adds substance to the belief that the Lennoxlove service was a standard line which was popular over a lengthy period. The pieces bear a cypher formed by the letters "I" or "JN", which may refer to Jane Fox who married the 4th Earl of Northampton in 1686. Items of Northampton plate entered the Chatsworth Collection through the marriage of the only daughter of the 7th Earl of Northampton to a son of the 4th Duke of Devonshire in 1782. The service was sold in 1958.

my estate both real and personal, plate, jewels, goods and chattels whatsoever after my debts and funeral charges are paid and satisfied, and after the legacies in this my will given . . . [should be administered] for the benefit of my said dear kinsman the said Walter Stuart and the heirs male of his body". The executors were instructed to purchase "lands or revenues of Inheritance in the Kingdom of Scotland, which state when purchased shall be called, and I appoint the same to be named and called Lennox love and to be settled upon my said dear and near kinsman the said Walter Stuart and the several sons and heirs male of his body successively". They agreed to buy Lethington in East Lothian and ensured that it was renamed Lennoxlove. The Blantyre family owned Lennoxlove until 1900, when the 12th Lord Blantyre died without male issue and the estate passed to Major William Arthur Baird, a descendant of the 12th Lord Blantyre on the female side. In 1947 Lennoxlove was bought by the 14th Duke of Hamilton although the service was not part of the sale and remained in the ownership of the Bairds until 1954 when it was purchased by the Royal Scottish Museum.

CULTURE & CONFLICT

The Act of Union of 1707 transferred the political control of Scotland to England. The peers and members of parliament representing Scotland had to spend much time in London, and many other Scots went south to further their careers. As a result English customs, fashions and ideas predominated.

Major buildings in Scotland at this time were essentially English in style. In the first half of the eighteenth century, William Adam (1689-1748), the leading Scottish architect, designed houses which reflected the work of Vanbrugh and Gibbs. But after 1740, Scottish lords increasingly employed London architects: the 3rd Duke of Argyll commissioned Roger Morris to design Inveraray Castle in 1744; the 8th Earl of Abercorn turned to Sir William Chambers in 1763 for Duddingstone House, Edinburgh; and Chambers was also commissioned by Sir Laurence Dundas for a mansion on the east side of St Andrews Square, Edinburgh, in 1771. Scottish peers were also able on many occasions to employ a compatriot, Robert Adam, who was working in London. Articles of English manufacture furnished the principal Scottish houses. As early as 1700, English furniture valued at £1,512 12. 5d had been shipped up to Scotland, and a high percentage of the most important silver was also English. Pottery, porcelain, glass, Sheffield plate, and books and other publications were brought north, all of these imports resulting in a demand for "English" works by Scottish craftsmen. Scottish printers produced copies of English editions, while Scottish furniture-makers, goldsmiths and later potters and glassmakers modelled their wares on English examples.

War between Britain and France during the eighteenth century curtailed the influence of French culture upon Scotland. Constant conflict and the French King Louis XIV's support for the deposed James II and VII meant that Scottish attitudes to France were divided. There were those who were content with the Hanoverian succession and the Union with England and who regarded France as a real or potential enemy, and there were those who supported James II and the Pretenders to the throne, who were dissatisfied with the Union, and saw France as the chief source of aid and as a place of refuge. The French provided sporadic support for the Jacobite resistance to the Hanoverians and fear of French invasion persisted throughout the century. In 1708 a fleet launched from Dunkirk carried James Francis Edward Stuart and 6,000 troops into the Forth, and disembarkation was only

prevented by the arrival of a superior English fleet. The French played little part in the rebellion of 1715, but opportunism led them to provide limited assistance to Prince Charles Edward Stuart's attempt to gain the throne in 1745. A 64-gun battleship, *L'Elizabeth*, escorted the tiny invasion fleet; the adventurers were provided with arms and ammunition, and money was sent from France just before the Battle of Culloden; but it was too little, and arrived too late.

Louis XIV's wars alienated much of Europe and there were many people who were no longer willing to accept Paris as the centre of civilization. European interest in the late seventeenth and early eighteenth centuries turned instead towards Italy, primarily due to a growing interest in Roman antiquities and Old Master paintings and sculpture. The attraction of Italy, especially of Rome, and the general hostility towards France is reflected in Sir John Clerk of Penicuik's account of his grand tour in the last year of the seventeenth century. Sir John (1676-1755) recalled in his *Memoirs* "the vast desire I had to see a country [Italy] so famous for exploits about which all my time had been hitherto spent in reading the classics, likeways a country so replenished with Antiquities of all kinds and so much excelling all other countries and music, . . . I am sure nothing in life had ever made me happy if I had denied myself this great pleasure and satisfaction". Returning to Scotland in 1699 Sir John passed through Paris. His observations reflect his political antagonism towards France and his desire to belittle French culture:

"In this City and at Versailes I saw a compend of all the splendour and vanities of the world. . . Paris was agreeable to me only for the conversation I found there, but was far from giving me that entertainment I had at Rome. . . Versailes and its gardens I found excelled in bulk and extent any thing I had ever seen before, but they seem'd at best but awkward imitations . . . and all entertainments except Dancing, displeased me exceedingly. At this last exercise I thought the French excelled all others, so that the greatest Encomium I cou'd bestow on a French man was to allow that he was a good dancer. . ."

Sir John was not alone in his fascination for Italy and his denigration of France. In 1736 Sir Alexander Dick visited Paris in the company of the young painter Allan Ramsay (1713-84) *en route* for Italy. In his account of Paris, Alexander dwells on the artificiality and sheer size of much that he came across, although he was still unable to resist purchasing French books:

"Saw that day the Luxembourg gallery, with all the fine paintings of Rubens there. Walked afterwards in the gardens, which are well kept, but not in the best taste; little of nature; all is regularity. . . We went to the Opera, but did not much admire the music, which was entirely in the French taste, loud and noisy, great in the execution, but very mean and little in the harmonious part which belongs to good music. . . Everything in Versailles has the look of too great an expense and too much show; consequently the taste is not universally good, though, it must be owned, there are great many fine things there. I bought up there the works of Porelle, where . . . the finest parts, buildings, and gardens of Versailles, are most elegantly and accurately described, which collection had belonged to Mons. Claude Bernard Audevurdes Comptes, a gentleman in high offices, who had died some time before our arrival, by which means I purchased this and some other of his things when they were brought to sale."

A delight in Italy and a low opinion of France is similarly evident in the letters of Robert Adam, who made a grand tour of France and Italy with Charles Hope, the youngest brother of the 2nd Earl of Hopetoun, in the mid 1750s. In one letter Robert comments that they had seen "a very small degree of perfection in any building" in Paris, and when his brother James expressed the desire to see Paris Robert was dismissive: "As to all your objections concerning your seeing Paris and the places you are to pass through", he wrote, " they don't signify a farthing, as if you once saw them you would wish you never had, as they do much harm and no good. As for seeing the manners of Paris and French people, that is a jaunt that can be accomplished at any time".

Most leading Scottish nobles and artists and architects went to Italy in the eighteenth century. The painter Allan Ramsay studied under Francesco Imperiali in Rome and Francesco Solimena in Naples and until the early 1760s built up his portraits in the Italian manner, first creating a red mask and then applying white glazes to achieve flesh tones. The artists Gavin

22. **David Hume** (1711-76) by Allan Ramsay (1713-84). Scottish (London), 1766. Oil on canvas. 76.2 x 63.5 cms. Scottish National Portrait Gallery, Edinburgh.

Hamilton and Jacob More actually settled in Rome. The Scottish lords returned from their tours with Roman antiquities, Old Master paintings and contemporary Italian portraits.

Resumption of interest in French culture begins with the philosopher David Hume (1711-76). Hume (Fig. 22) was the greatest and also the earliest of the Scottish thinkers whose work formed the nucleus of the Scottish Enlightenment, an intellectual and cultural movement which was centred in Edinburgh but which had an influence throughout Europe and on the new United States of America. Enlightenment ideas from Scotland and the inspiration of revolutionary France played a crucial role in the stand taken on liberty and human rights by the framers of the American constitution.

Hume was familiar with the work of French philosophers and historians and it is known that before writing the *Treatise of Human Nature* he had read several seminal French works including Pierre Bayle's *Dictionnaire critique et historique*. Hume went to France in 1734 "with a View of prosecuting my Studies in a Country Retreat", spent a year at Rheims and two years at La Flèche in Anjou. It was at La Flèche that the major part of the *Treatise of Human Nature* (1738) was written. According to Hume it "fell dead-born from the Press" although it was subsequently recognized as his greatest philosophical work. During the 1740s Hume had contacts with Montesquieu and helped to see a translation of his *L'Esprit des Lois* through the press. In the 1750s and early 1760s he wrote extensively, producing a succession of important works of which the most significant was the six volume *History of England* (1754-62). At this period in his life Hume, discouraged at the criticism and lack of sales of the first volume of the *History*, gave serious consideration to retreating to France. He writes in *My Own Life*: "I was, however, I confess, discouraged, and had not the war been at that time breaking out between France and England, I had certainly retired to some provincial Town of the former Kingdom, have changed my name and never more have returned to my native country. But as this Scheme was not now practicable, and the subsequent Volume was considerably advanced, I resolved to pick up Courage and to persevere".

Hume was ideally placed to influence thought in Edinburgh as Secretary of the Philosophical Society, Keeper of the Advocates Library, and one of the founder members of the Select Society. The latter was a club said to have been founded on the model of the French Academy or of the French societies which met for purposes of debate. Literary and philosophical societies such as the Literary Society of Glasgow (1752) and the Philosophical Society of Aberdeen (1758) played an important role in the dissemination of French and other Enlightenment ideas in Scotland, although the discussions were far from uncritical, and there was often disagreement with French views.

The major French writers were well known in Scotland. The number of works of Montesquieu, Voltaire and Rousseau published in Scotland between 1750 and 1800 was remarkable for the time, amounting to more than 80 editions. Two booksellers and printers were primarily responsible for these: Robert Urie, in Glasgow, and Alexander Donaldson, in Edinburgh. During the second half of the century extracts from French writers appeared in translation for a wider readership in the columns of the *Scots Magazine* and the *Edinburgh Magazine*.

Apart from wine and books, relatively few French items were brought into Scotland before the end of the Seven Years War in 1763. There was little French furniture in Scotland, because it was not only inconvenient to

23. Knee-hole Table with Boulle decoration. French, 18th century. 82.5 x 117 x 51 cms. Supplied by Thomas Chippendale to the 5th Earl of Dumfries for Dumfries House in 1759 at a cost of fifteen guineas. Private Collection.

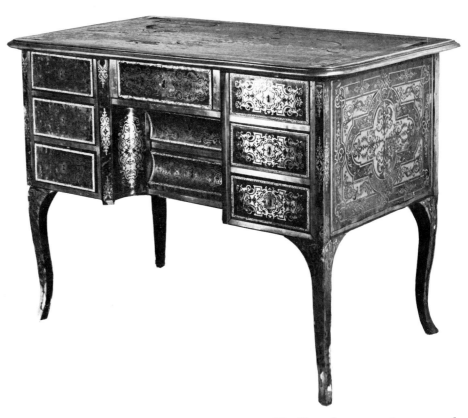

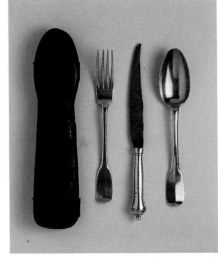

24. Knife, Fork and Spoon, with case, owned by Prince Charles Edward Stuart (1720-88). French (Paris), 1737-9. Silver. Knife: 22.3 cms; fork: 19.4 cms; spoon: 19.8 cms; case: 24.6 x 6.3 x 2.5 cms. Engraved: "*Ex. Dono C.P.R. July 3ᵈ 1746*". Private Collection. Presented by the Prince to a follower during his escape from Scotland after the defeat at Culloden (16 April 1746).

transport but also subject to prohibitive tax. The French commode veneered with turtleshell and brass which Thomas Chippendale supplied to the 5th Earl of Dumfries for Dumfries House in 1759 at a cost of fifteen guineas (Fig. 23) is a rare example. French pieces imported into Scotland at this time were generally small and easily transported. Scottish travellers could not resist buying French costume and accessories, including snuffboxes, and some French silver was also purchased. The most interesting survival from this period is a curiosity: a set of knife, fork and spoon, made in Paris in the late 1730s, which was presented to a supporter by Prince Charles Edward Stuart during his escape from Scotland after the Battle of Culloden (Fig. 24).

Nonetheless French styles and designs were adopted in Scottish houses before 1763, despite the lack of authentic French objects, and some patrons had a decided interest in contemporary French ideas. Lord Annandale, for example, wrote from Hopetoun House in January 1725 to his nephew in Paris requesting him to "take particular note of the French way of furnishing rooms, especially with double doors and windows and door curtains and finishing them with looking-glass, marble, painting and gilded stucco; and their way of gilding and painting wainscotting. Give me leave to advise you to take a plan of everything that pleases you and to endeavour to understand the way of executing it". Craftsmen in England and Scotland were influenced by the work of the French Huguenots who had been forced to leave France as a result of the revocation of the Edict of Nantes in 1685. Many Huguenots settled in England influencing English, and consequently Scottish production, particularly of silver and furniture. The French rococo style was introduced into England, and to Scotland, by immigrant French artists and craftsmen and by imported French books and sheets of designs. Wealthy Scots acquired furniture and silver in the latest French-inspired styles from London cabinet-makers and goldsmiths, or from Scottish craftsmen working

in Edinburgh, Glasgow, Aberdeen and the smaller Scottish burghs. Patrons who commissioned Scottish craftsmen generally supplied or specified an item or a design for the craftsmen to copy and work of high quality was produced in this way. During the second quarter of the century, Scottish lords were able to commission fine rococo plaster ceilings from Thomas Clayton of Leith. The later paintings of Allan Ramsay reflect first-hand knowledge of the work of Maurice Quentin de la Tour, Jean-Marie Nattier and other contemporary French artists. Generally, however, the influence of France was transmitted to Scotland through English work in the French style.

French artists and craftsmen were employed in two schools of art and design established before 1763 in Scotland. The earliest school was in Glasgow and was the achievement of two booksellers, Robert and Andrew Foulis. Their interest in a school of art and design can be traced back to their first visits to France:

"In the years 1738 and 1739, having gone abroad, and resided several months at each time at Paris, we had frequent opportunities of conversing with gentlemen of every liberal profession, and to observe the connection and mutual influence of the Arts and Sciences upon one another and upon Society. We had opportunities of observing the influence of invention in Drawing and Modelling on many manufactures. And 'tis obvious that whatever nation has the lead in fashions must previously have invention in drawing diffused, otherwise they can never rise above copying their neighbours."

During the 1740s, Robert was working towards the establishment of a school. In 1751 he went abroad and in 1752 he bought paintings, including works said to have been in Cardinal Richelieu's collection, drawings, books, original engravings and prints after Old Masters. He also engaged and sent to Glasgow "a Painter and a celebrated engraver whose name is Mr Avline and likewise a printer en taille douse". In October 1753 his efforts were rewarded and the University took the school under its patronage. The school opened in 1754 and a newspaper advertisement appeared, advising readers:

"On Monday the first of December next at six in the evening will be opened, within the College of Glasgow, with the approbation and protection of the University, and subject to their special direction a school for the Art of Designing, to be taught by the Sieurs Avelin and Payien upon the same plan with the foreign Academies."

The school employed three French teachers: the professor of painting M. Payien, the engraver François Antoine Aveline, who had worked for Parisian booksellers and printers, and the copper-plate printer M. Dubois. Although the school was well received and exerted a considerable influence, including among its pupils David Allan and James Tassie, it was not a financial success and eventually was forced to close and the collection of paintings was sold.

The other major school of art was opened in Edinburgh in 1760 by a government department, the Board of Trustees for Improving Fisheries and Manufactures in Scotland. The Board devoted most of its finances to the promotion of the linen industry, and their first appointment to the school was Monsieur Delacour "to teach gratis, the Art of Drawing for the use of manufacturers, especially the drawing of Patterns for the Linen and Woollen

manufacturers". William Delacour, possibly French by birth, was a particularly suitable teacher for a drawing school intended to apply art and design to manufacturing, since he had experience as a stage designer, interior decorator, and was the author of a series of eight books of rococo designs, entitled *Books of Ornament*. He worked as a stage designer in Edinburgh and was employed by the Adam brothers as an interior decorator for various schemes, including in 1761 a series of seven large paintings of Roman ruins for the Marquess of Tweeddale's newly-completed Great Salon at Yester House in East Lothian. Delacour was followed by another French designer, Charles Pavillon, but after his death the school was staffed by Scots.

In 1763 after the signing of the Treaty of Paris which ended the Seven Years War, there was a general stampede to visit France. Horace Walpole morbidly observed that since the peace the way to France had become "like the description of the grave . . . the way of all flesh" and he estimated that 40,000 British visitors had passed through Calais in the two years since the signing of the treaty. Among the many Scots who visited France after 1763 were David Hume and Adam Smith, the economist and major Enlightenment figure. Hume went as the private secretary to the first peacetime ambassador to France, Lord Hertford, and he later became the official secretary to the embassy. In *My Own Life*, Hume reflected "Those who have not seen the Strange Effect of Modes will never imagine the Reception I met with in Paris, from Men and Women of all Ranks and Stations. The more I recoiled from their excessive Civilities, the more I was loaded with them. There is, however, a real satisfaction in living in Paris for the great Nature of sensible, knowing and polite company with which the City abounds above all places in the Universe. I thought once of settling there". Hume travelled back to England with Jean-Jacques Rousseau, the great revolutionary thinker. Unfortunately, Hume and Rousseau did not remain on friendly terms, although Hume managed to persuade Rousseau to have his portrait painted by the Scottish artist, Allan Ramsay (Fig. 25).

Adam Smith became tutor to Henry Scott, the young 3rd Duke of Buccleuch, and in 1764 they set off for Paris. They were joined by the Duke's brother and together they toured through the south of France and on to Geneva, where Smith met Voltaire. Returning to Paris, Smith met most of the principal intellectuals: Holbach, Helvetius, D'Alembert, Necker, Turgot and Quesnay.

Among other Scots who visited France in these years were Major-General John Campbell, the Marquess of Lorne and the future 5th Duke of Argyll, and his wife, the celebrated Irish beauty Elizabeth Gunning, widow of the 6th Duke of Hamilton. The Marquess and his wife were painted in Paris in 1763 by François-Hubert Drouais (Figs. 26 and 27). Drouais had been appointed portrait painter to the French court and was unrivalled in his paintings of women and children; he painted many portraits of Mme de Pompadour, Mme du Barry and the royal family. At this time, William Hunter, a Glasgow physician, added French paintings to his already considerable collection by acquiring three paintings by Chardin: the *Scullery Maid* (1738), the *Cellar Boy* (1738), and the *Lady drinking tea* (1735). They were all bequeathed to the University of Glasgow in 1783, and are now in the Hunterian Art Gallery and Museum.

In the years of peace between 1763 and 1778 French writings became much better known. The first edition of the *Encyclopaedia Britannica* was published in Edinburgh in 1771 and was one of the chief organs in the

25. Jean-Jacques Rousseau (1712-78) by Allan
Ramsay (1713-84). Scottish (London),
1766. Oil on canvas. 75 x 64.8 cms.
National Gallery of Scotland, Edinburgh.
As a special favour to Hume, Rousseau sat
for a portrait by Ramsay, posing in his
famous Armenian costume, consisting of a
long purple robe lined with dark brown fur
and a black fur cap. Rousseau suffered
from a persecution phobia and viewed the
portrait as a grotesque representation of
himself: he protested that Ramsay had
given him the features of a Cyclops.
Hume, however, was pleased with the
work, which Ramsay presented to him as
a gift. He wrote that the artist "has
succeeded to admiration, and has made a
most valuable portrait". The two paintings
of Rousseau and Hume by Ramsay hung
in Hume's parlour in Edinburgh.

26. John, 5th Duke of Argyll (1723-1806), by
François-Hubert Drouais (1727-75).
French (Paris), 1763. Oil on canvas.
71 x 58.5 cms. Collection of the Duke of
Argyll, Inveraray Castle.

27. Elizabeth, Duchess of Argyll (1723-90), by
François-Hubert Drouais (1727-75).
French (Paris), 1763. Oil on canvas.
71 x 58.5 cms. Collection of the Duke of
Argyll, Inveraray Castle.

dissemination of Enlightenment ideas. This was inspired and influenced to some extent by the great *Encyclopédie, ou Dictionnaire raisonné des sciences, des arts et des métiers, par une société de gens de lettres*, edited by Denis Diderot and Jean D'Alembert. Much of the first edition of the *Encyclopaedia Britannica* reflected the interests in natural history and the sciences of the first editor, William Smellie, but later editions were broadened in scope to include the arts and writings of contemporary authors.

With the French supporting the rebellious colonies in America, Britain and France were once again at war. The renewed threat of French invasion restricted the flow of French items and impeded the exchange of ideas. The American colonies achieved their goal of independence in 1783 and peace was temporarily restored.

This intermittent disruption of amicable relations between France and Britain limited the possibilities open to patrons. However the French programme of interior decoration carried out at Inveraray Castle (Figs. 28 and 29) shows with what alacrity one Scottish peer could respond to changing circumstances. The castle was built between 1746 and 1758. The 5th Duke of Argyll who succeeded in 1770 was keenly interested in Inveraray and employed Robert and William Mylne as architects, moving the entrance to the castle from the north to the south side and dividing the long gallery. Once construction work was completed, orders were given for the decoration and fitting-out of rooms, and Robert Mylne prepared the drawings. The actual decoration of these rooms was probably not discussed in earnest until 1783 when peace with France made it possible for the Duke and his architect to consider a far more elaborate, French programme of decoration than they had previously been able to contemplate. With the easing of tension between the two countries the future Prince Regent, who came of age in 1783, was also able to commence the decoration by French artists and with French furniture of his own establishment, Carlton House. The Duke of Argyll was not slow to follow this lead and in 1784 the first French artist to be recorded at Inveraray is Guinand, followed by another painter, Irrouard le Girardy, who had been involved with the decoration of Carlton House between 1783 and 1786.

Work at Inveraray apparently began in the dining-room. John Inglis, a Lanarkshire farmer, described the room as "just finishing" in July 1784. He remarks "though very small " [the dining-room] will be the finest room in Scotland, it is painted and gilded very elegantly by two foreigners who were at work in it". Although Girardy also worked in the dining-room the two foreigners referred to were most likely to be Guinand and the gilder Dupasquier, who was employed seasonally at Inveraray. Stebbing Shaw, a clergyman who visited Inveraray in 1787, noted:

> "on the left hand . . . an excellent dining room elegantly fitted up, the ceiling and ovals richly finished by Guinon and Gerardi; but the former died during this undertaking, and the latter is now at work in the opposite drawing-room, which, when complete, will be most elegant; the modern French tapestry is here as beautiful as fancy can design, and art execute".

Stebbing Shaw's brief reference to Girardy's activity in the drawingroom is confirmed by an entry of 1788 in the Argyll papers which records that he completed "three small Cornesses for the Tops of the doors large Drawing Room Castle a draught of which was drawn by Mr Girardy and also a draught for the Tope of the glass in said Room". An inscription on one of

Overleaf left
28. The Dining-room at Inveraray Castle. The painted decoration French, mid 1780s. Started by Guinand and completed by Girardy.

Overleaf right
29. The Drawingroom at Inveraray Castle. The painted decoration French, c. 1788; the tapestries French (Beauvais), probably ordered in 1785 and hung in 1787.

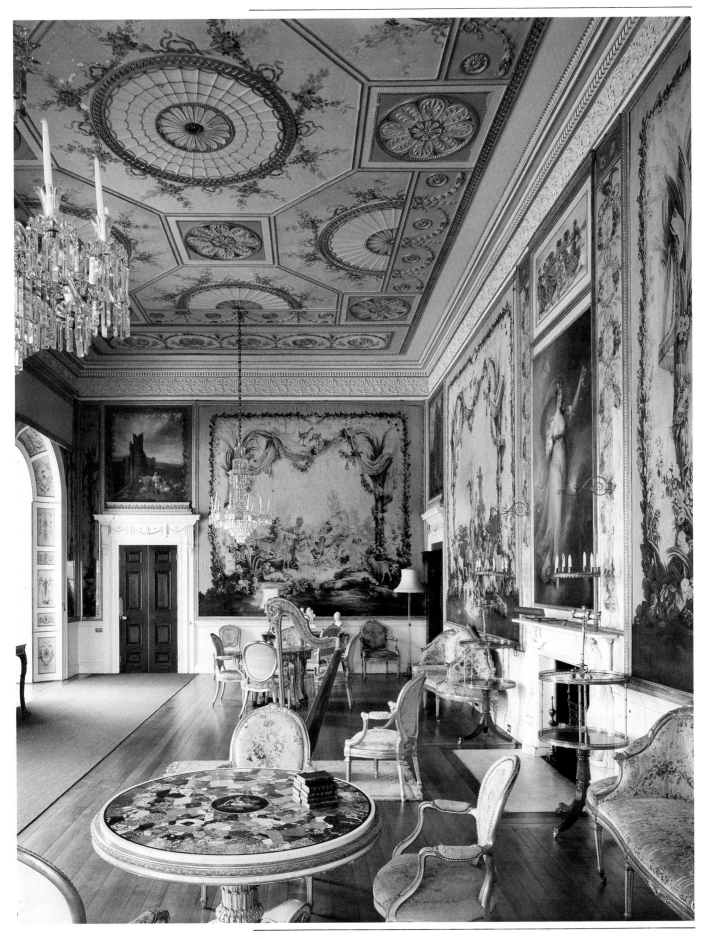

the walls, which is concealed by a tapestry, testifies in French that "all the paintings in this room were designed and painted by Irrouard le Girardy in the year 1788. This artist born in Paris, belonged to the Academy of Painting in this town and in that of London".

The Beauvais tapestries hanging in the drawingroom were thought to have been commissioned in 1763 by the Duke and his wife when they visited France, but recent research shows this to be impossible. The first of this particular set of tapestries, called the *Pastorales à draperies bleues et arabesques*, after designs by Jean-Baptiste Huet, was not woven until 1780, and although French sources have not yet revealed who commissioned or bought the third set (1785), the available details appear to relate to the tapestries at Inveraray. The Duke and Duchess were in France between November 1784 and June 1785, and may have acquired the tapestries at that time.

The Duke ordered a number of pieces of furniture from the London cabinet-maker John Linnell in this period and these items are of interest because some reflect French styles. Linnell, who had been taught to draw by French teachers at St Martin's Lane Academy in London, had many French friends and employed French craftsmen. The Duke also had furniture made by two Edinburgh cabinet-makers working at Inveraray, Peter Traill and his son Douglas. Dupasquier gilded a suite of chairs by them, and Beauvais tapestry covers were fitted by the local tailor.

There is doubt as to precisely how much French furniture the 5th Duke owned. The double lean-to desk by Bernard van Risenburgh II (Fig. 30) is said to have been bought by the Duke and his wife as early as 1763, but no evidence has so far been found to substantiate this suggestion. The desk appears to be a French royal piece and it is therefore difficult to explain how it could have come on the market before the French Revolution. It is more likely to have been purchased by the family in the nineteenth century.

30. Double Lean-to Desk by Bernard van Risenburgh II (master before 1730-d.1765/66). French (Paris), c. 1750. Tulipwood, kingwood and other woods. Gilt bronze mounts. 104.8 x 152.4 x 83.8 cms. Ex-Duke of Argyll Collection. The J. Paul Getty Museum, Malibu, California. Reputed to have been bought in Paris in 1763 by Elizabeth Gunning, but probably acquired at a later date.

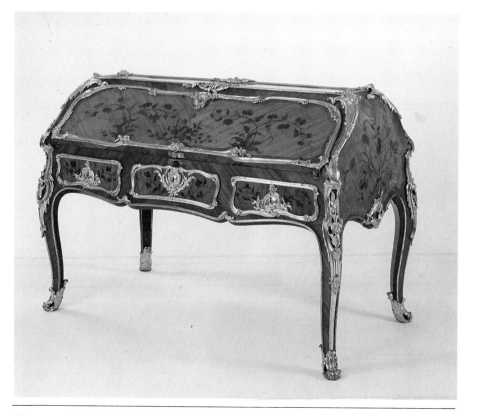

In addition to French painted rooms and tapestries there were other French aspects to Inveraray Castle. The 5th Duke of Argyll collected French books and the ladies of the household played French music on the great mid eighteenth century organ in the hall at Inveraray, on other keyboard instruments and on the harp. The family entertained French visitors such as the geologist Barthélemy Faujas de St-Fond, who paid a visit to Scotland in 1784. St-Fond records that "French was spoken at this table with as much purity as in the most polished circles in Paris". He also notes that "the dishes are prepared after the manner of an excellent French cook; everything is served here as in Paris".

The investigations and writings of French scientists and mathematicians were of international importance in the late eighteenth and early nineteenth centuries and had a profound influence on Scots involved in these fields. The work of the pioneering chemist Antoine Laurent Lavoisier, for example, was of cardinal significance. Lavoisier's works were known from French editions and from English and Scottish editions of translations, and he was in direct contact with scientists in Scotland such as Joseph Black (1728-99), the Professor of Chemistry and Medicine at Edinburgh University from 1766, and the distinguished geologist Sir James Hall. In 1788 there was a full-scale debate in the Royal Society of Edinburgh on Lavoisier's theory of the nature of combustion. One Scot to make good use of French research was Charles Tennant of Glasgow who began the industrial production of bleach based on Claude-Louis Berthollet's discovery of the bleaching properties of chlorine. Another was George Mackintosh who established the production of "turkey-red" dyeing with the assistance of the French chemist P. J. Papillion. The French established important early collections of research material for the purposes of scientific observation. Part of the collection of natural history specimens belonging to Louis Dufresne, the head taxidermist of the Muséum National d'Histoire Naturelle in Paris, was purchased by the University of Edinburgh Natural History Museum in 1818. The remains of this collection are now in the Royal Scottish Museum. Dufresne had been in charge of the Empress Josephine's natural history collection at Malmaison and it is just conceivable that some items in his collection came from this source.

The French Revolution was a watershed in the history of Western civilisation. In Scotland, as elsewhere, it made a dramatic impression being received in some quarters with horror and in others with enthusiasm. The Whig Club of Dundee voted the following address to the National Assembly in Paris in 1790:

> "The triumph of liberty and reason over despotism, ignorance, and superstition, is an interesting event to the most distant spectators. . . Accept, Sir, our sincere congratulations on the recovery of your ancient and free constitution and our warmest wishes that liberty may be permanently established in France. . . Our hopes are that your example will be universally followed, and that the flame you have kindled will consume the remains of despotism and bigotry in Europe."

There was a widespread desire in Scotland for reform at the time of the Revolution because of a reluctance on the part of the government in London to initiate change. The apparent attainment of greater freedom in France was contrasted with restrictions on freedom in Britain. The French Revolution increased people's expectations, it breathed new life into the existing

31. **Lord Adam Gordon, Commander of the Forces in Scotland and Governor of Edinburgh Castle, and the Comte d'Artois walking arm-in-arm in Edinburgh, in 1796,** by John Kay. Scottish (Edinburgh), 1796. 18.5 x 10.2 cms. Scottish National Portrait Gallery, Edinburgh.

associations for reform and led to the foundation of new societies. That the Revolution failed to exert even greater influence was due to the violence and anarchy that followed in its wake. The poet Robert Burns, for example, had been an enthusiastic supporter of the Revolution from the start and in 1792 he bought four carronades from a captured smuggler and sent them as a gift to the French Convention. But by 1793 the Revolution had become saturated in blood, Britain and France were at war, and Burns found himself in danger of losing his government appointment as an excise officer if he continued his support of the Revolution.

Large numbers of Scots were recruited during the Revolutionary and Napoleonic Wars and this involvement is commemorated in many buildings and monuments and silver. A monument to Lord Nelson, victor at Trafalgar, was erected on Calton Hill, Edinburgh, in 1807. A monument to the fallen of the Napoleonic Wars was proposed in 1815 and begun in 1826. In 1829 the building, a facsimile of the Parthenon, came to a halt with only part of the stylobate, twelve columns at the west end and their architrave completed. Monuments commemorating groups of men and individuals were erected in many parts of Scotland, and presentation silver, medals and weapons are displayed in the Scottish United Services Museum in Edinburgh Castle and in other museums in Scotland. A particularly fine presentation sword is in the House of the Binns near Edinburgh. It was awarded by the Patriotic Society to Admiral William Dalyell for his extraordinary bravery against the privateer *Vimereux* whilst only a midshipman. Ship-owners also awarded captains of merchantmen and other ships who evaded capture by French naval vessels and privateers with items of plate. An example of this is the silver punch bowl presented by the owners and underwriters of the *Europa* of Greenock to Captain Robert Leitch "for his Gallant conduct in defence of that Ship against A FRENCH PRIVATEER on 27 Novr. 1797" (now in the Royal Scottish Museum).

The Revolutionary and Napoleonic Wars created many problems for Scotland. The hardships were most keenly felt in the Highland communities, where many of the regiments were raised. In the cities there was less finance available for public works, private building and for industrial growth. On the other hand the wars stimulated the demand for information and led to the publication of larger newspapers. Writers and poets were also inspired by the wars, most notably Sir Walter Scott (1771-1832). Scott was a founder member in 1797 of the Edinburgh group of the Midlothian Yeomanry Cavalry. His years as a volunteer were some of the happiest times in Scott's life and many of his poems were composed and written when he was at camp at Musselburgh or on manoeuvres. The draft of the *Lay of the Last Minstrel* was written in 1802 after a kick from his horse obliged Scott to stay in his lodgings for three days. Two long poems, the *Vision of San Roderick* and the *Field of Waterloo*, together with a number of shorter poems, celebrate contemporary battles.

One unexpected outcome of the French Revolution was the arrival on board the frigate *Jason*, at Leith on 6 January 1796, of Charles Philippe, Comte d'Artois (1757-1836), the brother of Louis XVI and the Comte de Provence (the future Louis XVIII). The Comte (Fig. 31) was heir-presumptive to the French throne and had sought refuge in England. He had become involved in the attempted mass uprising and was in debt. The British government decided to place him at a distance from themselves, and from the *émigrés*, and sent him to Scotland, where he occupied the Royal Apartments

32. **Seascape** by Madame Elizabeth de France (1764-94), sister of Louis XVI. Oil on canvas. 78.5 x 98 cms. Inscribed *"Elizabeth pour son frère D'Artois 1792"*. Collection of the Duke of Buccleuch, Drumlanrig Castle.

at Holyrood Palace for three years. The Comte was joined by others, including his elder son, the Duc d'Angoulême. The Royal Apartments were furnished for the French royal household by the Edinburgh cabinet-makers and upholsterers, Young, Trotter and Hamilton, at the expense of the British government, and some of this furniture is still at Holyrood. The Comte d'Artois was eventually able to return to France and after the death of Louis XVIII in 1824, he succeeded to the throne as Charles X. His ultra-conservative policies resulted in the 1830 Revolution and his fall. Once again he sought refuge in Britain and was again offered the use of Holyrood Palace. The last of the Bourbon kings finally left Scotland in 1832.

The periods of exile of the French royal family at Holyrood are marked by a number of items which still remain in Scotland. The French *émigré* artist Henri-Pierre Danloux was in exile in England in the 1790s and visited Scotland in 1798. Several of his works are still in Scotland, including portraits of the Comte d'Artois and his two sons, the Duc d'Angoulême and the Duc de Berri. These are in the Collection of the Duke of Buccleuch at Bowhill and are believed to have been commissioned by Elizabeth, the wife of the 3rd Duke of Buccleuch and a strong supporter of the French exiles. The Duke of Buccleuch also owns a seascape (Fig. 32) painted by Madame Elizabeth de France, the sister of Louis XVI and the Comte d'Artois, who was

guillotined in 1794. It is inscribed *Elizabeth pour son frère D'Artois 1792* and is said to have hung in the Comte d'Artois' dining-room at Holyrood. The Comte apparently gave the painting to Lady Elizabeth Murray, daughter of the 4th Earl of Dunmore, and the 5th Duke of Buccleuch bought it from her grandson in 1830. During their second exile in Edinburgh the French royal family received assistance from Father James Gillis, who had attended the seminary of St Nicholas in Paris from 1818-23 and had been received by the royal family. They supplied him with letters of introduction and recommendations to raise money in France for the foundation of the first religious house in Scotland since the Reformation, St Margaret's Convent of the Ursulines of Jesus, Edinburgh. Around the time of her departure, in August 1832, the Duchesse d'Angoulême presented Father Gillis with locks of hair of all the members of the royal family and with two bronze busts of her father and mother, Louis XVI and Marie-Antoinette. Father Gillis bequeathed the busts to the Convent; these are now on loan to the Royal Scottish Museum. Another reminder of the French royal family's stay in Edinburgh is the monstrance which the Duc de Bordeaux, the posthumous son of the Duc de Berri, presented to St Mary's Chapel to commemorate his first communion on 2 February 1832.

THE GREAT COLLECTIONS

Great collections were formed by a number of Scottish lords in the century after 1820. Enormous quantities of furniture and works of art were dispersed from the palaces, *châteaux* and town houses of the French aristocracy following the 1789 Revolution and the Napoleonic Wars, and many *ancien régime* treasures of the principal French households and material relating to Napoleon began to be absorbed into British stately homes.

The greatest collection of French works of art ever to be formed in Scotland was assembled during this period at Hamilton Palace in Lanarkshire, the chief seat of the Dukes of Hamilton in the nineteenth century. This outstanding collection contained some of the most magnificent furniture made for the French royal family as well as important works relating to the Emperor Napoleon and his favourite sister, the Princess Pauline Bonaparte-Borghese. Sadly, the collection is now dispersed, mainly as a consequence of the great sale of 1882. Hamilton Palace itself was emptied, stripped and demolished between 1919 and 1926.

Alexander Archibald Douglas (1767-1852), from February 1819 the 10th Duke of Hamilton and 7th Duke of Brandon (Fig. 33), had spent many formative years in Italy and was a serious collector by 1800, with a network of dealers, agents and advisers. The Hamilton estates and the Hamilton collieries in Lanarkshire and Stirlingshire were becoming steadily more profitable. However the collection which Alexander built up was not simply the product of combining his genuine interest in collecting with the large financial resources which became available to him after 1819. It is to be explained primarily in terms of Alexander's exalted view of his own status which necessitated, in his opinion, a magnificent palace filled with works of art of the first quality, preferably with royal or imperial associations.

Alexander was the premier peer of Scotland, with an impressive list of Scottish and English titles and offices and a family whose fortunes had been closely linked with the history of Scotland. Furthermore, he claimed to be Duke of Châtelherault, the title awarded in 1549 to his ancestor, the 2nd Earl of Arran, for his support of the marriage of Mary Queen of Scots to the Dauphin of France. The title had been in abeyance since 1649, but this did not stop the Duke from consistently using it. Lastly, and most significantly, Alexander believed himself to be the legitimate heir to the throne of Scotland, the direct Stuart line having come to an end in 1807. Alexander's

tremendous pride in his own station is clearly demonstrated by the arrangements he made for the disposal of his body. He had a great Neo-classical mausoleum erected close to his palace, at an estimated cost of £130,000. Work was begun on this during the early 1840s but the project was still incomplete at the time of the Duke's death in August 1852. The writer of the Duke's obituary in the *Gentleman's Magazine*, published in October, recorded that the structure "is believed to be the most costly and magnificent temple for the reception of the dead that was ever erected—at least in Europe." But this was not all. The Duke had left instructions that he was to be embalmed and his wishes were duly carried out. The writer of the obituary in the *Gentleman's Magazine* criticized the "insane pride" which led the Duke to request "a process which even royalty has of late years judged proper to decline". The embalmed body was brought from London to Hamilton by special train. On 4 September the mortal remains of the "very Duke of very Dukes" were lowered into an Egyptian basalt sarcophagus housed in his mausoleum, there to lie in splendid state like some latter-day Pharaoh.

There can be no doubt that Alexander was also influenced and inspired by the taste and example of his father-in-law, William Beckford (1760-1844). Alexander had known Beckford since childhood and in 1810 married his second daughter, Susan Euphemia. Beckford had inherited an estate worth about a million pounds from his father who had been the Lord Mayor of London and the owner of large sugar plantations in the West Indies. Income estimated at £100,000 per annum enabled Beckford to become one of the great collectors of the age and to undertake a huge rebuilding programme at his family home, Fonthill Abbey in Wiltshire. In so doing he overextended himself and was forced to sell the new house and much of its contents in 1822 to the Anglo-Indian millionaire John Farquhar. Nevertheless Beckford was still able to collect and to execute further building projects. In the 1820s and 1830s, Alexander bought major French items from Beckford's collection. On Beckford's death his remaining collection was bequeathed to his favourite daughter Susan, Duchess of Hamilton, and to her husband Alexander.

Other collectors and builders influenced Alexander, particularly the Prince Regent, who became George IV in 1820. The Prince Regent had formed the most extensive collection of French works of art in Britain. Given Alexander's royal pretensions, it was inevitable that in his collecting policy he would strive to compete with the sovereign. As soon as he became duke in 1819, Alexander initiated an extensive building programme at Hamilton Palace. The palace consisted of an early tower house which had been considerably expanded in the late seventeenth century. In 1819 Alexander approached Francesco Saponeri in Rome for designs for a new north front. The Duke was not entirely satisfied with these designs and in 1822 he decided to employ a local architect with family connections, David Hamilton (1768-1843). The Duke probably believed that he could control Hamilton and that, between them, they could produce exactly what he wanted. They set to work on a new north front, using as their basis a scheme prepared by William Adam for the 5th Duke of Hamilton in about 1730. The scheme had not been carried out but had been published in *Vitruvius Scoticus* about 1812. The final result was a Palladian Neo-classical building (Figs. 34 and 35) which measured 80.5 metres in length and had a central portico supported by a double row of monolithic Corinthian columns 7.6 metres in height and 1 metre in diameter.

33. Alexander, 10th Duke of Hamilton (1767-1852), by Sir Henry Raeburn (1756-1823). Scottish (Edinburgh), early 19th century. Oil on canvas. 250 x 183 cms. Collection of Viscount Cowdray, Cowdray Park.

34. The North Front of Hamilton Palace after designs by David Hamilton (1768-1843). Now demolished.

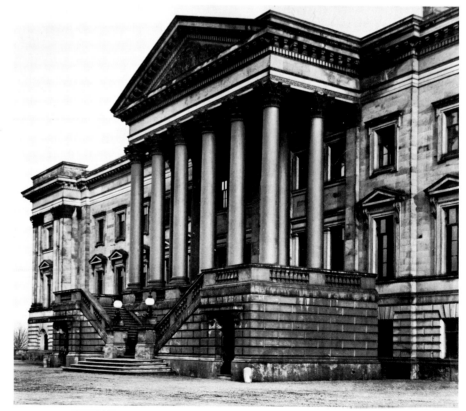

35. The Portico of the North Front of Hamilton Palace after designs by David Hamilton (1768-1843). Now demolished.

The interior was to be even more impressive than the facade. The Duke commissioned Napoleon's leading architect and designer, Charles Percier, to supply drawings for the principal rooms in the new north block (Figs. 36, 37 and 38). Percier and his partner, Pierre-François-Léonard Fontaine, were famous for their work for Napoleon and for the influential series of designs entitled *Recueil de Décorations intérieures*, which were published between 1801 and 1812. Unfortunately Percier's designs for Hamilton Palace were not carried out, and the interiors were instead based on the less sophisticated proposals of David Hamilton and the London decorator and designer Robert Hume.

To create an imperial ambience the Duke made lavish use of coloured marbles. The grand staircase and landings were of black marble from the Angliham quarries on the shores of Loch Corrib, county Galway, which has been described as the best black marble in the world. Large consignments of marbles and sculptures were obtained from the Palazzo Braschi in Rome and from other sources in the 1820s. Monumental decorative bronzework was supplied by the Parisian firm of Soyer and Inge over many years and included two colossal bronze figures which appeared to support the upper landing of the staircase. Gustav Waagen, the director of the Royal Gallery in Berlin, who visited the palace shortly before the Duke's death, made the following observations on the finished effect: "As the Duke combined in equal measure a love of art with a love of splendour, and was an especial lover of beautiful and rare marbles, the whole ameublement was on a scale of costliness, with a more numerous display of tables and cabinets of the richest Florentine mosaic than I had seen in any other palace. As a full crimson predominated in the carpets, a deep brown in the woods of the furniture and a black Irish marble, as deep in colour as the nero antico, in the specimens of marble, the general effect was that of the most massive and truly princely splendour; at the same time somewhat gloomy, I might almost say Spanish, in character".

36. and 37. *overleaf.* Designs for the Entrance Hall of Hamilton Palace by Charles Percier (1764-1838). French (Paris), c. 1827-9. 56.3 x 42.3 cms.; 56.3 x 42.3 cms. Collection of the Duke of Hamilton, Lennoxlove. The sculptures represent the ancestors of the 10th Duke of Hamilton. The scheme draws attention to the great age of the family line of Hamilton and to the 2nd Earl of Arran, who became Duke of Châtelherault and was heir-presumptive to the throne of Scotland during the reign of Mary Queen of Scots until the birth of the future James VI and I. The designs were not carried out.

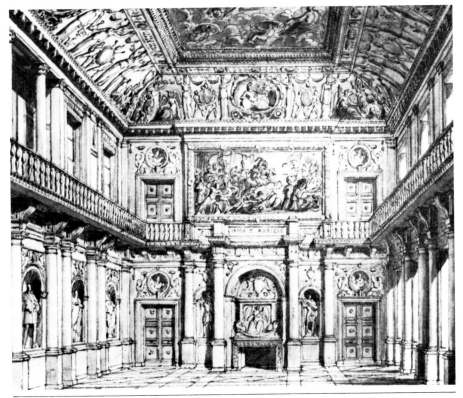

75

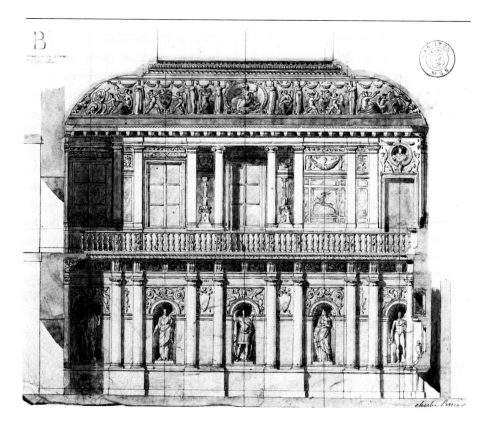

38. Designs for the Tribune of Hamilton
Palace by Charles Percier (1764-1838).
French (Paris), c. 1827-9. 42 x 56.2 cms.
Collection of the Duke of Hamilton,
Lennoxlove. The designs were not carried
out.

The magnificent Hamilton Palace Collection included French furniture, and French faience or tin-glazed earthenware, Sèvres porcelain and French illuminated manuscripts, printed books and bindings. Six free-standing bronzes, formerly in the French royal collection, from the estate of the Sieur Laneuville, were also acquired probably between 1826 and 1828.

Alexander collected some of the most superb French furniture ever made. He had a fondness for Boulle furniture, which is decorated with cut-out designs in turtleshell, brass and other metals and named after the leading maker, André-Charles Boulle (1642-1732). He owned, amongst many pieces, the pair of *armoires* attributed to André-Charles Boulle of about 1700 (now in the Musée du Louvre), and the commode or chest of drawers by Étienne Levasseur (1729-98) delivered in 1777 to the Comte d'Artois in the Hôtel du Grand Prieur du Temple in Paris. This piece is now at Versailles. Alexander's interest in French regency or rococo furniture was more limited; the only major piece in the collection appears to have been the commode attributed to Charles Cressent, of about 1730 (Fig. 39).

A fabulous collection of marquetry and lacquer furniture by the great royal *ébéniste* Jean-Henri Riesener (1734-1806) was assembled by the Duke. The marquetry furniture included the commode from the bedroom at Versailles of the Comtesse de Provence (wife of the future Louis XVIII), commissioned and delivered in 1776 (Fig. 40); the drop-front secretaire from the large set of furniture supplied in 1777 for Louis XVI's private study in

39. Commode attributed to Charles Cressent (1685-1768). French (Paris), c. 1730. Mahogany and purplewood veneers. Gilt bronze mounts. Brèche d'Aleps marble top. 91.1 x 158.1 x 66 cms. Ex-Hamilton Palace Collection. The National Trust, Waddesdon Manor.

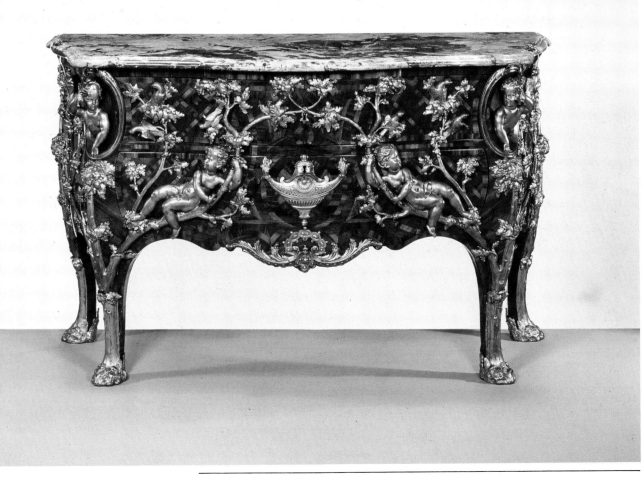

the Petit Trianon (Fig. 41); the drop-front secretaire and commode made for Marie-Antoinette, dated 1790 and 1791 respectively (Figs. 42 and 43); and the writing table from the Petit Trianon, dated c. 1780-85 (Fig. 44). Three remarkable items of furniture by Riesener incorporate panels of Japanese lacquer: the drop-front secretaire and commode from the Cabinet-intérieur of Marie-Antoinette at the Château of St Cloud, probably made in 1787 (Figs. 45 and 46), and the drop-front secretaire of about 1785 which may have come from the Cabinet-intérieur of Louis XVI at Versailles (Fig. 47).

A well-informed collector, the Duke was aware of the historical significance of these pieces, that they had belonged to Marie-Antoinette or were from other apartments in the French royal palaces. He was also conscious of the provenance of the early Neo-classical style writing table and filing cabinet by J. B. Sené which he owned and which is now in the Musée Condé, Chantilly in France: it had belonged to Étienne-François de Choiseul de Stainville, Duc de Choiseul, Minister of Louis XV from 1758 to 1770. The table and cabinet are from the Cabinet à la Lanterne in the Hôtel de Choiseul, in Paris and were in existence by 1770-71.

Some of the Duke's furniture was acquired directly from France. At the sale in 1827 following the death of his former agent, the Chevalier Féréol Bonnemaison, the Duke purchased the commode by Levasseur. Before the sale he bought a pair of octagonal pedestals attributed to André-Charles Boulle, of about 1700, from a member of the Bonnemaison family. A list drawn up by the Duke and preserved in the Hamilton archives reveals that the commode attributed to Cressent (Fig. 39) was also sent from France in 1827. Alexander acquired many of his best French pieces in England. The

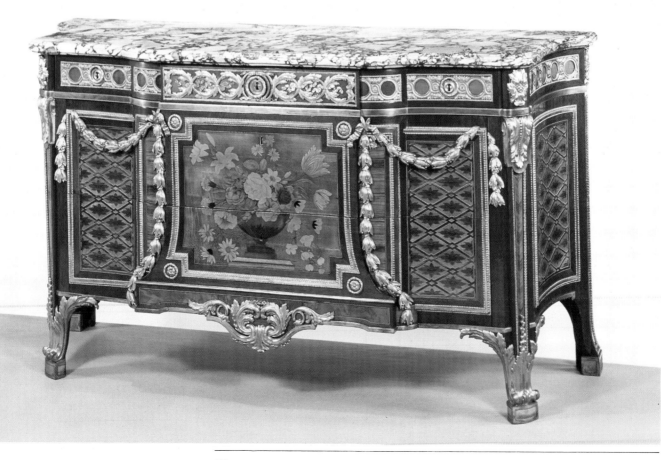

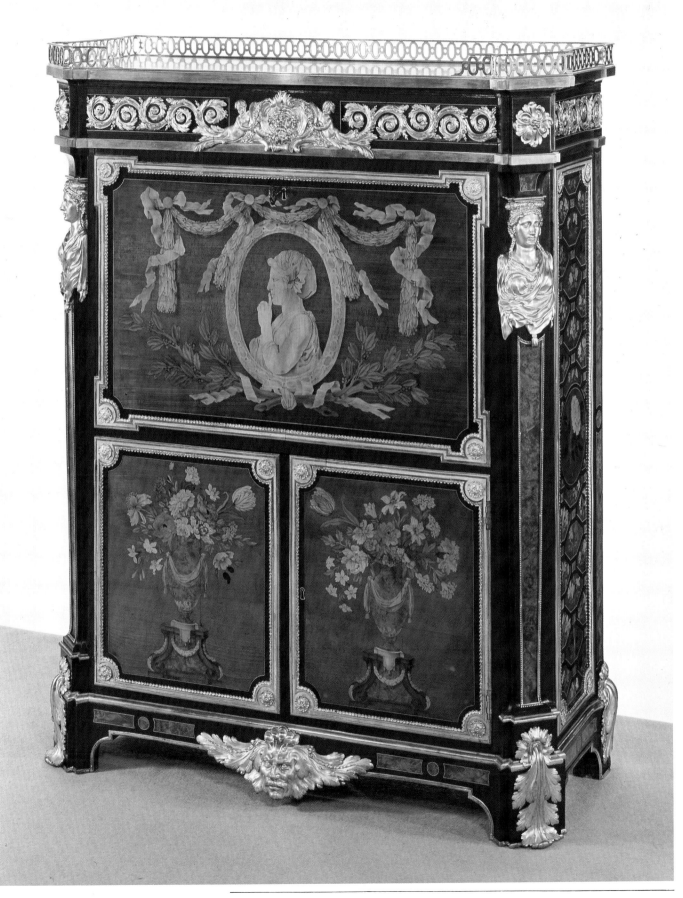

79

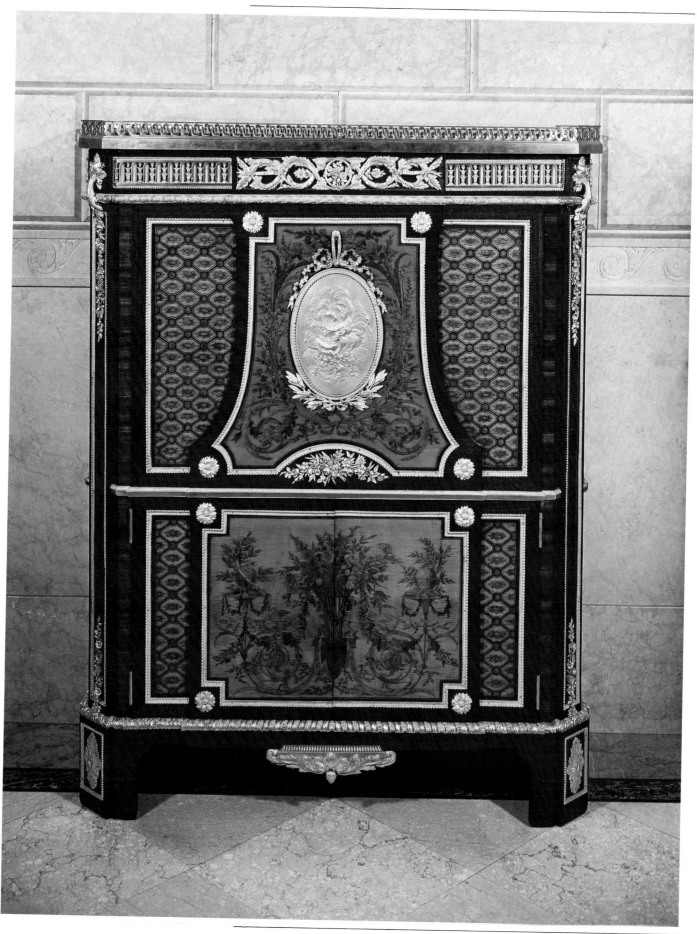

Opposite left

42. Drop-front Secretaire by Jean-Henri Riesener (1734-1806). French (Paris), dated 1790. Satinwood, boxwood, amaranth, tulipwood and other woods. Gilt bronze mounts. Marble top. 143.1 x 115.5 x 43.8 cms. Ex-Hamilton Palace Collection. The Frick Collection, New York.

43. Commode by Jean-Henri Riesener (1734-1806). French (Paris), dated 1791. Satinwood, boxwood, amaranth, tulipwood and other woods. Gilt bronze mounts. Marble top. 95.9 x 144.3 x 62.5 cms. Ex-Hamilton Palace Collection. The Frick Collection, New York.

44. Writing Table by Jean-Henri Riesener (1734-1806). French (Paris), c. 1780-85. Purplewood, mahogany, satinwood, boxwood, ebony, sycamore and other woods. Gilt bronze mounts. 73.3 x 59 x 41.9 cms. Ex-Hamilton Palace Collection. The National Trust, Waddesdon Manor.

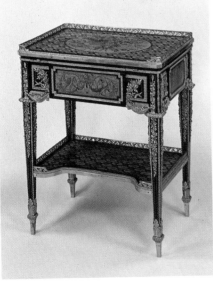

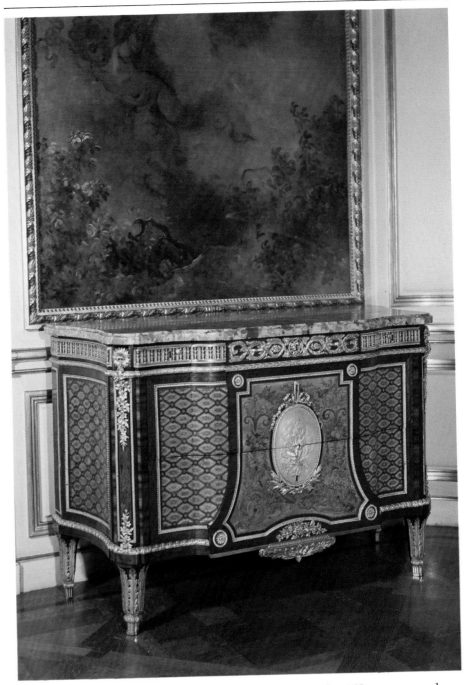

armoires (now in the Musée du Louvre) were bought for 450 guineas at the Fonthill Abbey sale of 1823. These had been acquired by William Beckford and had been included in the purchase of Fonthill and its contents by John Farquhar in 1822, but Farquhar sold off much of the Beckford Collection in sales between 9 September and 31 October 1823. The Duke continued to buy articles from Beckford's collection; for example, the "Auguste cabinets", on which the Parisian goldsmith Auguste is said to have worked, were bought in 1831, through the Duke's agent, Robert Hume.

From the extensive collection of George Watson Taylor, Alexander acquired the three superb items by Riesener incorporating panels of Japanese lacquer (Figs. 45, 46 and 47). The Taylors were reputedly the richest commoners in England, but lived so extravagantly that in 1832 Taylor went bankrupt owing half a million pounds. According to Sir Robert Peel, no

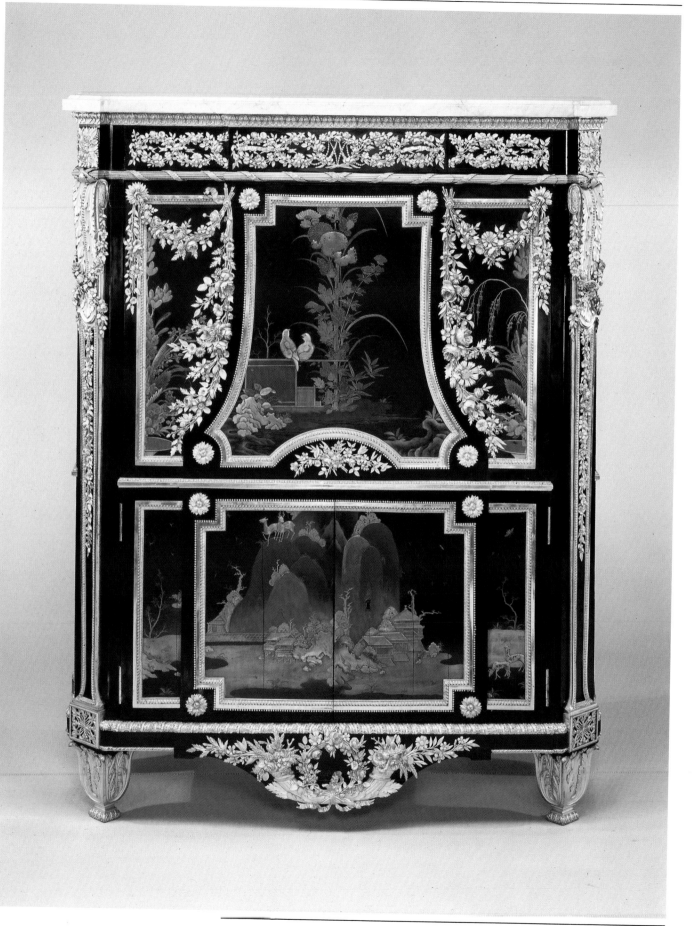

Opposite left

45. Drop-front Secretaire by Jean-Henri Riesener (1734-1806). French (Paris), c. 1787. Japanese lacquer panels. Gilt bronze mounts. Replacement marble top. 144.8 x 109.2 x 40.5 cms. Ex-Hamilton Palace Collection. The Metropolitan Museum of Art, New York. Bequest of William K. Vanderbilt, 1920.

Right

46. Commode by Jean-Henri Riesener (1734-1806). French (Paris), c. 1787. Japanese lacquer panels. Gilt bronze mounts. Replacement marble top. 93.3 x 138.4 x 59.7 cms. Ex-Hamilton Palace Collection. The Metropolitan Museum of Art, New York. Bequest of William K. Vanderbilt, 1920.

Below

47. Drop-front Secretaire attributed to Jean-Henri Riesener (1734-1806). French (Paris), c. 1785. Japanese lacquer panels. Gilt bronze mounts. Black marble top. 154.3 x 113.7 x 46.3 cms. Ex-Hamilton Palace Collection. The J. Paul Getty Museum, Malibu, California.

48. Writing Table and Filing Cabinet designed by Louis-Joseph Le Lorraine (c. 1714-59). French (Paris), c. 1757. Ebony and brass veneers. Gilt bronze mounts by Philippe Caffieri (1714-74). 86 x 195 x 108 cms; 161 x 108 x 54.5 cms. Ex-Hamilton Palace Collection. Musée Condé, Chantilly.

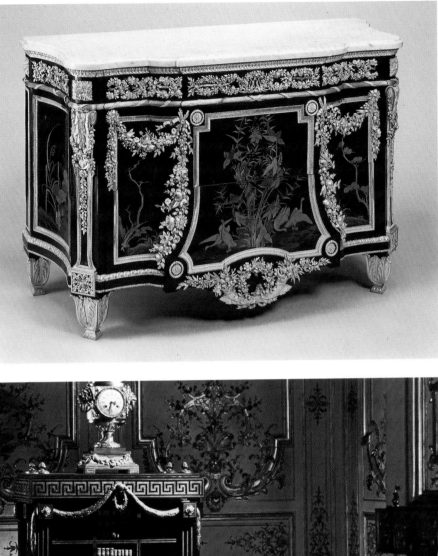

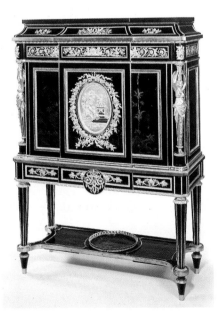

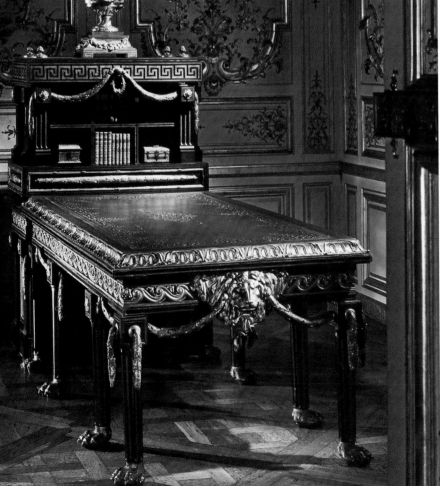

man bought ridicule at so high a price! Two major sales of the Taylor Collection took place in 1825 and 1832. In the first sale George IV had managed to acquire the famous Riesener jewel cabinet made for the Comtesse de Provence.

One important piece in the Hamilton Collection about whose acquisition little has so far been established is the writing table and filing cabinet commissioned by Ange-Laurent de Lalive de Jully (1725-79), art collector and chief of protocol at the French court (Fig. 48). It is one of the earliest pieces of Neo-classical style furniture to have been made in France and sufficiently grandiose to have appealed to Alexander although there is no evidence that he was the purchaser. The only reference that has been found to date is in the 1876 inventory.

A number of the finest pieces of French furniture were concentrated in the Duke's dressing-room. According to the 1835 inventory of Hamilton Palace they included the commode by Cressent (Fig. 39) and four pieces by Riesener (Figs. 41, 45, 46 and 47). They were subsequently joined by the two octagonal pedestals attributed to Boulle, which had been in the drawingroom. The *armoires* (now in the Musée du Louvre) were on the first-floor gallery, the Duc de Choiseul's desk was in the library, and the Artois commode by Levasseur was in the drawingroom. Another Riesener drop-front secretaire and its companion commode (now in the Frick Collection) were in the Duchess's sitting-room in 1835 (Figs. 42 and 43).

Alexander acquired works associated with three ruling families, the Stewarts, the Russian Tzars and the Bonapartes. The most interesting of these relate to the Emperor Napoleon (1769-1821) and his second sister, the Princess Pauline Bonaparte-Borghese (1780-1825), and their acquisition over four decades was the expression of Alexander's long and fervent admiration for the Emperor.

Alexander's interest in Napoleon can be traced back to his Whig politics. The Whigs interpreted the French Revolution as the equivalent of the Glorious Revolution of 1688 in Britain, and saw Napoleon as the saviour and consolidator of the Revolution accepting that he had a mandate from the French people to govern. They viewed Napoleon as an enlightened leader fighting against despotic regimes and it was their hope that he would bring about more representative forms of government in Europe. They opposed any British support for despots who resisted Napoleon and urged non-intervention and peace with France.

It was as a declared Whig that Alexander was elected a member of parliament for Lancaster in 1802. Four years later, in May 1806, shortly after the Whigs had come to power, he was appointed ambassador to St Petersburg. At the Russian court he represented a government which was seeking to make peace with France and apparently experienced no difficulties in denying Russia the aid she desperately needed if she was to withstand Napoleon and the *Grande Armée*. The Tzar was greatly annoyed at the new ambassador's unhelpful attitude and tactlessness and Alexander was quickly replaced after the Portland ministry took office in the spring of 1807.

The great portrait of the *Emperor Napoleon in his Study in the Tuileries* by Jacques-Louis David (Fig. 49) was the first important work connected with Napoleon which Alexander acquired. This painting was commissioned by Alexander himself through his agent Bonnemaison, in 1811, at a time when Britain was at war with France. It was completed a year later and shipped to England. The Hamilton Palace painting appears to have been the first of

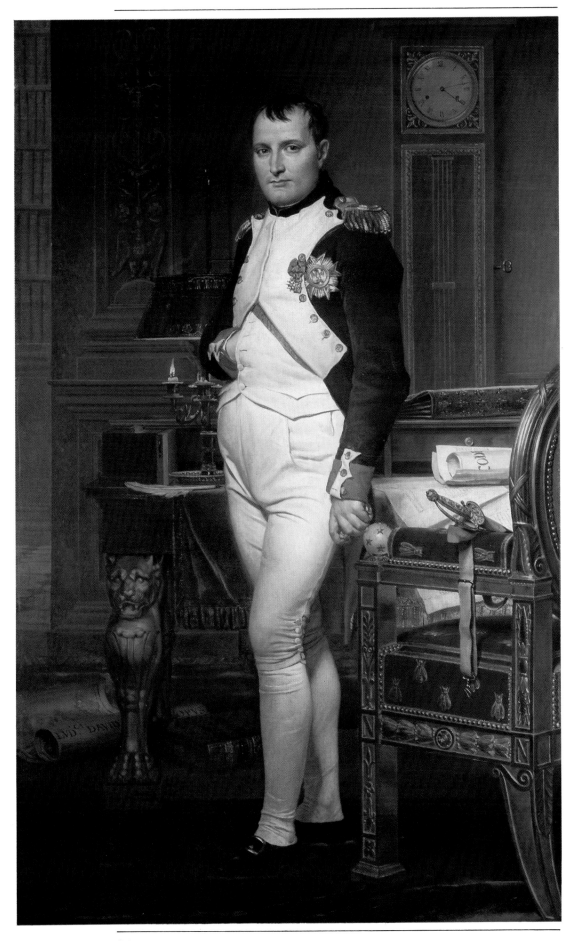

50. Travelling Service of the Princess Pauline Borghese (1780-1825) supplied by Martin-Guillaume Biennais (1764-1843). French (Paris), probably 1803. Mahogany chest with brass mounts containing silver-gilt and other items. Chest: 57.3 x 40 x 18.8 cms. Collection of the Duke of Hamilton. An inscription on the upper edge of the lower part of the case, "*Biennais Orfevre du Premier Consul au St Honoré No 119 au Singe Violet à Paris*", restricts the date of the completion of the service to the period between the establishment of the Consulate in November 1799 and 18 May 1804, when Napoleon became Emperor. The most likely date would appear to be 1803, when the Princess returned to France, redecorated and refurnished the Hôtel de Charost and, perhaps more significantly, married the Prince Camillo Borghese (secret marriage 28 August, civil ceremony 6 November). The service was bequeathed to Alexander, 10th Duke of Hamilton, in 1825. Details about the contents of the chest are included in the Checklist.

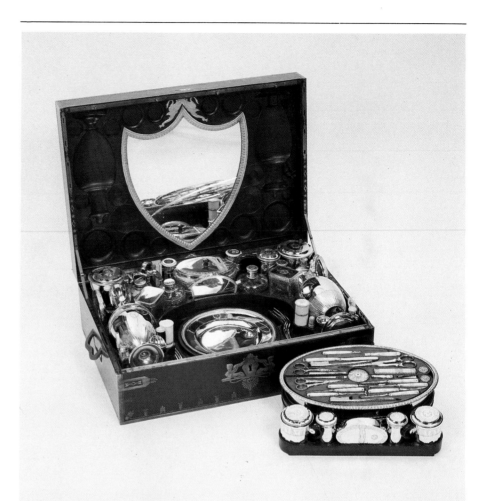

several versions; it is not only a fine work of art but also of propaganda. David has represented Napoleon as a "great man" (note the setting and the copy of Plutarch's *Lives of Great Men* under the desk). Napoleon's prowess as a soldier is barely indicated and what is emphasized are his qualities as an administrator and law-maker and law-giver. The Napoleon portrayed has just risen, at 4.13 in the morning, from long hours of paperwork at his desk. David has depicted the *Code Napoléon* (issued in 1804) lying symbolically upon a map to suggest its use throughout the Empire. It is just the type of image which would have appealed to a Whig and it is regrettable that we do not know more about the genesis of the work. In 1835, the painting is recorded as hanging with other large canvases in the new dining-room at Hamilton Palace.

The second major Napoleonic item in the 10th Duke's collection was the *nécessaire de voyage* or travelling chest containing items for meals, the toilet, writing and needlework (Fig. 50) which had belonged to Napoleon's sister, the Princess Pauline Borghese. An inscription on the case reveals that the service was supplied by Martin-Guillaume Biennais and indicates that it would have been assembled and completed between November 1799 and 18 May 1804. Pauline (Fig. 51) probably acquired the service in 1803, the year in which she returned to France, purchased and refurbished the Hôtel de Charost and married the Prince Camillo Borghese. In later life, after Napoleon's final downfall in 1815, the Princess settled in Rome. One writer recalled her walking on the Pincian Hill in 1818 "with a bevy of admirers; as smart and pretty a little bantam figure as can be imagined". In the same year,

51. Princess Pauline Borghese (1780-1825) by Robert Lefèvre (1755-1830). French (Paris), 1806. Oil on canvas. 80.6 x 63 cms. Apsley House, London.

the American traveller George Ticknor took a less charitable view, calling her "the most consummate coquette" he had ever seen. The Princess, a celebrated beauty, encouraged the attentions of British aristocrats, partly because she thought that she could influence them to assist her brother then in British custody on the island of St Helena. In 1818 Alexander, then Marquess of Douglas, formed a close friendship with the Princess and escorted her in Rome and in Lucca, causing a minor scandal. After Alexander returned to Britain and became Duke of Hamilton their friendship continued and when the Princess died in June 1825, she left the travelling service to him "as a mark of my friendship". Two Sèvres vases were left to the Duchess and a ring set with opals to her daughter. Letters have survived written to the Duke between 1825 and 1827 which relate to the collection of the travelling chest from Florence, where the Princess had died. It appears that the Duke collected the chest or arranged for its transportation when he was in Italy in 1827.

It is possible that the bequest of the *nécessaire*, a fine example of the Empire style, inspired the Duke to commission leading Napoleonic designers. Certainly in the same year that the *nécessaire* was collected the Duke employed Charles Percier, Napoleon's architect, to supply designs for the principal rooms of the new north block of Hamilton Palace.

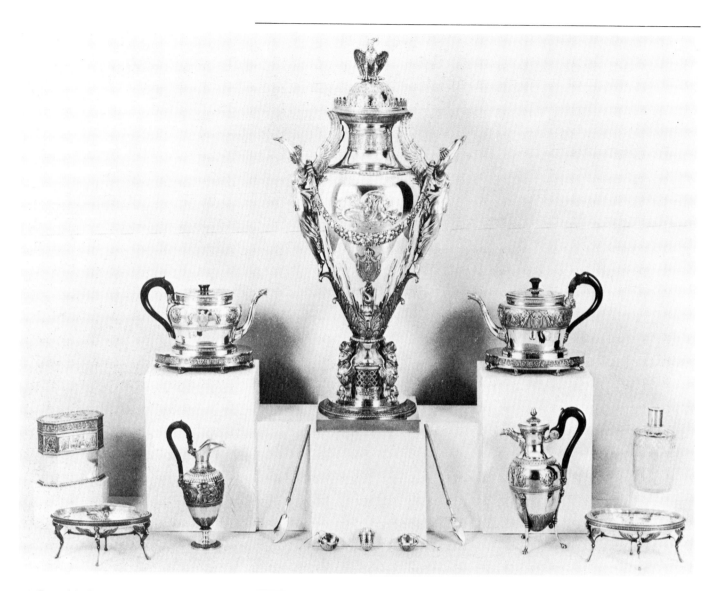

52. Part of the Tea Service made for the Emperor Napoleon supplied by Martin-Guillaume Biennais (1764-1843). French (Paris), 1810. Silver-gilt and crystal. Musée du Louvre, Paris. The service is contained in two chests. Chest one (illustrated here) is in the Louvre, while the second chest is in the Royal Scottish Museum, Edinburgh (Fig. 53). Both chests were acquired by the 10th Duke of Hamilton, probably in 1830. Details about the items are included in the Checklist.

53. Part of the Tea Service made for the Emperor Napoleon supplied by Martin-Guillaume Biennais (1764-1843). French (Paris), 1810. Silver-gilt. Royal Scottish Museum, Edinburgh. This illustration shows the articles in the second chest. Details about the items are included in the Checklist.

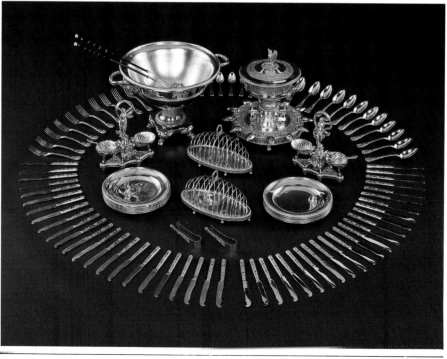

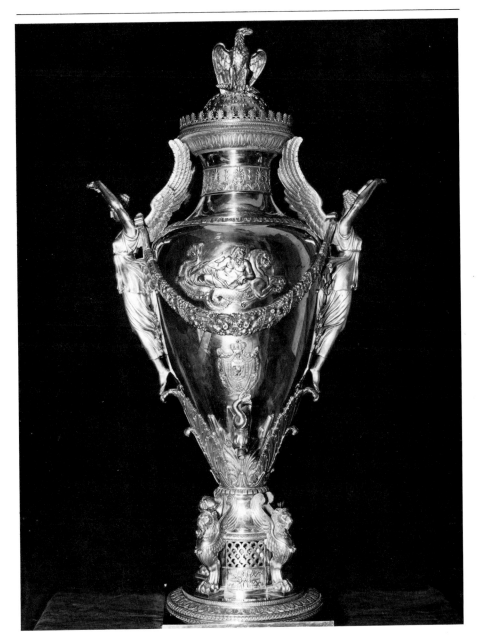

54. Tea Urn from the Service made for the Emperor Napoleon supplied by Martin-Guillaume Biennais (1764-1843). French (Paris), 1810. Silver-gilt. 80 x 45 cms. Musée du Louvre, Paris.

Napoleon's magnificent silver-gilt tea service by Martin-Guillaume Biennais, now divided between the Musée du Louvre (chest one) and the Royal Scottish Museum (chest two) (Figs. 52 to 55), was acquired by Alexander, probably in 1830. The commission to Biennais is believed to be connected with the marriage of Napoleon to his second wife, the Archduchess Marie-Louise of Austria, in April 1810, and the service had almost certainly been delivered to the Tuileries for the Emperor's use by 20 August 1810. The French royal accounts reveal that the service was purchased by "foreigners" in May 1830, possibly by agents acting for the Duke. A letter of April 1832 suggests that the service was at Hamilton Palace in the early months of that year and it is clearly referred to in an inventory of plate at the palace drawn up on 17 January 1835. It is conceivable that Percier was involved in the purchase as he had originally supplied Biennais with designs for the service. Certainly it was an excellent and apposite purchase: a major relic of Napoleon and an exceptional Empire service ideal for use in the Empire-style rooms being planned in Hamilton Palace.

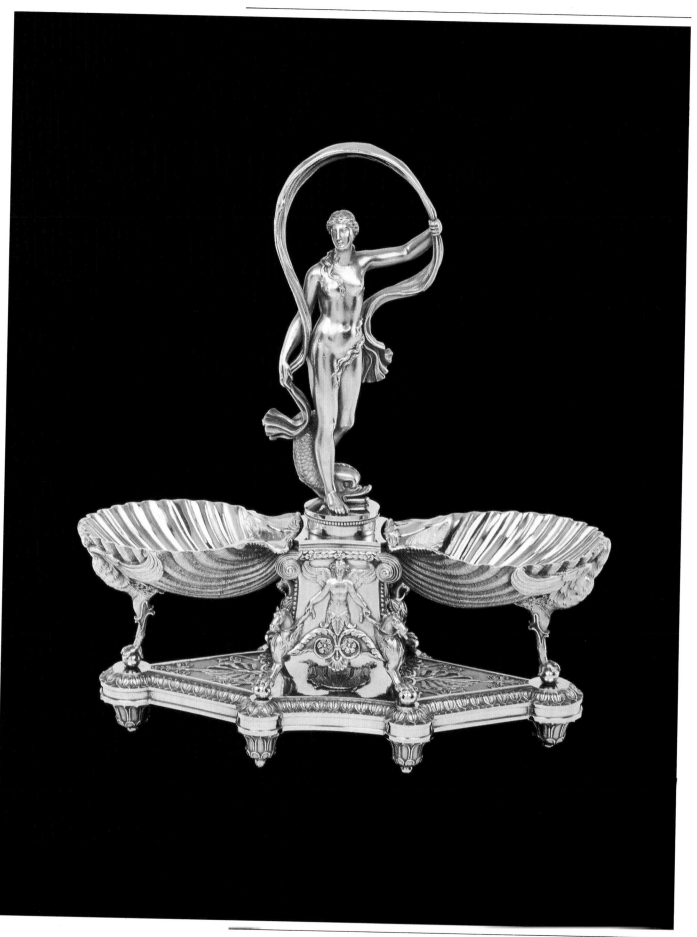

Opposite left

55. Double Salt from the Tea Service made for the Emperor Napoleon supplied by Martin-Guillaume Biennais (1764-1843). French (Paris), 1810. Silver-gilt. 24 x 21.2 cms. Royal Scottish Museum, Edinburgh.

The Duke collected a number of other works relating to Napoleon and concentrated them in his bedroom and sitting-room. The 1835 inventory records the following items in his bedroom: a print of Napoleon, a portrait of Napoleon, a painting of Napoleon on horseback at the battle of Austerlitz, and a miniature of Napoleon in bronze with gilt bronze frame which was in the first dressing-room when the inventory was undertaken but was subsequently moved into the Duke's bedroom. The same inventory lists in the sitting room a marble bust of the Princess Pauline Borghese on "Granite Column and red Porphyry Plinths", a bronze figure of Napoleon and a bronze bust of Napoleon.

The last major work relating to Napoleon which the 10th Duke acquired was a bust of the *Emperor Napoleon apotheosized* by the Danish sculptor Bertel Thorvaldsen, who worked in Rome (Fig. 56). "A List of Articles of Vèrtu and Furniture &c lately arrived at the Palace but not from Bath" reveals that the bust was brought to the palace in February 1846 and was placed in the first floor tribune, or anteroom, next to the new dining-room which contained David's portrait of Napoleon. The entry for the Thorvaldsen bust in the post-auction, souvenir catalogue of the 1882 Hamilton Palace sale notes that the work was "said to have been presented by the Princess Pauline Bonaparte", but this is almost certainly a mistake. Instead, the arrival of the bust at Hamilton Palace in February 1846 suggests that it had been acquired from the estate of Alexander Murray of Broughton, an ultra Whig and member of parliament for Kirkcudbright from 1838 to 1845, or from one of the sales after Murray's death in July 1845. Murray had commissioned a bust of Napoleon from Thorvaldsen in 1829.

56. **Napoleon Bonaparte** (1769-1821) by Bertel Thorvaldsen (1770-1844). Danish (Rome), c. 1830. Marble. 99.9 cms. Thorvaldsen Museum, Copenhagen. Believed to be the bust from the Hamilton Palace Collection.

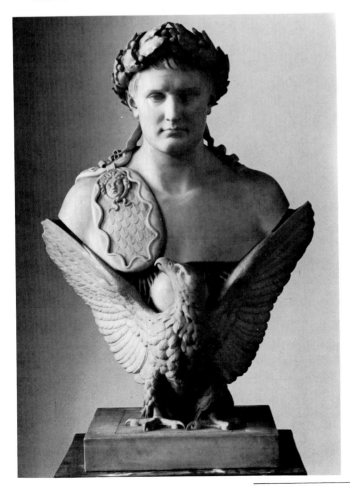
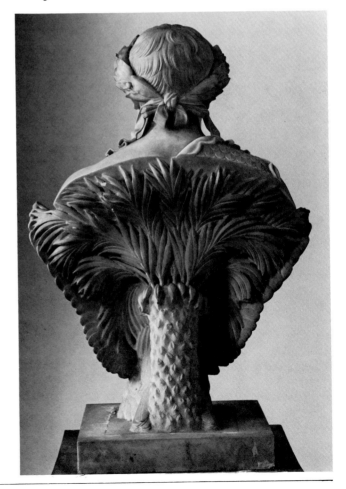

It must be evident that the 10th Duke of Hamilton was obsessed about Napoleon, but he was not content merely to own items associated with his hero. His ambition was to link the house of Hamilton and the French imperial family by marriage. Alexander achieved this on 23 February 1843, when his son William Alexander Archibald Douglas (1811-63), Marquess of Douglas and the future 11th Duke of Hamilton, married the Princess Marie Amélie of Baden, the youngest daughter of the Grand Duke of Baden and his wife Stéphanie de Beauharnais, the adopted daughter of the Emperor Napoleon. Princess Marie was third cousin to Louis Napoleon, who became President of France in 1848 and Emperor in 1852. Contemporary observers noted that the Marquess married the Princess "in obedience to the wishes of his father". The Duke's pride knew no bounds: "He arranged a triumphal procession from the borders of the county to Hamilton Palace in honour of her Serene Highness and to commemorate what he considered a national event, a series of pictures were published in all of which the Duke is himself the prominent figure—well, after all, this was very harmless vanity."

William's marriage in 1843 resulted in works relating to Napoleon III and the Empress Eugénie entering the Hamilton Palace Collection. The 11th Duke and his wife acquired, by gift or purchase, the full-length portraits of the Emperor and Empress by the German artist Franz X. Winterhalter, which hung on the marble stairs; the busts of Napoleon III and the Empress Eugénie in the tribune; the plaster bust of Napoleon III in the Princess's boudoir; the small bronze bust of Napoleon III in the Duke's dressing-room; and the picture of *Napoleon III reviewing the French Troops after the Crimean War*. The Emperor and Empress gave the Duke and Duchess a number of items, including a table which was in the library in 1876: "A Beautifully painted Circular Table of Sevres Porcelaine mounted in Metal Gilt, the Stand of Porcelaine of a rich dark blue, with gilt Metal feet. Presented by the Empress Eugenie to the Duchess of Hamilton (née Princess of Baden)."

Not all the French items in the Hamilton Palace Collection were collected by the Dukes of Hamilton. When William Beckford died in 1844, leaving his estate to his younger daughter, many of his works were brought to Hamilton Palace. The principal additions to the collection, the books and manuscripts, which included important French editions and bindings, were installed in a new library built specially for them.

Nevertheless the credit for the Hamilton Palace Collection should go to Alexander, 10th Duke of Hamilton. At his death in 1852, the *Illustrated London News* informed its readers "Hamilton Palace was made, by the taste of the nobleman whose death we are recording, one of the noblest residences in Europe; and it probably contains a greater collection of precious curiosities and rare works of art than the abode of any man under the rank of a Sovereign. In what is really solidly valuable, it far surpasses Chatsworth as it is, and Stowe as it was. But the collection at Hamilton was the work of the late duke's long lifetime; and is the result of his exquisite taste, varied learning, vast wealth, and anxious search".

After the death of the 10th Duke, his successors were less interested in sustaining the palace and the collection. The 12th Duke (d. 1895) who succeeded in 1863, at the age of eighteen, was a sportsman and gambler. He quickly found himself in financial difficulties and was obliged to dispose of assets; at first racehorses and greyhounds, and then works of art. The great Hamilton Palace sale took place in 1882 and over 17 days, 2,213 lots were

offered, realising a total of £397,562—an immense sum for those days. The auction has been described as "an event unrivalled in the annals of French furniture in the saleroom". The books and manuscripts were disposed of soon afterwards. Only 30 years after the death of "Alexander the Magnificent" his great collection was scattered. A century after he had begun to design the north block and give form to his imperial dream, contractors moved in to demolish the palace.

After the Hamilton Collection, the most important collection of French works of art in Scotland was assembled by the Buccleuchs. Unlike the Hamilton Collection, it is still largely intact and was developed by Walter Francis Montagu Douglas Scott (1806-84), 5th Duke of Buccleuch and 7th Duke of Queensberry—the man represented on the monument in front of the west door of the High Kirk of St Giles in Edinburgh. When he succeeded to the title in 1819 the 5th Duke inherited a number of houses and collections. He took possession of the Buccleuch properties, including the chief seat, Dalkeith Palace, near Edinburgh, which had been built between 1701 and 1711 by Anne, Duchess of Buccleuch (the widow of Charles II's eldest natural son, the Duke of Monmouth and Buccleuch), after designs by James Smith; and Bowhill in Selkirkshire, an early eighteenth century house which had been extended after designs by William Atkinson in the 1810s. He also became the owner of two magnificent late seventeenth century houses: Boughton in Northamptonshire, the home of the Dukes of Montagu, inherited by Elizabeth, the sole surviving child of the 3rd Duke of Montagu and the wife of the 3rd Duke of Buccleuch; and Drumlanrig Castle in Dumfriesshire, which had passed to the 3rd Duke of Buccleuch on the death of the 4th Duke of Queensberry, "Old Q", in 1810.

Many French works of art were located in these and other Buccleuch, Montagu and Queensberry houses in the early nineteenth century. Boughton contained items acquired by Ralph Montagu (d. 1709), an ambassador to France in the late 1660s and 1670s. It also contained works collected by his great-grandson, Lord Monthermer, in the mid eighteenth century. There were French works at Dalkeith Palace, including, it is believed, the two great ornamental cabinets now in the drawingroom at Drumlanrig Castle (Figs. 57 and 58). These French royal pieces are said to have been presented by Louis XIV to Charles II and given to Charles' natural son, the Duke of Monmouth (1649-85).

The 5th Duke of Buccleuch did not begin to add to these collections until the late 1820s, although pieces were bought for him, most notably in connection with the visit of George IV to Dalkeith Palace in 1822. He was only thirteen when he succeeded and did not complete his education, at Eton and St John's College, Cambridge, until 1827. On 13 August 1829, the Duke married Lady Charlotte-Anne Thynne and it is clear that this event necessitated and inspired a great many purchases. Drumlanrig Castle is said to have been "a semi-derelict castle in a ravaged landscape" and at Bowhill the building programme, which added a block onto the eighteenth century house, a library and study to the west and the dining-room to the east, created a need for furniture and fittings. At the same time, it was almost inevitable that the Duke and Duchess would want to add items to their principal residence, Dalkeith Palace, and their town house in London.

The Duke appears to have turned to the London dealer Edward Holmes Baldock (1777-1845) for many of his early French purchases. Baldock supplied French furniture and ceramics to royalty, to George IV, William IV

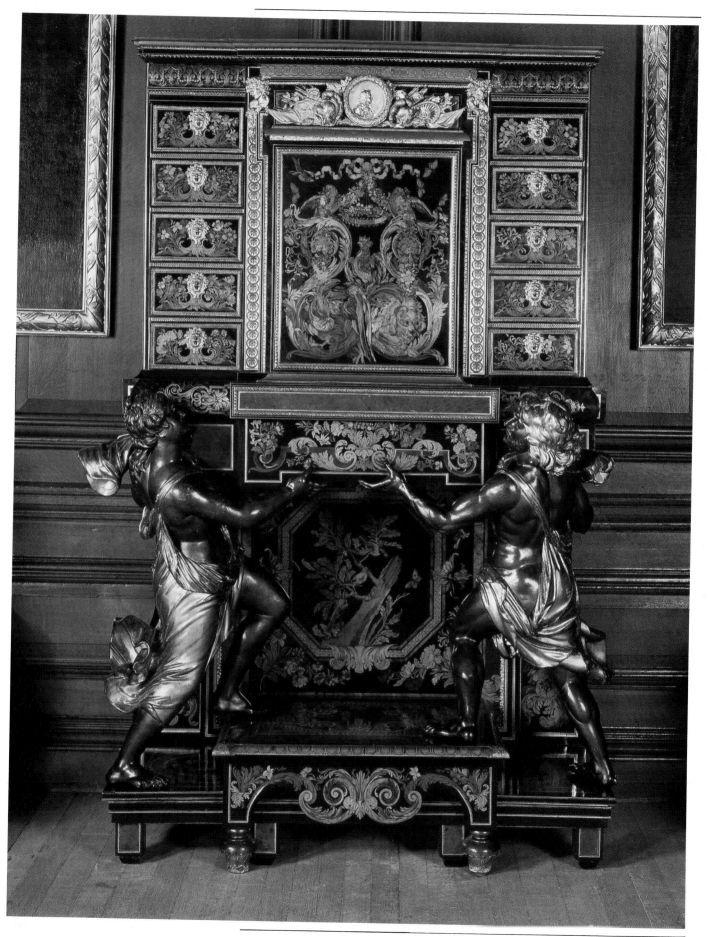

57. Cabinet attributed to André-Charles Boulle (1642-1732). French (Paris), 1670-80. Veneered with marquetry of stained and natural woods, turtleshell, pewter, brass and ivory. The figures are of wood, painted to resemble patinated and gilded bronze. Gilt bronze mounts. 225 x 139 x 67.5 cms. Collection of the Duke of Buccleuch, Drumlanrig Castle. The cabinet was probably made for Louis XIV. It is decorated with medallions which bear representations of his head in profile and his device (a radiant sun and the motto "NEC PLVRIBVS IMPAR": "Not unequal to many"). The latter is dated 1664. The marquetry decoration of the door, consisting of a cock with a floral circlet suspended above it standing above an eagle and a lion, probably alludes to France's victory over the Empire (the eagle) and the Low Countries or Holland (the lion, *Leo belgicus*). Such symbolism could have been used in connection with the Wars of Devolution (1667-8) or, perhaps more convincingly, with the Dutch Wars (1672-9).

58. Cabinet attributed to André-Charles Boulle (1642-1732). French (Paris), c. 1670. Veneered with natural and stained woods, turtleshell, pewter, brass and copper. The figures are of wood and gilt. Gilt bronze mounts. 192 x 114 x 54 cms. Collection of the Duke of Buccleuch, Drumlanrig Castle. The two caryatid figures represent Summer (left) and Autumn (right). The medallion bears a representation of Louis XIV.

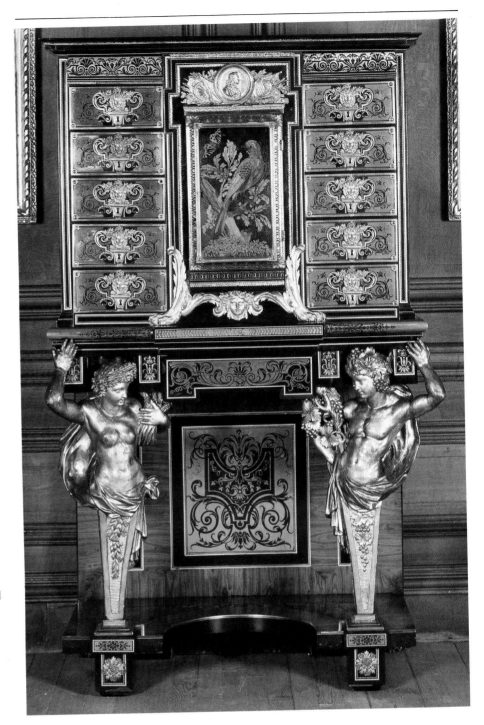

and Queen Victoria, and to the Duke of Northumberland and other members of the aristocracy. Baldock did not simply supply furniture and ceramics but met all the diverse requirements involved in the fitting-out of an establishment, including arranging to have pieces made, repaired, altered or adapted. Furniture, clocks, precious and base metalwork and stationery were supplied by Baldock to the 5th Duke, along with designs and working drawings for furniture.

One of the Duke's most important pieces was bought from Baldock: the cylinder-top desk (Fig. 59) reputedly made for Pierre-Augustin Caron de Beaumarchais (1732-99). This was purchased in 1832 for £600 and later described by Baldock's son as a bargain. Some of the Boulle furniture in the

Buccleuch Collection came from Baldock, who specialised in these items. Among the Duke's purchases of Boulle furniture are the two pairs of cabinets by Étienne Levasseur at Boughton. These are incised with Baldock's initials "EHB" and were probably supplied in 1830. Baldock also supplied the Duke with furniture mounted with Sèvres plaques from the workshop of Martin Carlin (*maître ébéniste* 1766-85), including the *bonheur du jour* with plaques dated 1768 at Boughton.

Baldock also sold some nineteenth century furniture in Louis XV-style to the Duke. He was responsible for providing the Louis XV revival lean-to secretaire veneered with satinwood, inlaid with flowers and the cypher of the Duchess, and fitted with Sèvres porcelain plaques now in the boudoir at Bowhill (Fig. 60). This bears the mark "EHB" and was apparently supplied in 1841. Baldock probably supplied the similar *bureau de dame* now in the Duchess's sitting-room at Drumlanrig, although this does not bear his mark. He certainly supplied the Louis XV-style table with marquetry inlay, including depictions of dwarfs after designs by Jacques Callot (published in 1616). This is in the morning-room at Bowhill, and is branded "EHB". It may have been included with the furniture sold to the Duke in 1840-41. Some contemporary furniture was also supplied by Baldock, including the English

59. Cylinder-top Desk reputedly made for Pierre-Augustin Caron de Beaumarchais (1732-99). French (Paris), 1777-81. Tulipwood, purplewood, mahogany, sycamore, holly, boxwood and other woods. Gilt bronze mounts. 133.5 x 210.8 x 113.7 cms. Ex-Buccleuch Collection. The National Trust, Waddesdon Manor. The mounts are by the bronze manufacturer Danchot, about whom little is known.

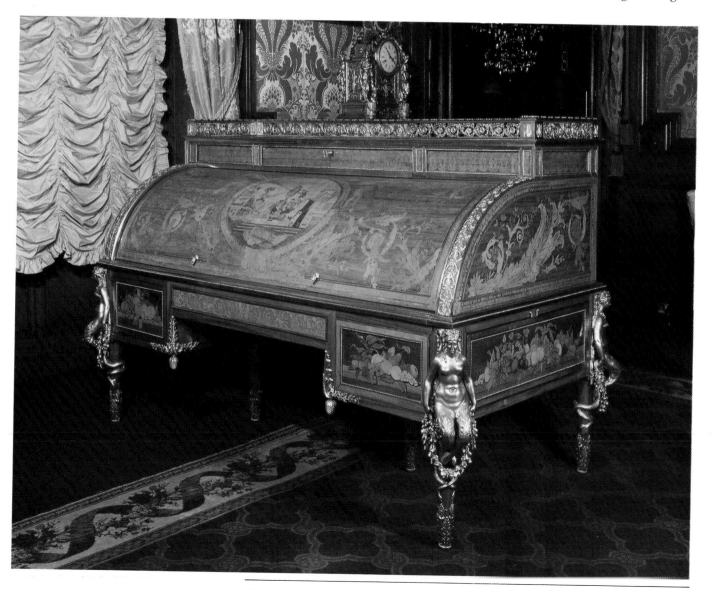

60. Louis XV-style *Bureau de Dame* supplied to the 5th Duke of Buccleuch by Edward Holmes Baldock (1777-1845). Either imported from France or made in Baldcock's workshop, c. 1841. Satinwood veneer inlaid with marquetry flowers and the cypher of the Duchess and fitted with Sèvres porcelain plaques. 95 x 124.5 x 61 cms. Collection of the Duke of Buccleuch, Bowhill.

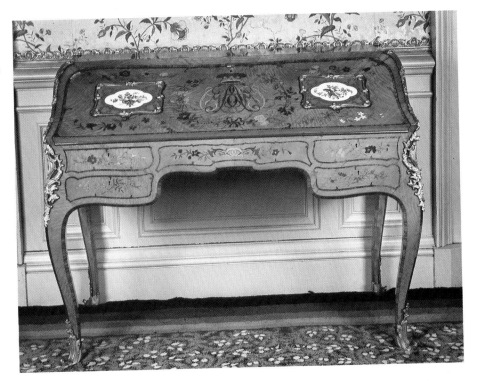

octagonal inlaid table now at Temple Newsam, Leeds, which the Duke bought in 1840. After the retirement of Baldock the Duke continued to buy French works of art. A remarkable administrator and improver, he enlarged Bowhill, rebuilt Montagu House and greatly enriched the Buccleuch Collection, in particular by assembling the celebrated group of miniatures.

A few items are no longer in the Buccleuch Collection, most notably the Beaumarchais desk and the jewel casket by Carlin, now in the Wrightsman Collection in the United States. The present room arrangements at Drumlanrig Castle and Bowhill are not the same as those at the time of the 5th Duke as many of the principal pieces have come from Dalkeith Palace and Montagu House. Both Drumlanrig and Bowhill contain many significant items of French furniture and other works of art, and Drumlanrig has the distinction of containing the two extremely important Louis XIV cabinets.

A smaller scale Scottish collection of French furniture was assembled by the Dukes of Gordon at their castle near Fochabers in north-east Scotland. Little is known about what was in the castle, nor how the items were acquired. Some of the French furniture owned by the Dukes of Gordon was bequeathed by Elizabeth, Duchess of Gordon (1794-1864), to her kinsman William Brodie, and is at Brodie Castle, near Forres. Among the pieces bequeathed by the Duchess is the bed table with kingswood veneer and detachable upper section, of about 1770. French items from other sources appear in an inventory of 1852 (for example, the *bureau plat* by Jean-Baptiste Hédouin. of about 1765).

The Dukes of Sutherland acquired French furniture, although it was intended primarily for their English properties. Some pieces were brought north to Dunrobin Castle, near Golspie, Sutherland. One item no longer at Dunrobin is the magnificent *bureau plat* with dolphin corner mounts which was acquired in 1838 by the 2nd Duke of Sutherland for £1,000. A large "w" reveals that this piece was at Versailles (now in the Stavros Niarchos Collection).

Other Scottish peers collected French furniture and works of art at this time. One of the most interesting collections was formed by the Earls of Mansfield at Scone Palace, near Perth. This contains French furniture and other items possibly purchased by the judge and Lord Chief Justice William Murray (1705-93), the 1st Earl of Mansfield. Murray stayed with his nephew in Paris in 1774 and had other opportunities to purchase French items. The nucleus of the collection however, is likely to have been acquired by David, 7th Viscount Stormont (1727-96), nephew of William Murray, ambassador to France from 1772 to 1778 and an influential Whig. Many more French pieces came into the Mansfield Collection in the nineteenth century and a number may have been acquired to furnish Scone after it was rebuilt by the 3rd Earl.

Of all the works of art at Scone, the most remarkable is the little table by Jean-Henri Riesener (Fig. 61). The tradition that this was presented to Queen Marie-Antoinette to the 7th Viscount during his period as ambassador is incorrect. The underside of the table is marked with the number "3077". The relevant entry in the *Journal du Garde-Meuble de la Couronne*, the

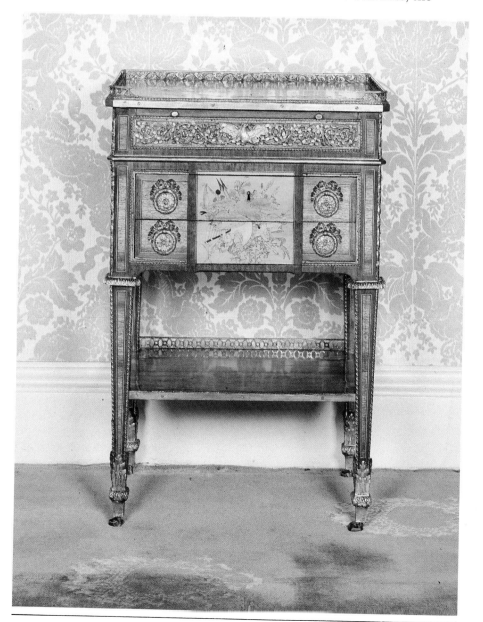

61 Work and Writing Table by Jean-Henri Riesener (1734-1806). French (Paris) c. 1781. Purplewood, mahogany, satinwood, boxwood, ebony, sycamore and other woods. Gilt bronze mounts. 77 x 50.5 x 38.5 cms. Collection of the Earl of Mansfield, Scone Palace.

register of furniture delivered to the royal household which was begun by Louis XIV and Colbert in 1666, establishes that the piece was not supplied until April 1781—three years after the 7th Viscount had returned to Britain. The *Journal* reveals that the Scone piece was one of a number of matching items supplied for the new rooms of Marie-Antoinette at the Château of Marly:

> "A matching work table with three locking drawers, one furnished with an inkwell, powder-box and sponge-box of silver-plated copper, having a pull-out slide in the front covered with black velvet bordered with gold braid, and a second tray below with a balustrade surround, the upper part like that of the writing table with similar ornaments which an eagle is holding in its beak, the whole in chased bronze and gilded with ormoulu 19 inches long by 14 inches wide and 28 inches high."

The Mansfield Collection also includes a set of twelve armchairs by Pierre Bara, who worked closely with the *tapissier* Planqué and the needlework panels on the chairs may be his. Other items at Scone include the unsigned Topino-style mechanical table with marquetry decoration which may depict Francis I of France, and the pair of commodes with floral marquetry decoration by the French *ébéniste* Pierre Langlois, who worked in London. The commodes, which probably date from the 1760s, were designed in a sophisticated manner so that the pattern on one is almost a mirror image of the pattern on the other.

The Marquesses of Lansdowne assembled another interesting collection containing many items of French furniture. The 2nd Marquess of Lansdowne (1765-1809) had French republican sympathies, and made a number of purchases including the painting by Andrea Appiani of *Napoleon as the Victor of Lodi*, now in the collection of the Earl of Rosebery at Dalmeny House (Fig. 62). Further items were acquired by the 4th Marquess and his parents-in-law, Comte de Flahaut-de-la-Billardie and Margaret, Baroness Nairne and Keith. The Comte was the natural son of Talleyrand, aide-de-camp to Napoleon and ambassador to the Court of St James. The Comte and his wife lived in Paris, where Margaret established a Salon and the Comte became a close friend to the young Duc d'Orléans, the heir to the throne.

Dalmeny House, near Edinburgh, the ancestral home of the Earls of Rosebery, houses the cream of a collection of French works of art originally assembled by Baron Meyer Amschel de Rothschild to furnish his new house, Mentmore Towers, in Buckinghamshire. These splendid pieces of French furniture and other items of applied art were acquired by Baron de Rothschild in the middle of the nineteenth century. The collection was inherited by his daughter Hannah who married the 5th Earl of Rosebery (1847-1929) in 1878.

Dalmeny provides an impressive sequence of examples of French furniture from the early eighteenth to the early nineteenth century including some extremely important pieces. These are, most notably, the *bureau en pent* or lean-to desk, c. 1750, by Bernard van Risenburgh II (Fig. 63); the *bureau plat* with gilt bronze dolphin mounts, c. 1760, attributed to Jean-François Oeben or Gilles Joubert; the drop-front secretaire by Oeben, which was probably finished by Jean-Henri Riesener (between 1763 and 1768 Riesener worked for Oeben's widow and was using Oeben's stamp); and the great mahogany cylinder bureau, c. 1780, by Jean-François Leleu which is reputed to have been used by Jacques Necker, the finance minister of Louis XVI. All these

62. **Napoleon as the Victor of the Battle of Lodi** by Andrea Appiani (1754-1817). Italian (Milan), 1796. Oil on canvas. 97.5 x 73.5 cms. Collection of the Earl of Rosebery, Dalmeny House.

63 The Drawingroom at Dalmeny House, near Edinburgh. The illustration shows (from left to right): the *Bureau Plat*, c. 1760, attributed to Jean-François Oeben (c. 1720-63) or Gilles Joubert (1689-1775), 79 x 151 x 82 cms; the Drop-front Secretaire, mid 1760s, by Jean-François Oeben (c. 1720-63) and Jean-Henri Riesener (1734-1806), 148.5 x 116.8 x 44.2 cms; and the Lean-to Desk, c. 1750, by Bernard van Risenburgh II (d. 1765/6), 103.5 x 143 x 71 cms.

works are in the drawingroom at Dalmeny. The same room is further enhanced by five mid eighteenth century Beauvais tapestries from a suite of six of *La Tenture Chinoise* after sketches by François Boucher; a large Savonnerie carpet from a series made for the French royal palaces; and a small late seventeenth century Savonnerie rug with the entwined initials "MTL" beneath an enclosed crown, referring to Louis XIV and his wife, Marie Theresa of Spain. Dalmeny has an impressive range of French eighteenth century furniture, and in addition a variety of interesting Sèvres ceramics, including vases of porcelain flowers and a small moulded animal said to represent Marie-Antoinette's favourite lap-dog.

Although remembered chiefly as a Liberal Foreign Secretary and Prime Minister, the 5th Earl of Rosebery was also a keen historian and a prolific author. His books include *Pitt* (1891), *Sir Robert Peel* (1895), *Oliver Cromwell* (1900) and *Chatham: His Early Life and Career* (1920). The 5th Earl was particularly interested in Napoleon and his book, *Napoleon: The Last Phase* (1900), shows a balanced appreciation of his subject and is an excellent record of the political and moral outlook of a patrician Whig in the late nineteenth century.

The 5th Earl's interest in history was reflected in his purchases of paintings and other items. He collected portraits of important individuals in Scottish history, including Jacobites, eighteenth century British politicians and men of letters, and portraits of Napoleon and his family. His most

important acquisition was the portrait of Napoleon by Jacques-Louis David from the Hamilton Palace Collection (Fig. 49) which he purchased after the Hamilton Palace sale in 1882. The Earl owned several works illustrating the Republican period of Napoleon's career: a standard marble bust of Napoleon as First Consul; the painting by Appiani of Napoleon as the republican victor of the Battle of Lodi, formerly belonging to the 2nd Marquess of Lansdowne (Fig. 62); and a bronze statuette of Napoleon as First Consul by François-Jacques Boileau. Napoleon as Emperor was represented by Appiani's painting, *Napoleon in Coronation Robes as King of Italy*; Jacques-Louis David's pen and wash drawing of *The Coronation of the Empress Josephine*, a preparatory study for the famous painting in the Louvre; and the David portrait of *Napoleon in his Study*. The years after Waterloo were illustrated by Sir Charles Eastlake's *Napoleon on board "Bellerophon"* and Baron Steuben's *The Death Bed of Napoleon*. The Earl also had a collection of personalia, including the state chair used by Napoleon before he became Emperor in 1804 and the shaving stand from Napoleon's dressing-room at Malmaison. He was sufficiently interested to acquire portraits of the imperial family. There are a set of four paintings by Robert Lefèvre of Madame Mère (Napoleon's mother), Joseph Bonaparte, King of Spain, the Empress Josephine and the Empress Marie-Louise. Other works include a chalk drawing of the *Empress Josephine* by Dominique Vivant Denon, the artist who accompanied Napoleon to Egypt; the *Portraits of Louis Napoleon* by Girodet and Anne-Louis Girodet-Trioson; and the *Portrait of Lucien Bonaparte* by Jean-Baptiste Wicar.

The Floors Castle collection of French furniture, tapestries and other works of art at Kelso, Roxburghshire, is largely the result of the marriage in 1903 of the 8th Duke of Roxburghe to Mary Goelet, the heiress of a rich New Yorker. This was one of many marriages between British peers and wealthy American women in the late nineteenth and twentieth centuries. The significant role that these Americans played as interior decorators and

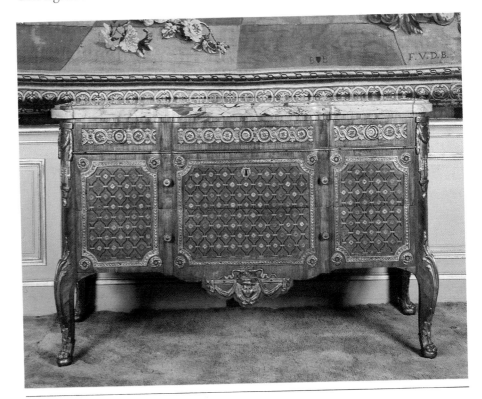

64. Commode by Gilles Joubert (1689-1775). French (Paris), 1773. Tulipwood, kingwood, holly and other woods. Gilt bronze mounts. Sarrancolin marble top. 92.5 x 146.5 x 65 cms. Collection of the Duke of Roxburghe, Floors Castle.

furnishers of great houses in Britain is not always fully appreciated. May, Duchess of Roxburghe, for example, brought French furniture and tapestries from her family home on Long Island to Floors Castle and she had the principal rooms remodelled and decorated to her taste.

There are several pieces with French royal associations at Floors. The commode in the drawingroom (Fig. 64) was supplied by the royal *ébéniste* Gilles Joubert in 1773, for the apartment of the newly married Comte and Comtesse d'Artois at Versailles. Joubert was royal *ébéniste* from 1763 to 1774. During this decade alone he delivered 2,200 items of furniture to the royal household including no less than 544 commodes. He did not, of course, make all these items himself or in his own workshop. As was common practice at the time, many of the orders were sent out to craftsmen in other workshops who were required to follow Joubert's designs. The commode at Floors is an excellent example of a type of item which was produced in large numbers under Joubert's name and illustrates the design of marquetry studded with gilt bronze rosettes which he favoured in the late 1760s and early 1770s.

A TOUCH OF CLASS

Interest in French works of art and in Napoleon was not confined to the richest, aristocratic collectors of Scotland. The less wealthy aristocracy also assembled small-scale collections and after 1850 they were joined by the prosperous middle classes, who began to develop a taste for French art.

A fascination with Napoleon was an obvious feature of the first half of the nineteenth century. Napoleonic material was enthusiastically acquired by Whigs and those with strong republican and Bonapartist sympathies. One such individual was Charles, 8th Baron Kinnaird (1770-1826). In 1815 he purchased three paintings of the Emperor from the French painter Horace Vernet, who was himself a fervent admirer of Napoleon.

However not all Scots who were interested in Napoleon were Whigs or Jacobins. Sir Walter Scott, for example, was a patriotic Tory and ardent royalist, who had married a French *émigré*, Charlotte Margaret Charpentier, in 1797. Scott derived immense enjoyment and satisfaction from his activities as a volunteer during the Revolutionary and Napoleonic Wars and followed the progress of the campaigns on maps, marking out the routes the armies took. As soon as hostilities ceased Scott travelled to France to inspect Paris and the battlefield of Waterloo. He already had a sizeable collection of "old swords, bows, targets and lances". One of his reasons for going abroad appears to have been the desire to obtain examples of arms and armour from the greatest age of warfare the world had yet seen to place alongside items which "medieval" knights had worn. Scott was able to collect some items from the battlefield of Waterloo and his guide, Major Pryse Gordon, secured additional pieces for him. The Major's own collection of spoils was subsequently sent to Scott by his son, George Huntly Gordon, after the Major's death and some objects were given to Scott by friends and admirers. He assembled an impressive collection of Napoleonic relics at his country house, Abbotsford, near Melrose, including cuirasses, swords, pistols, standards and accessories used by French and Allied soldiers and articles believed to have been owned by the Emperor himself. Amongst the latter were a pair of pistols by Boutet, said to have been taken from the Emperor's carriage after the Battle of Waterloo; a pen case and blotting book decorated with Napoleon's initials; and two clasps in the shape of bees (a Napoleonic motif).

In 1825 Scott embarked upon a major life of Napoleon which was eventually published in nine volumes under the title *A Life of Napoleon*

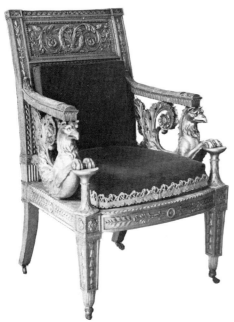

65. Armchair with arm-rests supported by acanthus-tailed griffins, part of a suite associated with Napoleon's step-uncle Cardinal Fesch (1763-1839). Italian, c. 1800. Gilt wood. 110 x 75.5 x 58 cms. Dunimarle Museum, Culross, Fife. The suite, which is now widely dispersed, includes armchairs, chairs and three- and four-back settees. The design is related to a drawing by the Santi brothers in the Cooper-Hewitt Museum, New York, and to their published work.

Buonaparte, Emperor of the French with a preliminary view of the French Revolution, by the Author of Waverley (1827). Scott's son-in-law, J. G. Lockhart, calculated that the *Life* took Scott about twelve months to write and equalled five of the Waverley novels, an extraordinary achievement given the financial and personal tragedies experienced by Scott at this time. The *Life* incorporates a great deal of original research and pre-dates the official encouragement of the cult of Napoleon by the French ruler Louis Philippe. The *Life of Napoleon* was favourably received and Scott was paid the enormous sum of £18,000 by his publisher.

Another interesting group of items relating to Napoleon is at Culzean Castle, Maybole, Ayrshire, the seat of the Kennedys, Earls of Cassillis and Marquesses of Ailsa. The principal work, a handsome full-length portrait of the Emperor by Robert Lefèvre, signed and dated 1813, is one of three dozen versions of *Napoleon as Emperor*, the first being painted in 1806. Three marble busts of Napoleon, the Empress Marie-Louise and Napoleon's sister, Elisa, appear to have come from the sculpture workshops at Carrara, which were developed by Elisa who was Princess of Piombino and Duchess of Lucca.

Magnificent gilt-wood furniture from a suite owned by Napoleon's step-uncle, Cardinal Fesch (1763-1839), Archbishop of Paris and of Lyons and a great collector, was brought to Scotland in the first half of the nineteenth century (Fig. 65). The size of the suite has still to be established, but carved Roman numerals on the undersides suggest that it was made up of dozens of pieces. The florid character of the arm supports suggest that the furniture is Italian; this supposition would seem to be corroborated by the absence of French makers' marks. The suite was probably dispersed in a sale of items belonging to the Cardinal held in Paris in 1815 or 1816.

At least three groups of pieces from this suite came to Scotland. The group at Dunimarle Museum, Culross, Fife, is said to have been acquired by Sir James Erskine of Torrie who served with Wellington in Paris after the fall of Napoleon. A second group was at Abercairny Abbey in Perthshire and is reputed to have been bought in Paris in 1815 by Colonel James Moray or his brother William; eight armchairs and six chairs from Abercairny are now at the Royal Pavilion, Brighton. The third group was owned by the Murray family and was in the collection of the Duke of Atholl. These pieces are now at Beningbrough Hall, a National Trust property in Yorkshire. Dunimarle Museum also possesses six Empire-style X-shaped stools which bear the mark of the restored French royal family and the stamp for items in the Tuileries Palace.

Several important Old Master paintings were acquired from French collections in the first half of the nineteenth century but, in general, Scottish interest in French paintings was limited during this period. The 7th Earl of Elgin, detained in France from 1803-6, purchased a series of paintings illustrating the history of the Medici family. These had been carried out in Florence around 1627 and had hung in the *Cabinet Doré* of Marie de' Medici, the widow of Henri IV and Regent of France, in the Luxembourg Palace, Paris.

Important paintings from the Orléans Collection can be seen in the National Gallery of Scotland, Edinburgh, where they are either on loan from the Duke of Sutherland or have been acquired for the nation. This fine collection of Old Masters was bequeathed in 1803 to George Granville Leveson-Gower, who became the 1st Duke of Sutherland in 1833.

A fascinating record of members of the French royal family, great ladies, statesmen, soldiers, churchmen and musicians, during the reigns of Louis XV and Louis XVI, was painted by Louis Carrogis de Carmontelle. This little-known collection of French works was acquired in 1831 by the Gordon Duff family of Banff in north-east Scotland. In 1877 most of the 530 wash drawings were sold by Major Lachlan Gordon Duff of Drummuir to Colnaghi's from whom they were bought by Henri d'Orléans, Duc d'Aumale, for the palatial Musée Condé at Chantilly.

In the mid nineteenth century paintings by notable French artists could be seen on the walls of houses in Edinburgh's New Town. Lord Murray had paintings attributed to Watteau, Pater and Greuze in his drawingroom and he also owned a portrait of Madame de Pompadour in a blue silk dress attributed to Boucher or his studio. Another painting of Madame de Pompadour in a white silk dress, seated in a garden, and attributed to Boucher, was owned by James Gibson Craig.

Little contemporary French painting came into Scotland at this time. One exception is the portrait of the French politician and historian Guizot by Delaroche at Haddo House, near Aberdeen, which was presented to the 4th Earl of Aberdeen by Guizot himself in 1847 as an acknowledgement of their amicable political relationship.

Increased manufacturing and commercial wealth in Scotland from the mid nineteenth century enabled the middle classes to indulge a growing interest in French contemporary painting and works of art. The Dundee jute magnate, Joseph Grimond of J. & A. D. Grimond, who owned the huge Bowbridge factory, invited Charles Fréchou to decorate the interior of his mansion, Carbet Castle in Broughty Ferry. Charles Fréchou (d. 1887) painted the vestibule ceiling in the Hôtel de Ville in Paris and is believed to have carried out work in the Paris Opera House. Grimond had a keen interest in the decorative arts; he pioneered highly decorative jute Brussels carpets and was involved in both the designs and the selection of colours. He exhibited examples of his carpets in Paris and perhaps the commission to Fréchou is linked with these visits. The decoration in the Second Empire style of the dining-room and drawingroom of Carbet Castle around 1871 was Fréchou's major project in Scotland. A large part of Carbet Castle was demolished in 1922 and the rest of the house has now been razed. Before the final demolition began it was discovered that the dining-room ceiling and part of the drawingroom ceiling were still intact, although the latter was much decayed. The dining-room ceiling was removed in sections (Fig. 66), along with one panel from the drawingroom ceiling.

Fréchou was probably also responsible for the drawingroom ceiling in Salisbury Green House, Edinburgh (now part of the University of Edinburgh), owned at that time by William Nelson of the well-known printing and publishing house.

Increased interest was shown in French art by Scottish critics, such as R. A. M. Stevenson and D. S. MacColl. Most of the artists who became known as the "Glasgow Boys" trained under French painters: Lavery, Christie and Kennedy under Bouguereau; Roche and Millie Dow under Gérôme; Dow and R. A. M. Stevenson under Carolus Duran; Roche, Park, Corsan Morton and Harrington Mann under Boulanger and Léfebevre; and Whitelaw Hamilton and Crawhall under Aimé Morot. French art was shown in the International Exhibitions in Edinburgh in 1886 and Glasgow in 1888.

Two Scottish dealers who handled French paintings established galleries in

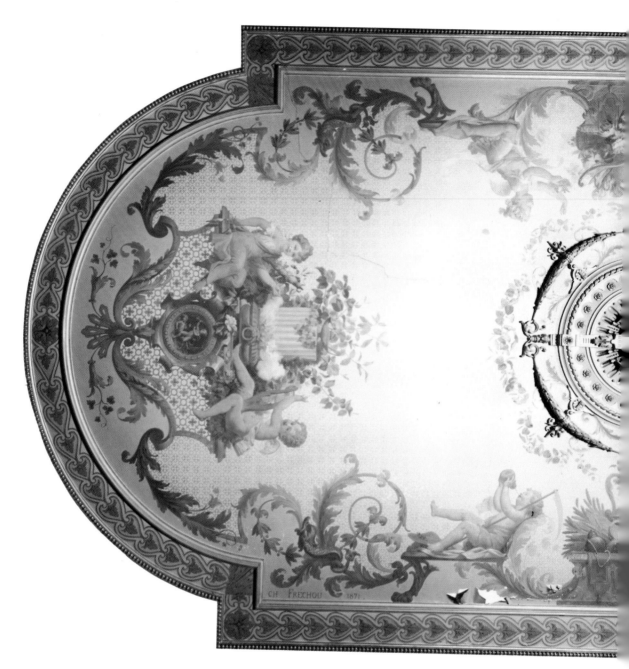

66. Photomontage of the painted ceiling formerly in the ground-floor diningroom of Carbet Castle, Broughty Ferry, Dundee (now removed and awaiting conservation). Commissioned by Joseph Grimond and carried out by the French decorative painter Charles Fréchou (d. 1887), about 1871. The painted ceiling is now in the possession of Dundee Civic Trust.

Glasgow, where they catered particularly for successful businessmen who wished to acquire paintings for their large houses. Craibe Angus opened his gallery in 1874 and Alexander Reid his *Société des Beaux Arts* in 1889. Reid is the more important of the two. Before opening his gallery Reid had worked briefly in the Paris firm of Boussodon and Valadon (formerly Goupil), where he had met Vincent van Gogh's brother, Theo, and through him had been introduced to principal members of the Paris avant-garde. Reid sold some important works, but generally they passed through his hands many years after they had been painted and had usually been overtaken by more modern styles. The artists included Rousseau, Diaz, Daubigny, Millet, Corot, Monet, Picasso, Sisley and Degas. The preference was for the safe and the inoffensive and little attempt was made to promote more "modern" artists such as van Gogh and Matisse.

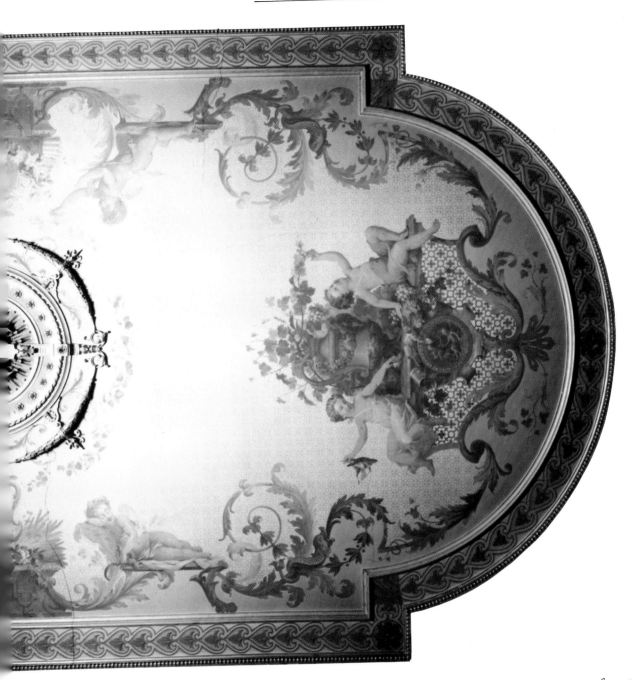

A similar pattern can be observed in the acquisition of contemporary sculpture in Scotland, namely that the aristocracy commissioned works in the first half of the nineteenth century and the middle classes adopted the role of patron from the 1850s. In 1837 the 2nd Duke of Sutherland and his wife arranged for their eldest son, the Marquess of Stafford, to be sculpted in full Highland dress by Jean-Jacques Feuchère. The bronze (Fig. 67) was exhibited in the Paris Salon in 1838 and was then installed at Stafford House in London. It now occupies a central position in the entrance hall of Dunrobin Castle.

The Sutherlands were also involved with the Staffordshire pottery industry, through their inheritance of the Bridgewater estates and their decoration of Trentham Hall, near Stoke. The French sculptor Carrier-Belleuse arrived at Mintons, the ceramics factory, in 1850 and in 1852 he

67. **The Marquess of Stafford and future 3rd Duke of Sutherland in Highland costume** by Jean-Jacques Feuchère (1807-52). French (Paris), 1837. Bronze. 134 cms. Cast by the Vittoz foundry. Exhibited at the Paris Salon in 1838. Collection of the Countess of Sutherland, Dunrobin Castle.

68. **Lords Ronald and Albert Leveson-Gower** by Albert-Ernest Carrier-Belleuse (1824-87). Bronze. 43 cms. Collection of the Countess of Sutherland, Dunrobin Castle.

Opposite
69. Ornamental Fountain in West Princes Street Gardens, Edinburgh, by A. Durenne. French (Sommevoire, Haute-Marne), 1860-2? Cast-iron. The figures are said to have been designed and modelled by Klagmann. This fountain or a fountain of the same design was shown in the London International Exhibition of 1862, in the Horticultural Gardens. It was donated to the City of Edinburgh by Daniel Ross and shipped from Dunkirk to Leith in 122 pieces in 1869. Four female figures on seahorses were placed in the lower basin of the fountain shown in the International Exhibition of 1862, but were omitted from the Ross fountain, apparently to reduce the cost.

modelled statuettes of Lords Albert and Ronald Leveson-Gower, the third and fourth sons of the 2nd Duke of Sutherland. Bronze and Parian porcelain statuettes were subsequently produced (Fig. 68). In 1854 the same sculptor undertook a statuette and a bust of the boys' sister, Constance. When in later years, Lord Ronald Gower decided to become an artist, he worked in Carrier-Belleuse's studio in Paris. Gower's best known work is the Shakespeare monument at Stratford-upon-Avon; he is immortalized as Lord Henry Wotton in Oscar Wilde's *The Portrait of Dorian Gray*.

The cast-iron fountain in West Princes Street Gardens in Edinburgh (Fig. 69) is the first major example of middle class patronage of French sculpture in Scotland. In 1864 an anonymous offer to provide Edinburgh with an ornamental fountain was made to the town council. It transpired that the donor was Mr. Daniel Ross, gunmaker, who was reported to have "acquired an extensive knowledge of natural history, and [to have] brought together in his museum a large number of beautiful mineralogical and geological specimens, and many articles of great artistic value". The fountain which Ross proposed to donate to the town was manufactured by A. Durenne at his famous Sommevoire works in the Haute-Marne. This fountain or a fountain of the same design had been exhibited at the Universal Exhibition in London in 1862, where it "obtained universal admiration". After some fierce and unedifying wrangling over the site the council agreed to erect the fountain in the valley of West Princes Street Gardens. Unfortunately, this "gift of a most liberal citizen" (said to have cost Ross over £2,000) was still not finished when Ross died in January

1871. The fountain, which includes female nude figures, was praised by some people and damned by others: *The Scotsman* referred to it as a "magnificent fountain" and "one of the most elaborate and ornate structures of its class in Europe", while Dean Ramsay, an eminent churchman, castigated it as "Grossly indecent and disgusting; insulting and offensive to the moral feelings of the community and disgraceful to the City".

The voluptuous character of French sculpture is further reflected in the marble statue of *Arthur St Clair Anstruther Thomson* by Aimé Jules Dalou (Fig. 70), which is associated with a visit the sculptor paid to Scotland. Dalou was a staunch republican with decidedly left-wing sympathies who had become involved with the Paris Commune and had been forced to flee from France when the uprising was suppressed. He came to England in July 1871 and his friend Alphonse Legros, then Professor at the Slade School of Art, introduced him to possible patrons. Dalou's close friend and biographer Maurice Dreyfous records that Dalou visited Scotland in 1877 and the marble statue of Thomson, dated 1877, appears to be associated with this visit. The boy was the youngest son of John Anstruther Thomson and Maria Hamilton Gray of Charleton in Fife. The sculpture seems to have been commissioned as a companion piece to a marble statue of the boy's mother as *Psyche*, which was carved by the Scottish sculptor Lawrence MacDonald in 1839. Dalou returned to France in April 1880. During his years in exile he had worked almost entirely in terracotta and the sculpture of Thomson is one of only three works in marble known from this period. The others are *Hush-a-Bye* (a mother seated in a rocking-chair nursing her baby), dated 1875, which was ordered by the Duke of Westminster and exhibited at the Royal Academy in 1876, and *Charity* (a female figure with small children), which was commissioned by the Broad Street Ward, London, in 1877; unfortunately *Charity* was ruined by the weather and had to be replaced by a bronze cast in the 1890s.

Dalou and the more famous Auguste Rodin were contemporaries and friends, and Rodin's work also appealed to a number of Scots. Robert Louis Stevenson, for example, who defended Rodin against the charge of excessive realism, owned a cast of *Le Printemps*, given to him by the sculptor. Sir William Burrell was sufficiently impressed to build up a collection of 14 bronzes by Rodin.

Other collections were formed in this period by the affluent middle classes. The Scottish painter Sir William Quiller Orchardson (1835-1910) made frequent visits to France and assembled a collection of eighteenth century French furniture which he used as props in his paintings. He too became interested in Napoleon and painted a number of works depicting the Emperor. Another private collector was Frederick B. Sharp (1862-1932), the youngest son of the Dundee jute manufacturer Frederick Sharp, who helped make Dundee into a major industrial city. Frederick Sharp had a reputation as one of the keenest and most knowledgeable financiers in Scotland. In 1904 he purchased Wemyss Hall in Cupar, Fife, a seventeenth century country house built to designs by Sir William Bruce. Sharp commissioned the Scottish architect Robert Lorimer to rebuild the house and then renamed it Hill of Tarvit. The drawingroom was decorated in "*Louis Quinze*" style for Sharp's collection of French furniture, consisting of items of good quality rather than of major importance. The two most noteworthy items are the *bureau plat* by Jean-Charles Saunier, with ormolu mounts stamped with the crowned "c" punch used between 1745 and 1749, and the commode by Adam

Weisweiler. The latter is in the simple post-1785 Etruscan style, which was partly inspired by Neo-classicism and partly by attempts to reduce expenditure. Veneers of mahogany are used rather than the much more expensive panels of elaborate marquetry mosaics. Both pieces are in the drawingroom at Hill of Tarvit, now the property of the National Trust for Scotland. Hill of Tarvit provides a classic example of a manufacturer and businessman, a *nouveau riche*, choosing to live in an old-style country house furnished with beautiful old items suggesting long tenure, stability, good taste and interesting family associations.

A very fine collection of eighteenth century French and French-inspired Swiss snuffboxes (Fig. 71) was assembled by the advocate James Cathcart White (1853-1943) and bequeathed to the Royal Scottish Museum. White's snuffbox collection, which includes boxes by such distinguished French makers as Charles Le Bastier, Mathieu Coiny and Jean-Marie Tiron, ranges from the early 1730s to 1819-38. Twenty of the boxes are definitely French and eleven, decorated in the French style, appear to be Swiss. A number come from the Hawkins Collection of snuffboxes, dispersed between 1896 and 1936. White, a senior member of the Faculty of Advocates, also became

71. French 18th Century Gold Boxes from the
James Cathcart White Collection, now in
the Royal Scottish Museum (James
Cathcart White Bequest).

A. *Bonbonnière.* Auguste-Gaspard
 Turmine. Paris, 1782-83. 1.9 x
 4.8 cms.

B. Snuffbox. Jean-Marie Tiron. Paris,
 1766-67. 3.6 x 8.9 x 4.4 cms.

C. Snuffbox. Possibly Charles Dueil.
 Paris, 1777-78. 3.1 x 7.9 x 5.9 cms.

D. Snuffbox. Possibly Louis Cousin or
 Louis Gallois. Paris, 1771-72. 3 x 6.5 x
 5 cms.

E. Snuffbox. Jean-Baptiste-Maurice Juin.
 Paris, 1772-73. 2.6 x 7.8 x 4 cms.

F. Snuffbox. Mathieu Coiny. Paris, 1774-
 75. 2.5 x 5.9 cms. Miniatures
 attributed to van Blarenberghe.

G. Snuffbox. Philippe Le Bourlier. Paris,
 1785. 2.5 x 10 x 3.1 cms.

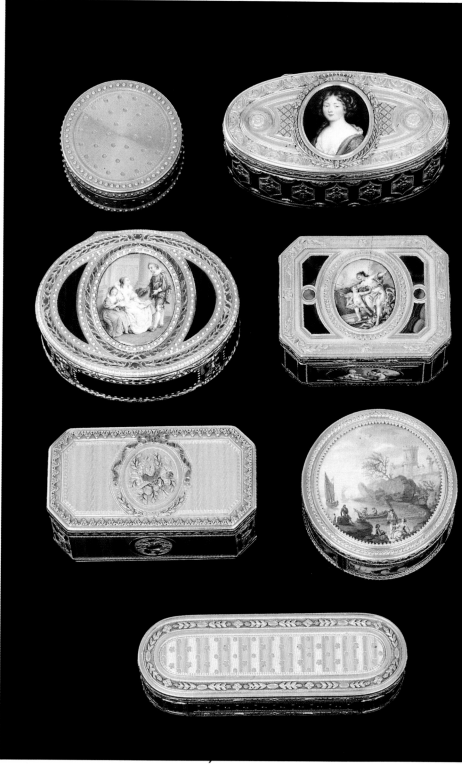

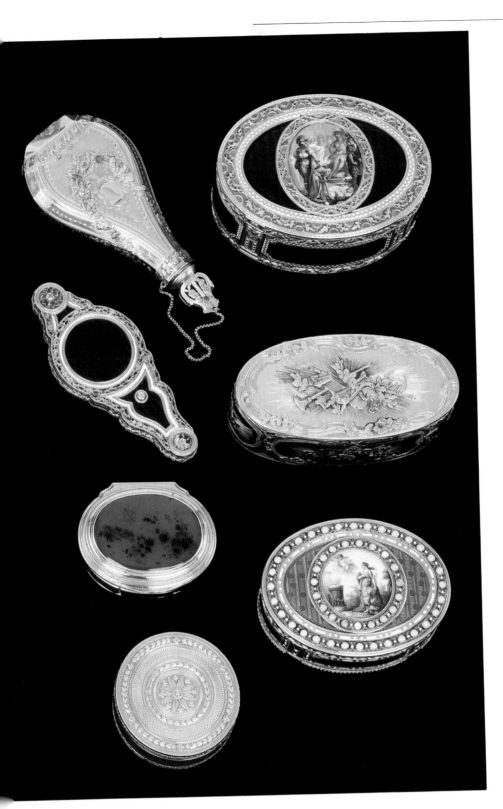

H. Scent Flask. Possibly Pierre Cerneau. Paris, 1766-67. 10 x 4.7 x 1.5 cms.

I. Snuffbox. Pierre-Denis Hoart. Paris, 1774-75. 3.4 x 8.3 x 6.2 cms.

J. Eyeglass. Pierre-Denis Hoart. Paris, 1775-76. 9.1 x 3.8 x 0.8 cms.

K. Snuffbox. Aymé-Antoine Chollet. Paris, 1761-62. 3 x 8.7 x 4.1 cms.

L. Snuffbox. Unidentified maker. Paris, 1731-32. 2.5 x 5.2 x 4.4 cms.

M. Snuffbox. Illegible maker's mark. Paris, 1780-81. 2.5 x 7 x 5.2 cms.

N. *Bonbonnière.* Charles Ouizille. Paris, 1778-79. 1.9 x 4.6 cms.

Details about the boxes are included in the Checklist.

greatly interested in the literary treasures preserved in Parliament House. Some of his fine collection of illuminated manuscripts, including French books of hours, and early printed books was bequeathed to Edinburgh University Library.

There was a growing interest in medieval and Renaissance antiquities in the latter part of the nineteenth century. This interest was stimulated by an important exhibition of antiquities mounted in Edinburgh in 1856; and there were other similar exhibitions in Liverpool (1854), Manchester (1857) and London (1862).

Sir Thomas David Gibson Carmichael (1859-1926), later Baron Carmichael of Skirling, was inspired to become a collector by his visit to Italy in 1881-82. After a spell as Liberal member of parliament for Midlothian, he became successively Governor of Victoria, Australia, of Madras, India, and the first Governor of Bengal. His wide-ranging collection included French medieval enamels, ivories and tapestries, fifteenth and sixteenth century Italian and German paintings and sculptures, as well as Egyptian and classical antiquities. Carmichael sold much of his collection in 1902 before he became a colonial administrator.

Sir William Burrell (1861-1958) thought very highly of Carmichael's collection. He acquired a number of works from the collection, including the Franco-Flemish tapestry of *Charity overcoming Envy* (Fig. 72), and the painting by the German artist Lucas Cranach the Elder of the *Stag Hunt* (1529). Burrell's wealth came from the family shipping business. He was a shrewd manager who built ships at low cost when yards were desperate for business, then made a huge profit when the depression ended and there was a demand for shipping. Such financial resources enabled Burrell to devote his life to Hutton Castle, near Berwick-upon-Tweed, which he purchased in 1916, and to the development of his collection. Although Sir William's taste was even more catholic than Carmichael's, his main interest was in medieval works of art. He acquired a very good collection of Limoges enamels, a number of French sculptures, including a fine *Virgin and Child* in boxwood from Lorraine in eastern France, made between 1325 and 1350, and a small group of ivories. He specialized in tapestries and stained glass. Amongst his most significant acquisitions are some fragments dating from the last quarter of the fourteenth century. These may have formed part of the famous *Apocalypse of Angers* tapestry (Castle of Angers) commissioned by Louis I, Duke of Anjou, and woven by Nicholas Bataillie's workshop in Paris between 1375 and 1378. The Duke of Anjou was the brother of Charles V of France and the designs for the tapestry are by the King's court painter, Jean de Bruges. A number of Franco-Flemish and Franco-Burgundian tapestries were bought by Sir William, including an early sixteenth century verdure tapestry with the punning arms (a mirror) of Gabriel Miro, doctor to the French King Louis XII. The stained glass collected by Burrell includes a panel depicting the Prophet Jeremiah (Fig. 73), which was part of the glazing commissioned between 1140 and 1145 by Abbot Suger for the royal chapel of St Denis; and three panels for one of the ambulatory chapels of the Cathedral of Notre Dame at Clermont-Ferrand, c. 1280-90. Burrell completed his collection of French medieval works of art with architectural sculpture previously owned by the newspaper proprietor William Randolph Hearst. The most noteworthy pieces are the portal from the west facade of the parish church at Montron, near Château Thierry, in north-east France, and doorways and windows decorated in the French flamboyant style.

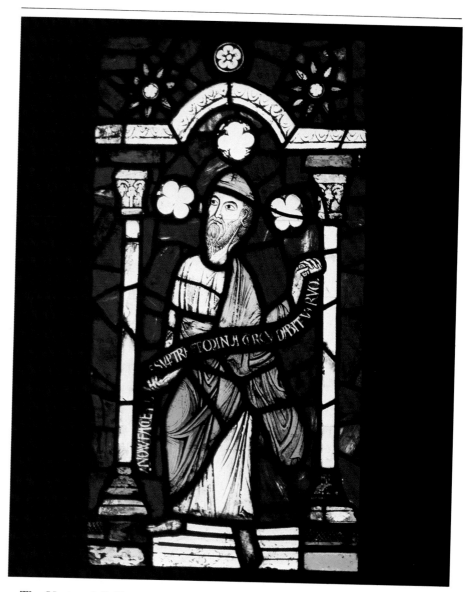

73. **The Prophet Jeremiah.** French, c. 1140-45. Stained glass. 61 x 33 cms. The Burrell Collection, Glasgow Museums and Art Galleries. Part of a commission placed by Abbot Suger for the Abbey of St Denis, near Paris.

The National Gallery of Scotland and the National Gallery of Modern Art, both in Edinburgh, between them house the major collection of French paintings in Scotland, but two local authority art galleries, Kelvingrove Art Gallery, Glasgow, and Aberdeen Art Gallery, also contain important French nineteenth and twentieth century paintings, together with some sculpture.

The principal collection of French applied art is in the Royal Scottish Museum, Edinburgh, although some interesting items in the National Museum of Antiquities of Scotland, Edinburgh, have strong Franco-Scottish associations. The Royal Scottish Museum collection, developed since 1870, is intended to illustrate the main types of objects and styles from the early medieval period to the present. Amongst important French items are Limoges enamels (Figs. 74 to 77), tin-glazed earthenware or faience (Fig. 79), the silver-gilt Lennoxlove toilet service (Fig. 18) and one half of the Biennais tea service made for the Emperor Napoleon (Figs. 53 and 55). Recent acquisitions include a marble bust of Madame Victoire of France by Louis-Claude Vassé (Fig. 80), associated with the Salon of 1761, and a drop-front secretaire by Guillaume Benneman (c. 1790). The museum collection also includes French ceramics, silver, sculpture, costume and textiles of the nineteenth and twentieth centuries.

116

74. Ciborium attributed to Magister Alpais. French (Limoges), early 13th century. Champlevé enamel on copper. 16 x 13.8 cms. Royal Scottish Museum, Edinburgh. A ciborium is the vessel used for the reservation of the Eucharist. This is one of only half-a-dozen surviving examples and is very close to a complete ciborium, with a domed lid, which is signed by the Magister Alpais. This signed piece was in the Abbey of Montmajor in the diocese of Arles and is now in the Musée du Louvre. Paris.

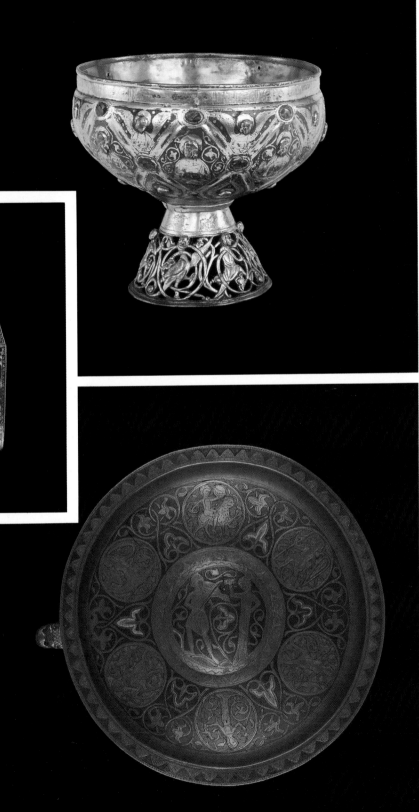

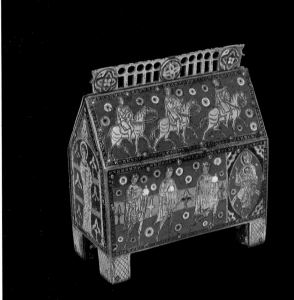

75. Reliquary Casket. French (Limoges), about 1225. Champlevé enamel on copper. 19.8 x 21.8 x 9.5 cms. Royal Scottish Museum, Edinburgh. The Journey of the Magi is represented on the roof and the Adoration of the Magi on the side.

76. Gemellion. French (Limoges), mid 13th century. Champlevé enamel on copper. 25.2 x 3.2 cms. Royal Scottish Museum, Edinburgh. A gemellion (from *gemellus*, twin) is one of a pair of bowls used for washing hands on ritual or ceremonial occasions. This has a spout and was for pouring.

77. Dish painted with *The Wedding Banquet of Cupid and Psyche* attributed to Léonard Limosin (c. 1505-75/77). French (Limoges), c. 1560. Enamels on copper. 44.3 x 4 cms. Royal Scottish Museum, Edinburgh. The composition is copied from a print after a drawing by the Fleming Michiel Coxie.

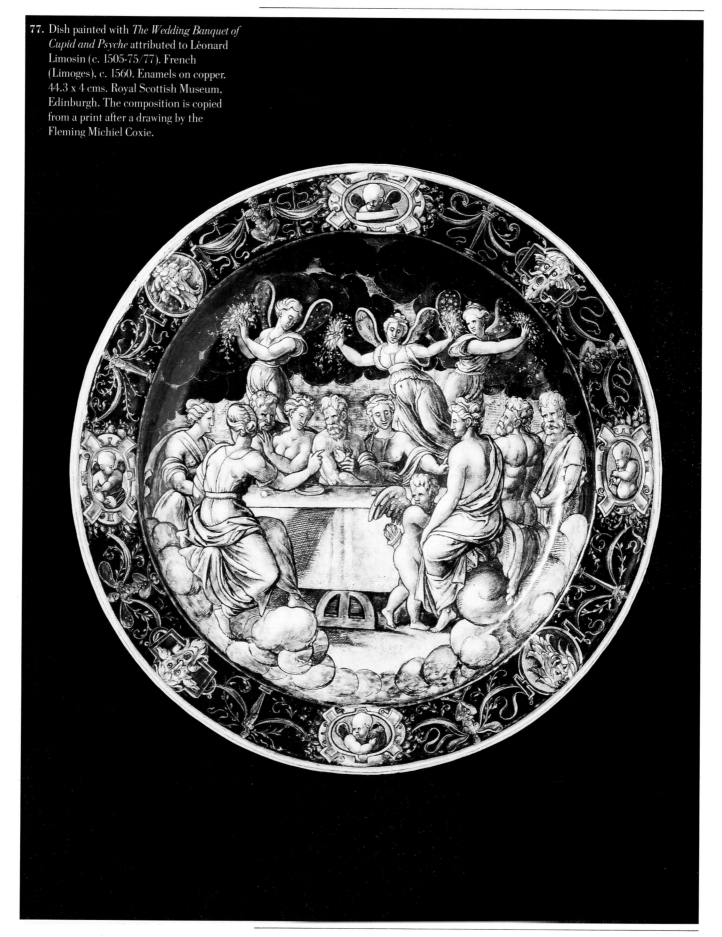

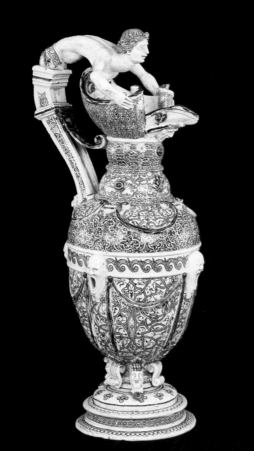

78. Ewer. French (Saint-Porchaire), c. 1540. Lead-glazed earthenware. 34.6 x 16 cms. Royal Scottish Museum, Edinburgh. Formerly in the collection of Horace Walpole at Strawberry Hill. Fewer than seventy pieces made at Saint-Porchaire, near Bressuire, Deux Sèvres, have survived. A fine-grained off-white clay is inlaid with intricate patterns of strapwork by means of punches, and the cavities filled with clays of contrasting colours.

79. Dish depicting *Joseph's Brothers before Joseph in Egypt*. French (Lyons), c. 1585. Tin-glazed earthenware. 44.1 x 6.7 cms. Royal Scottish Museum, Edinburgh. After an engraving by Bernard Salomon, the engraver and illustrator of the Lyons printers. The faience workshops of Lyons had strong connections with the maiolica pottery industry of Urbino in northern Italy.

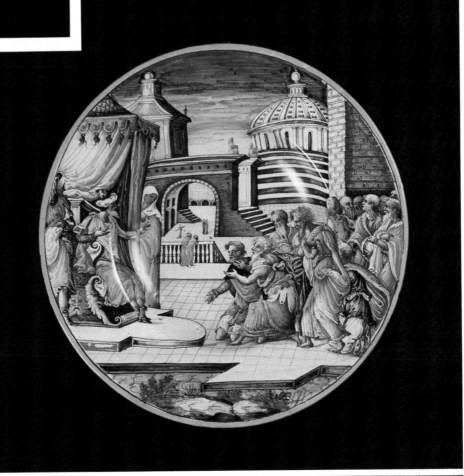

ACKNOWLEDGEMENTS

I would like to express my gratitude to the following owners for granting permission to inspect and photograph works: the Duke of Argyll; the Duke of Atholl; the Duke of Buccleuch and Queensberry; the Duke of Hamilton and Brandon; the Duke of Richmond and Gordon; the Duke of Roxburghe; the Marquess of Lothian; the Earl and Countess of Mansfield; the Earl and Countess of Rosebery; the Countess of Sutherland and Lord Strathnaver; the Viscount Cowdray; the Trustees of Dunimarle Museum; the Trustees of the Hamilton and Kinneil Estates; the Trustees of the Sutherland Trust; Mr. P. Maxwell Stuart; and those owners who wish to remain anonymous.

Thanks are also due to the following institutions and bodies for permitting inspection of items and for supplying photographs or permitting photography to be undertaken: Aberdeen University Library; Blairs College, Aberdeen; the Bodleian Library, Oxford; the Burrell Collection, Glasgow Museums and Art Galleries; St Margaret's Convent of the Ursulines of Jesus, Edinburgh; *Country Life*; Edinburgh University Library; the Frick Collection, New York; the J. Paul Getty Museum, Malibu, California; Goodwood Estate Company Ltd.; Hamilton Public Library; the Library of Emmanuel College, Cambridge; the Library of St John's College, Oxford; the Metropolitan Museum of Art, New York; the Musée du Louvre, Paris; the National Gallery of Art, Washington; the National Library of Scotland, Edinburgh; the National Museum of Antiquities of Scotland, Edinburgh; the National Trust; the National Trust for Scotland; the Royal Academy of Arts; the Royal Commission on the Ancient and Historical Monuments of Scotland, Edinburgh; the Royal Pavilion, Brighton; the Scottish Catholic Archives, Edinburgh; the Thorvaldsen Museum, Copenhagen; the University of Glasgow; the University of St Andrews; the Victoria and Albert Museum, London; Waddesdon Manor, Aylesbury; and York Minster Library.

I would also like to thank the following individuals for facilitating access to material and for providing me with information: Sir Valentine Abdy; Sister Aelred; Daniel Alcouffe; C. B. L. Barr; Lester Borley; Patrick Cadell; Jenni Calder; Dr. David Caldwell; Marian Campbell; Alastair Cherry; R. G. Coleman; Lieut-Col. A. Crawforth; George Dalgleish; Iain Davidson; Rev. Dr. Mark Dilworth; J. M. A. Dinkel; Dr. R. Donaldson; Svend Eriksen; Christopher Gilbert; Ian Gow; Rosamund Griffin; Dr. J. T. D. Hall; Dyveke

Opposite

80. Madame Victoire de France (1733-99) by Louis-Claude Vassé (1716-72). French (Paris), 1763. Marble. 71 cms. Royal Scottish Museum, Edinburgh. Madame Victoire was the fifth daughter of Louis XV and Queen Marie Leczinska. An almost identical bust is illustrated in the artist Gabriel de Saint-Aubin's copy of the catalogue of the Salon of 1761. The bust in the Royal Scottish Museum is believed to be the Salon piece with the date of final completion carved on the socle.

Helsted; Ralph Henderson; Lieut-Comm. A. Hutcheson; John Higgitt; Dr. D. B. Johnston; Bjarne Jornaes; Dorothy Kidd; Ian Larner; David Learmont; James Lomax; Lorna MacEchern; Helen McCabe; Brenda McGoff; Rev. John McIntyre; Colin McLaren; Dr. Richard Marks; Brenda Moon; Brian Nodes; Revel Oddy; David Patterson; Julia E. Poole; Geoffrey Quick; Prof. E. F. D. Roberts; Lieut-Comm. A. R. Robinson; Dr. Allen Simpson; Robert Smart; Ken Smith; J. C. & A. Steuart, W.S.; Naomi Tarrant; Keith Thomas; Dr. Duncan Thomson; Philip Vainker; David Walker; Philip Ward-Jackson; Rose Watban; Rowan Watson; Dr. Steven Watson; Julia K. Wood; and Dr. Lucy Wood.

The book was edited by Dr. Sheila Brock; Jenni Calder; Alison Harley; and Dale Idiens.

Godfrey H. Evans
ROYAL SCOTTISH MUSEUM

PHOTOGRAPHIC ACKNOWLEDGEMENTS

Bodleian Library, Oxford: 3
Burrell Collection, Glasgow Museums and Art Galleries: 72, 73
Edinburgh University Library: 9, 11
Eost and McDonald, London: 33
Svend Eriksen: 48
Godfrey Evans: 65
Frick Collection, New York: 42, 43
J. Paul Getty Museum, Malibu, California: 30, 47
Christopher Gilbert: 23
Goodwood Estate Company Ltd.: 20
Hamilton and Kinneil Estates: 19
Thomas Lumley: 21
Metropolitan Museum of Art, New York: 45, 46
Musée du Louvre, Paris: 52, 54
National Gallery of Art, Washington: 49
National Gallery of Scotland, Edinburgh: 25
National Library of Scotland, Edinburgh: 10, 16
National Museum of Antiquities of Scotland, Edinburgh: 2, 4, 14, 24
National Trust, Waddesdon Manor: 39, 40, 41, 44, 59
Royal Academy of Arts, London: 26, 27
Royal Commission on the Ancient and Historical Monuments of Scotland, Edinburgh: 12, 34, 35, 36, 37, 38, 66, 69
Royal Scottish Museum, Edinburgh: Cover, frontispiece, 1, 5, 7, 8, 15, 17, 18, 28, 29, 32, 50, 53, 55, 57, 58, 60, 61, 62, 63, 64, 67, 68, 70, 71, 74, 75, 76, 77, 78, 79, 80
Scottish Development Department (Historic Buildings and Monuments), Edinburgh: 6
Scottish National Portrait Gallery, Edinburgh: 13, 22, 31
Thorvaldsen Museum, Copenhagen: 56
Victoria & Albert Museum, London: 51

MAJOR SCOTTISH COLLECTIONS, HOUSES AND MONUMENTS OPEN TO THE PUBLIC

Dates and times of opening are given in good faith but should be checked by intending visitors.

Abbotsford House, Melrose, Borders
Tel: (0896) 2043
Open 18 Mar to Oct, Mon to Sat 10 to 5, Sun 2 to 5

Aberdeen Art Gallery, Schoolhill, Aberdeen
Tel: (0224) 646333
Open Mon to Sat 10 to 5 (until 8 on Thurs), Sun 2 to 5;
 closed Christmas and New Year

Binns, House of the, near Linlithgow, Lothian (NTS)
Tel: Philipstoun (050683) 4255
Open May to Sept, daily 2 to 5.30; parkland 10 to 7

Bowhill, near Selkirk, Borders
Tel: (0750) 20732
Open May to June & Sept, Mon, Wed, Sat, Sun, 2 to 6;
 July & Aug, Mon to Thur & Sat, 12.30 to 5, Sun 2 to 6

Brodick Castle, Isle of Arran, Strathclyde
Tel: (0770) 2202
Open Mon to Sat 10 to 5, Sun 12.30 to 5

The Burrell Collection, Pollok Park, 2060 Pollokshaws Road, Glasgow
Tel: 041-649 7151
Open Mon to Sat 10 to 5, Sun 2 to 5

Culzean Castle, near Maybole, Ayrshire (NTS)
Tel: Kirkoswald (06556) 269
Open Apr to Sept, daily 10 to 6;
 Oct, daily 10 to 4
 park open all year

Dalmeny House, South Queensferry, Lothian
Tel: 031-331 1888
Open Easter Sun & Mon, then May to Sept, Sun to Thur 2 to 5.30

Drumlanrig Castle, Thornhill, Dumfries & Galloway
Tel: (0848) 30248
Open May to Aug daily (*except* Fri) 12.30 to 5, Sun 2 to 6;
 except July & Aug, 11 to 5, Sun 2 to 6

Dunfermline Abbey, Pittencrieff Park, Dunfermline, Fife
Open Apr to Sept, weekdays 9.30 to 7, Sun 2 to 7;
 Oct to Mar, weekdays 9.30 to 4, Sun 2 to 4

Dunrobin Castle, Golspie, Sutherland
Tel: (04083) 3177
Open mid June to Sept, Mon to Sat 10.30 to 5.30, Sun 1 to 5.30

Earl Patrick's Palace, Kirkwall, Orkney
Open Apr to Sept, Mon to Sat 9.30 to 7, Sun 2 to 7;
 Oct to Mar, Mon to Thur 9.30 to dusk, Sun 2 to dusk;
 Fri, mornings only

Edinburgh Castle, Edinburgh
Open 5 Jan to Mar, weekdays 9.30 to 5.05, Sun 12.30 to 4.20;
 May to Oct, weekdays 9.30 to 6, Sun 11 to 6;
 Nov to Dec, weekdays 9.30 to 5.05, Sun 12.30 to 4.20

Falkland Palace, Falkland, Fife (NTS)
Tel: (03375) 397
Open Apr to Sept, Mon to Sat 10 to 6, Sun 2 to 6;
 Oct, Sat 10 to 6, Sun 2 to 6

Floors Castle, Kelso, Borders
Tel: (0573) 23333
Open Easter weekend; then May to Sept, Sun to Thur 11 to 5.30;
 walled gardens daily 9.30 to 5

Hill of Tarvit, Cupar, Fife
Tel: (0334) 53127
Open Easter, then May to Sept, Sun to Thurs & Sat 2 to 6;
 Oct, Sat & Sun 2 to 6;
 gardens and grounds open all year 10 to dusk

Holyroodhouse Abbey & Palace, Canongate, Edinburgh
Tel: 031-556 7371
Open Mon to Sat 9.30 to 5, Sun 10 to 4.30
The Palace and Abbey are closed when the Queen is in residence and at
other times so it is essential to check.

Hopetoun House, South Queensferry, Lothian
Tel: 031-331 2451
Open Easter; then end Apr to mid Sept daily 11 to 5.30

Huntly Castle, Huntly, Grampian
Open Apr to Sept, weekdays 9.30 to 7, Sun 2 to 7;
 Oct to Mar, weekdays 9.30 to 4, Sun 2 to 4

Inveraray Castle, Inveraray, Argyll
Tel: (0499) 2203
Open first Sat Apr to second Sun Oct, daily (*except* Fri) 10 to 1 & 2 to 6;
 April to June & Sept to Oct, Sun 2 to 6;
 July to Aug, daily 10 to 6, Sun 2 to 6

Kelvingrove Art Gallery, Kelvingrove Park, Glasgow
Tel: 041-334 1134
Open Mon to Sat 10 to 5, Sun 2 to 5; closed Christmas and New Year

Lennoxlove, Haddington, Lothian
Tel: (062 082) 3720
Open Apr to Sept, Wed, Sat, Sun 2 to 5; other times by appointment

Linlithgow Palace, Linlithgow, Lothian
Open Apr to Sept, weekdays 9.30 to 7, Sun 2 to 7;
 Oct to Mar, weekdays 9.30 to 4, Sun 2 to 4

Melrose Abbey, Melrose, Borders
Open Apr to Sept, weekdays 9.30 to 7, Sun 2 to 7;
 Oct to Mar, weekdays 9.30 to 4; Sun 2 to 4

National Gallery of Scotland, The Mound, Edinburgh
Tel: 031-556 8921
Open Mon to Sat 10 to 5 (until 6 *during Festival*);
 Sun 2 to 5 (11 to 6 *during Festival*)

National Museum of Antiquities of Scotland, Queen Street, Edinburgh
Tel: 031-556 8921
Open Mon to Sat 10 to 5 (until 6 *during Festival*);
 Sun 2 to 5 (11 to 6 *during Festival*)

Royal Scottish Museum, Chambers Street, Edinburgh
Tel: 031-225 7534
Open Mon to Sat 10 to 5, Sun 2 to 5; closed Christmas & New Year

St Andrews Castle, St Andrews, Fife
Open Apr to Sept, weekdays 9.30 to 7, Sun 2 to 7
 Oct to Mar, weekdays 9.30 to 4, Sun 2 to 4

Scone Palace, Scone, near Perth
Tel: (0738) 52300
Open Easter to end Sept, Mon to Sat 10 to 4.30, Sun 2 to 5;
 July to Aug, 11 to 5.30

Scottish National Gallery of Modern Art, Belford Road, Edinburgh
Tel: 031-332 3754
Open Mon to Sat 10 to 5 (until 6 *during Festival*);
 Sun 2 to 5 (11 to 6 *during Festival*)

Scottish National Portrait Gallery, Queen Street, Edinburgh
Tel: 031-556 8921
Open Mon to Sat 10 to 5 (until 6 *during Festival*);
 Sun 2 to 5 (11 to 6 *during Festival*)

Scottish United Services Museum, Edinburgh Castle, Edinburgh
Open (*see* Edinburgh Castle)

Stirling Castle & Palace, Upper Castle Hill, Stirling
Open Jan to Apr & Nov to Dec, Mon to Sat 9.30 to 5.05, Sun 12.30 to 4.20;
 May to Oct, 9.30 to 6, Sun 11 to 6

Thirlestane Castle, Lauder, Borders
Tel: (05782) 254
Open May to June, Wed & Sat 2 to 5;
 July to Aug, Sat to Thur 2 to 5

BIBLIOGRAPHY

I Alliance with France

The history of Scotland between 1066 and 1512, the period covered in this chapter, is treated in the first two volumes of the *Edinburgh History of Scotland*: A. A. M. Duncan, *Scotland: The Making of the Kingdom* (Edinburgh, 1975), and Ranald Nicholson, *Scotland: The Later Middle Ages* (London, 1974). Both contain extensive bibliographies which list books and articles relevant to the theme of the "Auld Alliance". The French psalter illustrated in Fig. 3 is catalogued by Otto Pächt and J. J. G. Alexander in *Illuminated Manuscripts in the Bodleian Library, Oxford* (Oxford, 1966), vol.I, p. 42, no. 535, and by A. C. de la Mare in *The Douce Legacy* (exhibition catalogue, Bodleian Library, Oxford, 1984), p. 44, no. 70. The music book from St Andrews now at Wolfenbüttel is published in facsimile in J. H. Baxter (ed.), *An Old St Andrews Music Book*, St Andrews University Publications, no. XXX (London, 1931). It is discussed by Edward H. Roesner in "The Origins of WI" in the *Journal of the American Musicological Society*, 1976, pp. 337-80. For Marcus Wagner see J. H. Baxter (ed.), *Copiale Prioratus Sanctiandree: The Letterbook of James Haldenstone, Prior of St Andrews (1418-1443)*, St Andrews University Publications, no. XXXI (London, 1930). Information on French or French-style enamels discovered in Scotland is contained in the *Proceedings of the Society of Antiquaries of Scotland (PSAS)*: the pricket candlestick found in digging the foundation of the parish church of Kinnoul, *ibid.*, 1860, p. 339; the crucifix found in the churchyard of Ceres, Fife, *ibid.*, 1883, pp. 146-51; the hasp found in the bank of Beck's Burn between the graveyard of the old church of Wauchope and Wauchope Castle, near Langholm, *ibid.*, 1895, pp. 7-9; the pricket candlestick from Bothwell Castle, Lanarkshire, *ibid.*, 1959-60, p. 253 and plate XVI; the dagger pommel from Fortingall, Perthshire, *ibid.*, 1975-6, pp. 322-3; and the plaque found in a grave, Borve, Benbecula, *ibid.*, 1977-8, pp. 378-80. John Morrow's activity is discussed by Richard Fawcett in "Scottish Medieval Tracery" in David J. Breeze (ed.), *Studies in Scottish Antiquity presented to Stewart Cruden* (Edinburgh, 1984), pp. 148-86. The maces at St Andrews and Glasgow are examined by Alexander J. S. Brook in "An Account of the Maces of the Universities of St Andrews, Glasgow, Aberdeen, and Edinburgh, the College of Justice, the City of Edinburgh, &c." in *PSAS*, 1892, pp. 440-514. Brooks identified the earlier of the two French maces at St Andrews as the mace of

the Faculty of Arts and the Scottish mace as the mace of the Faculty of Canon Law. This was in spite of their traditional identification, and the surviving documentation suggests that the Scottish mace belonged to the Faculty of Arts, while the French mace was used by the Faculty of Canon Law. For information on the first lecturers at St Andrews see J. M. R. Anderson, "The Beginnings of St Andrews University, 1410-18", *Scottish Historical Review*, April 1911, pp. 225-48. The St Salvator inventory is published in Ronald G. Cant, *The College of St Salvator* (London and Edinburgh, 1950). The manuscripts produced in Rouen are discussed by Rowan Watson in the introduction to the facsimile of *The Playfair Hours* (Victoria & Albert Museum, London, 1984); this contains bibliographical references to related manuscripts.

II The French Queens

For a succinct survey of the sixteenth century see Gordon Donaldson, *James V-James VII* (Edinburgh, 1965), the third volume in the *Edinburgh History of Scotland*. For information about the royal family see the same author's *Scottish Kings* (London, 1967); Rosalind K. Marshall, *Mary of Guise* (London, 1977); and Antonia Fraser, *Mary Queen of Scots* (London, 1969). The architectural projects of James V are examined by J. G. Dunbar in "The Palace of Holyroodhouse during the First Half of the Sixteenth Century", *Archaeological Journal*, 1964, pp. 242-54, and *The Historic Architecture of Scotland* (London, 1978). James V's patronage and that of other individuals is discussed by George Hay in "Scottish Renaissance Architecture" in *Studies in Scottish Antiquity presented to Stewart Cruden* (Edinburgh, 1984), pp. 196-231. Robert Scott Mylne, *The Master Masons to the Crown of Scotland and their Works* (Edinburgh, 1893), contains valuable information but has been largely superseded by more recent research. The "Stirling heads" are investigated by J. G. Dunbar in a booklet of the same title produced by the Royal Commission on the Ancient and Historical Monuments of Scotland (HMSO, Edinburgh, 1975). John Durkan and Anthony Ross discuss and list surviving early printed books owned by Scots in "Early Scottish Libraries" in the *Innes Review*, 1958, pp. 5-167. On the coinage of Mary Queen of Scots see Edward Burns, *The Coinage of Scotland* (Edinburgh, 1887), vol. II, pp. 269-348; J. K. R. Murray, "The Scottish Coinage of 1553", *British Numismatical Journal*, 1968, pp. 98-109; Joan E. L. Murray, "The First Gold Coinage of Mary Queen of Scots", *ibid.*, 1979, pp. 82-6; and Joan E. L. Murray and J. K. R. Murray, "Notes on the Vicit Leo Testoons of Mary Queen of Scots", *ibid.*, 1980, pp. 81-90. For Mary's possessions see J. Robertson, *Inventaires de la Royne Descosse, Douairiere de France, 1556-1569* (Edinburgh, 1863). Andrew Lang's *Portraits and Jewels of Mary Stuart* (Glasgow, 1906) should not be relied upon but nevertheless stimulates thought about the jewels described so briefly in the inventories. The painted ceiling formerly at Prestongrange is discussed by M. R. Apted and W. Norman Robertson in *PSAS*, 1974-5, pp. 158-60.

III "Distracted Tymes"

The quotation "as soon as they fall from the breast of the beast their mother" (etc.) is taken from P. Hume Brown (ed.), *Early Travellers in Scotland* (Edinburgh, 1891), p. 102, where it is assigned to Sir Anthony Weldon (?).

On the education of the Kerrs see Duncan Thomson, *A Virtuous & Noble Education* (Scottish National Portrait Gallery, Edinburgh, 1971). G. D. Henderson provides an excellent basic study of religion in this period in his *Religious Life in Seventeenth-Century Scotland* (Cambridge University Press, 1937). James Drummond's involvement with Bishop Bossuet is the subject of A. Joly, *Un converti de Boussuet: James Drummond, Duc de Perth, 1648-1716* (Lille, 1934). The interest of Dr. George Garden and others in the north-east of Scotland in the mysticism of Antoinette Bourignon and Madam Guyon could not be encompassed in this short chapter; a full account of the whole movement, which was basically Episcopalian with Jacobite leanings, may be found in G. D. Henderson, *Mystics of the North-East*, published by the Third Spalding Club in 1934. Patrick Cadell discusses the Panmure Music Books in an article, "French Classical Music from the Collection of the Earls of Panmure", which was due to be published in *Recherche sur la musique classique française* as this book went to press. For Sibbald and his contemporaries see A. D. C. Simpson, "Sir Robert Sibbald—The Founder of The College", in *Proceedings of the Royal College of Physicians Edinburgh Tercentenary Congress, 1981* (Edinburgh, 1982), pp. 59-91. For Sir William Bruce see H. Fenwick, *Architect Royal: The Life and Works of Sir William Bruce 1630-1710* (Kineton, 1970). The de Wet paintings in the chapel at Glamis Castle are discussed by M. R. Apted and R. L. Snowden in *Studies in Scottish Antiquity presented to Stewart Cruden* (Edinburgh, 1984), pp. 232-48. The quotation from Mackintosh is included in Adolph S. Cavallo's article, "Continental Sources of early Damask Patterns in Scotland", in the *Burlington Magazine*, 1965, pp. 559-63. On the tapestries at Holyrood see Margaret Swain, "The Furnishings of Holyroodhouse in 1668", *Connoisseur*, 1977, pp. 122-30. The Lennoxlove toilet service is discussed very briefly by E. Alfred Jones in "Silver given by Charles II to the Duchess of Richmond" in the *Connoisseur*, 1933, pp. 144-7. For further information on Frances Teresa Stuart see the relevant entries in the diaries of Samuel Pepys and Cyril Hughes Hartmann, *La Belle Stuart: Memoirs of Court and Society in the Times of Frances Teresa Stuart, Duchess of Richmond and Lennox* (London, 1924). The Chatsworth-Stonor service is examined by A. G. Grimwade in "Mr Francis Stonor's Collection of Silvergilt—II. The Toilet Service from Chatsworth" in the *Connoisseur*, 1961, pp. 36-41. The service at Rosenborg Castle is published by Gudmund Boesen in "La Service de Toilette Française de Hedvig Sofia" in *Opuscula in Honorem Carl Hernmark* (National Museum, Stockholm, 1966), pp. 22-38.

IV Culture and Conflict

For the eighteenth century historical background see William Ferguson, *Scotland: 1689 to the Present* (Edinburgh, 1968), the fourth and last volume in the *Edinburgh History of Scotland*, and Bruce Lenman, *Integration, Enlightenment, and Industrialization. Scotland 1746-1832* (London, 1981), vol. 6 of Arnold's *New History of Scotland*. French intervention and French support for the Jacobites are discussed by Lenman in *The Jacobite Risings in Britain 1689-1746* (London, 1980) and *The Jacobite Clans of the Great Glen 1650-1784* (London, 1984). Sir John Clerk's remarks are taken from John M. Gray (ed.), *Memoirs of the Life of Sir John Clerk of Penicuik, Baronet . . . extracted by himself from his own journals* (Edinburgh, 1892); the descriptions of Versailles and Paris in 1699 are on pp. 33-34. Extracts of Sir Alexander

Dick's account of his experiences in France in 1736 appeared in the *Gentleman's Magazine*, January and February 1853, pp. 22-26 and pp. 159-61. For Allan Ramsay see Alastair Smart, *The Life and Art of Allan Ramsay* (London, 1952). Robert Adam's views on France are included in John Fleming, *Robert Adam and his Circle* (London, 1978). For David Hume see Ernest Campbell Mossner, *The Life of David Hume* (London, 1954), which contains an extensive bibliography. Correspondence between Hume and major French figures was presented by the philosopher's nephew to the Royal Society of Edinburgh, along with other letters and papers. They are listed by J. Y. T. Greig and Harold Beynon in *Proceedings of the Royal Society of Edinburgh*, 1932, pp. 3-138. For Scottish editions of Montesquieu, Voltaire and Rousseau see Alison K. Bee, *Montesquieu, Voltaire and Rousseau in Eighteenth Century Scotland: A checklist of editions and translations of their works published in Scotland before 1801*. Bibliography submitted in part requirement for the University of London Diploma in Librarianship, May 1975. A copy is deposited in the National Library of Scotland. A slightly different version of this bibliography is published in *The Bibliothek*, vol. 2, no. 2, pp. 40-63. On the Foulis see David Murray, *Robert and Andrew Foulis and Glasgow Press* (Glasgow, 1913), and Francina Irwin, "Scottish Eighteenth-century Chintz and its Design-I", in the *Burlington Magazine*, September 1965, pp. 452-58. Delacour is discussed by John Fleming in "Enigma of a Rococo Artist", *Country Life*, 24 May 1962, and by Irwin, *op. cit.* The building and decoration of Inveraray Castle are described by Ian G. Lindsay and Mary Cosh in *Inveraray and the Dukes of Argyll* (Edinburgh University Press, 1973). Since then further information has been discovered on Girardy and the tapestries. Helen Hayward has found that the 5th Duke paid John Linnell £220.14s.9d. for furniture between 1774 and 1776 and a further £663.18s. between 1779 and 1781 (*Country Life*, 5 June 1975). Saint-Fond's remarks are taken from Barthélemy Faujas de Saint-Fond, *A Journey through England and Scotland to the Hebrides in 1784* (ed. by Sir Archibald Geikie) (Glasgow, 1907). For Scots and the French Revolution see H. W. Meikle, *Scotland and the French Revolution* (Glasgow, 1912); John G. Alger, *Englishmen and the French Revolution* (London, 1889); and Constantia Maxwell, *The English Traveller in France 1698-1815* (London, 1932). There is also the diary of a Scottish gardener who worked for French aristocrats and became involved in the French Revolution: see Francis Birrell (ed.), *Diary of a Scotch Gardener at the French Court at the end of the Eighteenth Century by Thomas Blaikie* (London, 1931). For the exile of the Comte d'Artois, the future Charles X, and others at Holyrood in 1796 and again in 1830 see Archibald Francis Steuart, *The Exiled Bourbons in Scotland* (Edinburgh, 1908), and Margaret Swain, "Furniture for the French Princes at Holyroodhouse 1796", in the *Connoisseur*, January 1978, pp. 26-35. A small exhibition of paintings by the French *émigré* artist Henri-Pierre Danloux (1753-1809), who worked in Scotland in 1798, is to be mounted in the Scottish National Portrait Gallery, Edinburgh, in August 1985 and a catalogue by Duncan Thomson and Helen Smailes was in preparation when this book went to press.

V The Great Collections

Photographs of Hamilton Palace, taken shortly before its demolition, were published in *Country Life*, 7, 14 and 21 June 1919. Some of these illustrations,

together with earlier photographs, are reproduced in G. Walker, *Hamilton Palace: a photographic record* (Hamilton District Libraries and Museum Department, n.d.). The north range is discussed by A. A. Tait, "The Duke of Hamilton's Palace", in the *Burlington Magazine*, July 1983, pp. 394-402. Percier's designs are at Lennoxlove. Waagan's description of the finished interior of the palace is taken from his *Galleries and Cabinets of Art in Great Britain* (London, 1854), vol. III, p. 295; the palace and the collection are assessed from pp. 294-309. The starting point for any investigation of the Hamilton Palace Collection is Christie's catalogues of the Hamilton Palace sales, 17 June-20 July 1882, and the *Hamilton Palace Collection Illustrated Priced Catalogue* (Paris and London, 1882). Inventories of the contents of the palace drawn up in 1787, 1835 and 1876 (with additions) are preserved in Hamilton Public Reference Library. The Hamilton archives at Lennoxlove contain large quantities of correspondence, accounts and other documentation,and a list has been prepared by the staff of the Scottish Record Office. Some of the most important furniture formerly in the palace is discussed by Ronald Freyberger, "Eighteenth-Century French Furniture from Hamilton Palace", in *Apollo*, December 1981, pp. 401-9. The pieces now at Waddesdon Manor are catalogued by Geoffrey de Bellaigue in *The James A de Rothschild Collection at Waddesdon Manor. Furniture, Clocks and Gilt Bronzes* (Fribourg, 1974), 2 vols. Documentation relating to the lacquer secretaire and commode now in the Metropolitan Museum, New York, is published by Pierre Verlet in *French Royal Furniture* (London, 1963), pp. 158-60. The writing table and filing cabinet belonging to the Duc de Choiseul, now in the Musée Condé, Chantilly, are shown in a miniature by Louis-Nicolas van Blarenberghe on a snuffbox illustrating the interior of the Duc de Choiseul's town house in Paris: see F. J. B. Watson, *The Choiseul Box* (Oxford University Press, 1963). The Lalive de Jully writing table and filing cabinet in the same museum are discussed by Svend Eriksen in *Early Neo-classicism in France* (London, 1974). Important works from Hamilton Palace (including items bequeathed by Beckford) are still to be found in Scotland at Brodick Castle, on the Isle of Arran (now a property of the National Trust for Scotland), and at Lennoxlove. The David portrait of Napoleon is catalogued by Colin Eisler in *Paintings from the Samuel H Kress Collection, European Schools excluding Italians* (Washington, 1977), pp. 352-8; documentation relating to the commission is published by A. A. Tait in the *Burlington Magazine*, July 1983, pp. 401-2. Julia E. Poole discusses the *nécessaire* of the Princess Pauline Borghese in the *Connoisseur*, October 1978, pp. 106-13. For further information on the Princess see Sir Pierson Dixon's *Pauline: Napoleon's Favourite Sister* (London, 1964). This contains references to other biographies; one which is not referred to is W. N. C. Carlton, *Pauline: Favorite Sister of Napoleon* (New York and London, 1930) The portion of the Napoleonic tea service now in the Louvre is published in Musées Nationaux [Department des Objets d'Art], *Catalogue de l'orfèvrerie du XVII^e, du XVIII^e et du XIX^e siècle* [Musée du Louvre et Musée de Cluny] (Paris, 1958), pp. 200-4. The items in the second chest, which was acquired by the Royal Scottish Museum in 1976, are illustrated, and the commission discussed, by Julia E. Poole in "A Napoleonic Silver-gilt Service by Martin-Guillaume Biennais" in the *Burlington Magazine*, June 1977, pp. 388-96. A number of versions of Thorvaldsen's bust of Napoleon were produced. For the commission see Af Else Kai Sass, *Thorvaldsens Portraetbuster* (Copenhagen, 1963), vol. II, pp. 230-8; the versions are listed in *ibid.*

(Copenhagen, 1965), vol. III, p. 97. The appearance and history of the bust now in Copenhagen suggest that it is more likely to have come from Hamilton Palace than the other main contender: the bust now in Auckland Art Gallery, New Zealand.

For a very similar cabinet to the one in the Buccleuch Collection (Fig. 57) see the piece in the Getty Museum, reproduced in Gillian Wilson, *Decorative Arts in the J. Paul Getty Museum* (J. Paul Getty Museum, 1977), no. I. Edward Holmes Baldock's provision of objects is examined by Geoffrey de Bellaigue in the *Connoisseur*, August and September 1975, pp. 290-9 and pp. 18-25. The desk associated with Beaumarchais is described and discussed by the same writer in the Waddesdon Manor catalogue of furniture; the jewel casket by Carlin receives similar treatment in F. J. B. Watson, *The Wrightsman Collection* (Metropolitan Museum of Art, New York, 1966), vol. I, pp. 140-5. The Brodie Castle Collection is considered by C. Hartley and J. Cornforth in *Country Life*, 7 and 14 August 1980. The bed table once owned by the Duchess of Gordon is illustrated in A. A. Tait (ed.), *Treasures in Trust* (HMSO, Edinburgh, 1981), p. 93. The *bureau plat* with dolphin corner mounts formerly at Dunrobin Castle is illustrated in Frances Buckland's article, "A Group of Bureaux Plats and the Royal Inventories", in *Furniture History*, 1972, plate 38B. The French furniture connected with Scone is discussed by Anthony Coleridge in the *Connoisseur*, April and May 1966, pp. 239-43 and pp. 10-16; some of the items are no longer at Scone. The Langlois commodes are illustrated in part 3 of Peter Thornton and William Rieder's article on Langlois in the *Connoisseur*, March 1972. pp. 179-80. The June 1984 issue of *Apollo* is devoted to Dalmeny House and contains many excellent illustrations of the paintings, furniture and other works. The architecture of Floors Castle and a few of the items are discussed by Marcus Binney in *Country Life*, 11 and 18 May 1978. The wedding of Mary Goelet is noted in *The Scotsman* of 11 November 1903; the Duchess's obituary appeared in the same newspaper on 27 April 1937. Documentation relating to the commode by Joubert is published by Pierre Verlet in *French Royal Furniture* (London, 1963), pp. 113-14.

VI A Touch of Class

Kinnaird's purchase of three portraits of Napoleon is noted in Armand Dayot, *Les Vernet* (Paris, 1898), p. 195. Scott's interest in Napoleon is recorded in J. G. Lockhart, *The Life of Sir Walter Scott* (various editions). Carmontelle's drawings and their history are discussed by Austin Dobson in *At Prior Park* (London, 1912). The portrait of Guizot by Delaroche is illustrated in D. Johnson, *Guizot: Aspects of French History 1787-1874* (London, 1963), p. 246. The connection between the Sutherland family and Carrier-Belleuse is covered by Philip Ward-Jackson in "A.-E. Carrier-Belleuse, J.-J. Feuchère and the Sutherlands" in the *Burlington Magazine*, March 1985, pp. 146-53. Durenne exhibited the Ross fountain or a fountain of the same design at the London Exhibition of 1862. It is described in the *Official Catalogue of the Industrial Department, Vol. III. Colonial And Foreign Divisons*, p. 138, 3035(1), and illustrated on p. 139. A better illustration appears in *The Art Journal Illustrated Catalogue of the International Exhibition, 1862* (London and New York, 1862/63), p. 222. Durenne was awarded a medal but it was "For the beauty of cast iron gates": see *International Exhibition, 1862. Medals and Honourable Mentions awarded by the International*

Juries (London, 1862), p. 183. There are many entries relating to the Ross fountain in the Edinburgh Town Council Minutes between 1864 and 1870. The gift is described and commented upon at some length in *The Scotsman*, 28 September 1869; Ross's obituary appeared in the same newspaper on 2 February 1871. It has been stated that the fountain was shown in the 1867 Paris Exhibition, however the "monumental fountain" recorded in the *Official Catalogue* (English version, London, 1867), Group III, Class XXII, p. 45, appears to have been another fountain: see the illustration published in *The Art Journal Illustrated Catalogue of the Paris Universal Exhibition, 1867* (London and New York, 1867), p. 267. For information about F. B. Sharp see his obituary in *The Dundee Courier*, 15 August 1932. The items shown in the Edinburgh Exhibition of 1856 are listed in A. Way, *Catalogue of Antiquities, Works of Art and Historical Scottish Relics exhibited in the Museum of the Archaeological Institute of Great Britain and Ireland during their Annual Meeting held in Edinburgh, July 1856* (Edinburgh, 1859). Major works from Carmichael's collection were sold by Christie's on 12 and 13 May 1902; other items were auctioned by Sotheby's between 8 and 10 June 1926. On Burrell's collection see Richard Marks, *et al*, *The Burrell Collection* (London and Glasgow, 1983). For further information on the medieval works of art see Richard Marks, "Medieval Sculpture in the Burrell Collection", *Apollo*, October 1983, pp. 284-91; Sir William's interest in French paintings is examined by Philip Vainker in "Sir William Burrell's Taste in Nineteenth-Century French Paintings", *ibid.*, pp. 322-9.

INDEX

The numbers in bold refer to illustrations.

Abbotsford House, 103

Aberdeen Art Gallery, 116

Aberdour Castle, 41

Acheson, John, 37

Adam, Robert, 55, 57

Adam, William, 55, 73

Ailsa, Marquesses of, 104

Angus, Craibe, 106

Appiani, Andrea, 99, 101; **62**

Argyll, 5th Duke of, 61, 63, 66, 67; **26**

Atholl, Duke of, 104

Atkinson, William, 93

Auguste (goldsmith), 81

"Auld Alliance" (*see also* Franco-Scottish Alliances)

Aveline, François Antoine, 60

Baldock, Edward Holmes, 93, 95, 96, 97

Balfour, Andrew, 45, 46

Bara, Pierre, 99

Bataillie, Nicholas, 114

Beaton, Cardinal David, 34, 35

Beckford, William, 73, 81, 92

Benneman, Guillaume, 116

Biennais, Martin-Guillaume, 9, 10, 86, 89; **50, 52-55**

Binns, House of the, 68

Blackadder, Robert, Archbishop of Glasgow, 26; **10**

Bonnemaison, Chevalier Féréol, 78, 84

Borghese, Princess Pauline, 71, 84, 86, 91; **51**

Boucher, François, 100

Boulle, André-Charles, 77, 78, 84, 95, 96; **57, 58**

Bowhill House, 93, 97; **60**

Brodie Castle, 97

Bruce, Sir William, 47, 110; **17**

Bruges, Jean de, 114

Buccleuch, Dukes of, 61, 93, 95, 97

Buchanan, George, 41

Burgkmair, Hans, 32

Burrell, Sir William, 114

Callot, Jacques, 96

Carlin, Martin, 96, 97

Carmichael, Sir Thomas David Gibson, 114

Carmontelle, Louis Carrogis de, 105

Carrier-Belleuse, Albert-Ernest, 107, 108; **68**

Carver, Robert, 34

Charles II, King of Great Britain and Ireland, 44, 45, 51, 52, 53, 93

Chartres, Thomas of, 19

Clayton, Thomas, 60

Clerk, Sir John of Penicuik, 56

Coiny, Mathieu, 111; **71**

Craig, James Gibson, 105

Cressent, Charles, 77, 78; **39**

Culzean Castle, 104

Dalkeith Palace, 93, 97

Dalmeny House, 99, 100; **63**

Dalou, Aimé Jules, 110; **70**

David, Jacques-Louis, 84, 86, 101; **49**

David I, King of Scotland, 11, 12

Debreuil, Toussaint, 50

Delacour, William, 60, 61

Dick, Sir Alexander, 56

Donaldson, Alexander, 58

Douai, Scottish College at, 45

Drochil, tower house at, 41

Drouais, François-Hubert, 61; **26, 27**

Drumlanrig Castle, 47, 93, 95, 96, 97

Drummond, John of Milnab, 33

Dubois, M., 60

Dufresne, Louis, 67

Dunfermline Abbey, 19

Dunrobin Castle, 107, 108

Dunsterfield, George, 47

Dupasquier, Leonard, 63, 66

Durenne, A., 108; **69**

Edinburgh
 National Gallery of Modern Art, 116
 National Gallery of Scotland, 104, 116; **25**
 National Library of Scotland, 27, 45; **10, 16**
 National Museum of Antiquities of Scotland, 13, 19, 34, 59; **2, 4, 14, 24**
 Royal Scottish Museum, 49, 54, 68, 89, 111, 112, 116-120; **18, 53, 55, 75-80**
 Scottish United Services Museum, 68
 University Library, 26, 28; **9, 11**

Edinburgh Castle, 41

Elgin, Earl of, 104

Erskine, Sir James of Torrie, 104

Eugénie, Empress, 92

Falkland Palace, 23, 30, 32, 34

Fesch, Cardinal Archbishop of Paris and of Lyons, 104

Feuchère, Jean-Jacques, 107, 108; **67**

Flahaut-de-la-Billardie, August-Charles-Joseph, Comte de, 99

Flamand, Pierre, 49, 50; **18**

Floors Castle, 101, 102

Foliot, Bartrahame, 31

Fontaine, Pierre-François-Léonard, 75

Forbes, Patrick, Bishop of Aberdeen, 44

Fortier, Vincent, 50

Foulis, Andrew, 60

Foulis, Robert, 60

France
 books from, 9, 34, 41, 44-47, 56, 58-60, 63, 67, 75, 77, 92, 114
 manuscripts from, 9, 13, 26-28, 34, 77, 114
 music books from, 20, 21, 34, 45
 painters, 41, 60-67, 69-70, 84-86, 101, 104-106, 114; **26-29, 32, 49, 66**
 scientists, 45, 67
 universities in, 19, 23, 24, 41, 43, 44

Franch, John, 23

Franch, Thomas, 23

Franco-Scottish Alliances (*see also* "Auld Alliance"), 9, 16-19, 29, 30, 34, 41, 43

Fréchou, Charles, 105; **66**

garde écossaise, 19

George IV, King of Great Britain and Ireland, 63, 73, 84, 93

Gilzeame (*tapistre*), 33

Girardy, Irrouard le, 63, 66; **28, 29**

Glasgow
 Burrell Collection, The, 114; **72, 73**
 Hunterian Art Gallery, 61
 Kelvingrove Art Gallery, 116

Glasgow Boys, the, 105

Gordon, Dukes of, 97

Gordon Duff (family), 105

Grimond, Joseph, 105

Guinand (artist), 63; **28**

Haddo House, 105

Hamilton, Alexander Archibald Douglas, 10th Duke of, 7, 10, 71-93; **33**

Hamilton, David, 73, 75; **34, 35**

Hamilton, John, Archbishop of St Andrews, 34

Hamilton, William Alexander Archibald Douglas, 11th Duke of, 92

Hamilton Palace, 71-93; **34-56**

Hawkins Collection, 111

Hédouin, Jean-Baptiste, 97

Hill of Tarvit, 110, 111

Holyrood Abbey and Palace, 12, 30, 33, 46, 47, 68-70; **1, 17**

Hopetoun House, 47, 59

Huet, Jean-Baptiste, 66; **29**

Hume, David, 58, 61, **22**

Hume, Robert, 75

Hunter, Dr. William, 61

Huntly, George, 4th Earl of, 36, 37

Huntly Castle, 36, 37

imperial family (French), 92, 101, 104

Inveraray Castle, 63, 66, 67; **28, 29**

James V, King of Scotland, 29-35

Joubert, Gilles, 99, 102; **63, 64**

Jully, Ange-Laurent de Lalive de, 84; **48**

Kennedy, James, Bishop of St Andrews, 24, 26; **8**

Kerr (family), 44

Kinnaird, Charles, 8th Baron, 103

Kinneil Castle, 41

Kinross House, 47

Kirkwall, Earl's Palace, 41

Langlois, Pierre, 99

Lansdowne, Marquesses of, 99, 101

Lauderdale, Duke of, 47

Le Bastier, Charles, 111; **71**

Lefèvre, Robert, 104, 111

Leleu, Jean-François, 99

Lennoxlove House, 38, 41, 50, 51

Lennoxlove toilet service, 49-54; **cover, frontispiece, 18**

Levasseur, Étienne, 77, 78, 84, 96

Linlithgow Palace, 30, 32, 35

Linnell, John, 66

Lorimer, Robert, 110

Lothian, Marquesses of, 45

Mansfield, Earls of, 98, 99

Mansioun, Andrew, 32, 33

Marie, Princess of Baden, 92

Martin, Moses, 31; **12**

Mary of Guise, 30, 31, 33, 35-38

Mary Queen of Scots, 32, 35-41, 71; **13, 14**

Mary Queen of Scots' casket, 38-41; **15**

Masse, Pierre, 49-50; **18**

Mayelle, Jean, 24, 26; **8**

Mayser, John, 31

Melrose Abbey, 22, 23; **6**

monastic orders, 12, 14, 15

Montagu, Ralph, 93

Monthermer, Lord, 93

Moray, Col. James, 104

Moray, Sir Robert, 45

Moreau, Robert, 32

Morrow, John, 22, 23; **6**

Mossman, John, 33

Murray, Alexander, 91

Murray, Lord, 105

Mylne, Robert, 63

Mylne, William, 63

Napoleon I, Emperor of France, 9, 10, 71, 75, 84, 86, 87, 89, 91, 92, 99-101, 103, 104; **49, 52-56**

Napoleon III, Emperor of the French, 92

Nelson, William, 105

Oeben, Jean-François, 99; **63**

Orchardson, Sir William Quiller, 110

Orléans Collection, 104

Passing (armourer), 33

Pavillon, Charles, 61

Payien, M., 60

Penman, James, 44, 45

Percier, Charles, 75, 87; **36, 37**

Planqué (*tapissier*), 99

Prévost, Pierre, 52

Ramsay, Allan, 56, 57, 60, 61; **22, 25**

Reid, Alexander, 106

Richmond, Duchess of, (*see also* Frances Teresa Stuart)

Riesener, Jean-Henri, 77-84, 98, 99; **40-47, 61, 63**

Risenburgh, Bernard van, II, 66, 99; **30, 63**

Robertson, Robert, 33

Rodin, Auguste, 110

Rosebery, Earls of, 99, 100, 101

Ross, Daniel, 108; **69**

Rothschild, Baron Meyer Amschel de, 99

Rousseau, Jean-Jacques, 58, 61; **25**

Roxburghe, 8th Duke of, 101

Roxburghe, May, Duchess of, 101, 102

Roy, Nicholas, 31; **12**

Roytell, Jean, 35

St Andrews Castle, 35

Saumur, French Reformed College at, 44

Saunier, Jean-Charles, 110

Scone Palace, 98, 99

Scott, Sir Walter, 68, 103, 104

Sené, J. B., 78

Sharp, Frederick B., 110, 111

Sibbald, Robert, 46

Smith, Adam, 61

Smith, James, 47, 93

Soyer and Inge, 75

Steel, George, 34

Stirling Castle, 30, 32, 33

Stormont, David 7th Viscount of, 98

Stuart, Prince Charles Edward, 59

Stuart, Frances Teresa, Duchess of Richmond & Lennox, 51-54; **18-20**

Sutherland, Dukes of, 97, 104, 107, 108; **67**

Taylor, George Watson, 81, 84

Thirlestane Castle, 47

Thorvaldsen, Bertel, 91; **56**

Tiron, Jean-Marie, 111; **71**

Traill, Douglas, 66

Traill, Peter, 66

Traquair, Earls of, 45

Urie, Robert, 58

Urquhart, Thomas, 45

Vassé, Louis-Claude, 116; **80**

Vrelant, William, 26; **9**

Wardlaw, Henry, Bishop of St Andrews, 23

Weisweiler, Adam, 110, 111

Wet, Jacob de, 47, 50

White, James Cathcart, 111, 114; **71**

Young, Trotter & Hamilton, 69

EXHIBITION CHECKLIST

FRENCH IMPORTS AND INFLUENCES, 1100-1600

1. Colour Photograph. Holyrood Abbey Church, 13th century. French ideas and styles were transmitted through the medium of England. Fig.1.

2. The Whithorn Crozier. *Champlevé* enamel on copper. English, late 12th century. 19.3 x 9 cms. Lent by the National Museum of Antiquities of Scotland, Edinburgh, KC (1984). Excavated in the wooden coffin of an unidentified bishop in the east end of the Premonstratensian Cathedral Priory church of Whithorn, Galloway. Whithorn came under the jurisdiction of the metropolitan see of York. Stylistic analysis of the crozier suggests that it may be connected with the West Country. Fig. 2.

3. *Gospel according to St Matthew.* Glossed. French?, 12th century. 25 x 15 cms. Lent by St John's College, Oxford, Ms.111. The book has been rebound but an ex-libris has been salvaged and pasted on to a modern fly-leaf. With abbreviations expanded, it reads: "Hic est liber sanctorum de May quem qui celauerit uel fraudem de eo fecerit, anathema sit". The Isle of May in the Forth estuary was the retreat of St Adrian and the place of his martyrdom. A small Cluniac priory was established on the island under David I. The king arranged that the monks of Reading Abbey would maintain nine brethren on the desolate, windswept spot to celebrate Mass for the soul of the founder, his predecessors and successors. During the reign of William the Lion the monks were apparently increased to thirteen. The Cluniac order developed elaborate liturgical observances and priests from the order were probably regarded as ideal servants of a royal, martyr foundation. The priory subsequently came under the Augustinian Abbey of St Andrews.

4. Psalter. French (Paris), 1240s. 14 x 10 cms. Lent by the Bodleian Library, Oxford, Ms. Douce 50. Three leaves with double miniatures depicting *Christ enthroned* and *Hell*, the *Adoration of the Magi* and the *Presentation in the Temple*, and the *Ascension* and *Pentecost* follow the calendar. The sequence, which illustrates the *Last Judgement* and the *Life of Christ*, is clearly incomplete and there must originally have been other similar leaves. Historiated initials. The calendar is English. January-February and November-December are missing. Scottish and Irish saints are included in the calendar and in the litany. St Brendan (18 May), St Columba (9 June, erased) and St Mundus (21 October) are all in red in the calendar. The saints in the litany include Cuthbert, Mundus, Patrick, Blane, Bean, Berchan, Columba, Bernard (? of Thiron), Fechan, Benedict, Anthony and Maurus. Mundus (21 October) is the Irish Fintan Munnu, founder of Taghmon in Ireland. He was also a follower of Columba, was venerated in Scotland and is said to have founded Kilmun in Argyll. These indicators may point to Ardchattan in Argyllshire, founded in 1230 or 1231 and one of three Valliscaulian priories in Scotland directly dependent on Val des Choux near Langres in France. An erased inscription at the end of the text appears to read "Liber . . . lis/prioris . . . cha . . .", and may confirm this theory. Fig. 3.

5. Bible. English or Northern French, 13th century. 16 x 11 cms. Lent by Mr P. Maxwell Stuart, Traquair House, Innerleithen, Peeblesshire. Ex-Culross Abbey, Fife. The Cistercian abbey of Culross was founded by Malcolm, Earl of Fife, in 1217.

6. *Mémoires touchant l'ancienne alliance entre la France et l'Escosse, et les priviléges des Escossis en France.* 30 x 22 cms. Lent by Aberdeen University Library, Ms.213. Manuscript in French containing a copy of the main documents relating to the alliances between France and Scotland. Presented to Marischal College, Aberdeen, in 1764 by George Irving, a graduate of the College who lived near New Deer.

7. Facsimile copy of *The Siege of Caerlaverock*, edited by Sir Nicholas Harris Nicolas (London, 1828). 28.7 x 22.3 cms. Lent by Aberdeen University Library. Caerlaverock Castle, near Dumfries, was taken by Edward I in July 1300. For two days, sixty Scots defended the stronghold against 3,000 English troops. This chivalric French poem chronicles the siege from the English standpoint. The original manuscript is in the British Library, London.

8. Carved Fragments from the Alabaster Tomb of Robert the Bruce. Thomas of Chartres. French (Paris), c. 1329. Lent by the National Museum of Antiquities of Scotland, Edinburgh, KG 65-8, 70-1, 74.

Robert the Bruce died at Cardross on 9 June 1329. His body (minus the heart, which was to be taken on pilgrimage) was conveyed to the Abbey Church of Dunfermline, and buried before the High Altar. An alabaster tomb by Thomas of Chartres, a sculptor living in Paris, was imported by way of Bruges and erected above the king's remains. The alabaster may originally have come from Nottingham; gold leaf was bought for the tomb in Newcastle and York. The tomb has long since been destroyed. References to it may be found in *The Exchequer Rolls of Scotland*, vol. I. A description of the excavation of the grave is published in *Archaeologica Scotica*, II, 435ff. Other fragments exist. Two more pieces associated with the tomb are in NMAS (KG 69 and 73). They are exhibited separately, on the right: their appearance suggests that they come from another monument.

Measurements in centimetres, reading from left to right:

KG 66 17 x 6.8 x 6
71 19.7 x 6 x 5.9
72 8.7 x 3.5 x 3.8
65 6.6 x 4 x 3
70 10.8 x 5.7 x 3.8
68 11.5 x 5.8 x 2.7
67 6.5 x 5.8 x 3.7
74 6.6 x 4.5 x 2.1
69 7.4 x 7 x 2.8
73 9 x 4.3 x 2.6

9. Figure of *Christ. Champlevé* enamel on copper. Relief figure of crucified, fully robed and crowned Christ from a crucifix or processional cross. The body and crown made separately. Four nail holes in the hands and feet. Christ is represented as the "King of Glory". He is shown alive, in majestic pose, with no suggestion of pain, wearing what would have been a colourful robe and a large crown. French (Limoges), 13th century. 17 x 13.3 x 1.1 cms. Lent by the National Museum of Antiquities of Scotland, Edinburgh, KE 7. Found in the churchyard at Ceres, Fife. Fig. 4.

10. Plaque showing *Christ blessing. Champlevé* enamel on copper. Square plaque, from the centre of the back of an altar cross, showing a beardless Christ with his right hand raised in blessing. French (Limoges), 13th century. 6.1 x 6.1 cms. Lent by the National Museum of Antiquities of Scotland, Edinburgh, KE (1977). The plaque was found in excavations into the Teampull Bhuirgh (church of the castle), Borve, Benbecula, in the Outer Hebrides, in 1943. It was on the chest of a skeleton. The two extra holes made on either side of Christ's head suggest that it was used as a costume accessory. Fig. 4.

11. Plaque showing the *Crucifixion. Champlevé* enamel on copper. French (Limoges), c. 1325. 15.1 x 3.8 cms. Lent by the Duke of Atholl, Blair Castle, Blair Atholl, Perthshire. Said to have been discovered during repairs at Dunkeld Cathedral in 1818. Fig. 5.

12. Hasp. Copper, chased and gilded, with *champlevé* enamel decoration. Two pieces of copper in the form of stylized animals joined by a hinge. French (Limoges), 13th century. 35 x 2.5 x 1.8 cms. Lent by the National Museum of Antiquities of Scotland, Edinburgh, KJ 88. From a coffer. Found in the bank of Beck's Burn, between the graveyard of the old church of Wauchope and Wauchope Castle, near Langholm, Dumfriesshire.

13. Pricket Candlestick. Copper with *champlevé* enamel decoration. French (Limoges), 13th century. 22.1 x 9 x 10.4 cms. Lent by the National Museum of Antiquities of Scotland, Edinburgh, KJ 22. Found in digging the foundation of the parish church of Kinnoul, near Perth.

14. Pricket Candlestick. Copper with *champlevé* enamel decoration. French (Limoges), 14th century. 9.1 x 6.3 x 5.8 cms. Lent by the National Museum of Antiquities of Scotland, Edinburgh, HX 506. Found at Bothwell Castle, Lanarkshire.

15. Dagger Pommel. *Champlevé* enamel on cast bronze. Crescent-shaped dagger pommel with decorative coat of arms. French (Limoges)?, late 14th century. 2.7 x 3.2 x 1.2 cms. Lent by the National Museum of Antiquities of Scotland, Edinburgh, LC (1975-6). Found in a garden in Fortingall, Perthshire. Fig. 4.

Slide Programme. The transparencies include selected folios from the manuscripts on display and a few items not in the exhibition, notably the so-called Mary Queen of Scots casket (Fig. 15).

16. Colour Photograph. Melrose Abbey, South Side, early 15th century. The tracery in the transept window and in some of the chapels is attributed to the French-born master mason John Morrow. Courtesy of the Scottish Development Department (Historic Buildings and Monuments), Edinburgh. Fig. 6.

17. Mace identified as that of the Faculty of Canon Law, University of St Andrews. Silver-gilt with enamelled plaques. French, c. 1410-18. 128.3 cms. Lent by the University of St Andrews. This mace is discussed in Chapter I, along with the two maces nos. 18 and 19. The figures on the plaques represent the Virgin Mary and Christchild, St John the Baptist with the *Agnus dei* or Lamb of God, St Michael fighting the dragon, St Andrew with his cross, St Leonard represented as an abbot (with crozier), and the "Woman of the Apocalypse" (see *Revelations* 12:1), interpreted as the Virgin Mary. Fig. 7.

18. Mace of St Salvator's College, St Andrews. Silver-gilt. Jean Mayelle. French (Paris), 1461. 116.2 cms. Lent by the University of St Andrews. The mace is discussed in Chapter I. It was commissioned by the founder of St Salvator's College, James Kennedy, Bishop of St Andrews (d. 1465). The hexagonal head is designed as an open shrine and contains a statuette of Christ as the Holy Saviour (the Sanctus Salvator, to whom the college is dedicated) standing on a globe, his hands raised in benediction. The angels hold instruments of the Passion. James Kennedy's initials, "ıĸ", are chased in spiral bands on the rod of the mace. Fig. 8.

19. Mace of the University of Glasgow. Silver-gilt with engraved and enamelled decoration. French or German, 1465-9? 146 cms. Lent by Glasgow University. The attribution of this mace has still to be resolved. The surviving documentation in the university archives does not appear to record its origin.

20. *Talbot Hours.* Northern French, mid 15th century. 22.4 x 9 cms. Lent by Blair's College, Aberdeen (on deposit in the National Library of Scotland, Dep. 221/1). Apparently made in France for a member of the family of Bethune of Balfour. The manuscript is displayed open to show a picture of the Virgin Mary and Christchild accompanied by two standing saints and a kneeling man and woman, the man bearing the Talbot arms on his tabard; a floral design including two identical shields of arms; and the letters "ıв" in a love knot. The arms are those for Bethune (1st and 4th azure a fess between three mascles or) and Balfour (2nd and 3rd argent on a chevron sable an otter's head erased of the first). An inscription on fo.1 reads "Ex bibliotheca Collegii Scotorum Paris".

21. Book of Hours. Scottish, c. 1450. 15 x 11 cms. Lent by the Victoria and Albert Museum, London, Reid 54. Use of Sarum. Scottish saints in the calendar and litany. Written for use in Scotland, perhaps in East Lothian. The miniatures with borders are in imitation of North French work.

22. Virgil Manuscript. French (Paris), c. 1460. 24 x 15 cms. Lent by Edinburgh University Library, Ms.195.

The manuscript contains the *Eclogues* or *Bucolics*, *Georgics* and *Aeneid* and also Vegio Maffei of Lodi's continuation of the *Aeneid*. A colophon reveals that it was written by one "Florius infortunatus" in Paris: "Florius infortunatus calamo parisius hunc librum exaravit. Deo gratias. Amen." The decoration is in the style of William Vrelant. The Royal Arms of Scotland on fo.65 indicate that the manuscript was executed or completed for a royal Scottish owner. The initials "ᴘʟ" are tentatively interpreted as referring to the Princess Leanora or Eleanor, daughter of James I. The manuscript is displayed open at fo.65 to show the royal arms and the initials. The miniature depicts the reception of Aeneas by Dido at Carthage. Aeneas is seen kneeling to Dido before the gate of the city. The two lines in gold are the beginning of the *Aeneid*. Fig. 9.

23. Prayerbook of Robert Blackadder, Bishop and subsequently first Archbishop of Glasgow (d. 1508). Northern French, 1483-92. 19 x 13 cms. Lent by the National Library of Scotland, Edinburgh, Ms.10271. A cleric, presumably Blackadder, is shown before the crucified Christ on fo.47v., and a prayer on fo.41 contains the supplication "Libera me domine, Robertum famulum tuum, ab omni malo". A number of Scottish saints are included in the calendar, such as Kentigern (13 January), Duthac (8 March), Kessog (10 March), Columba (9 June) and Ternan (12 June). 8 July has "Dedicatio ecclesie glasguensis" in red and 2 November "Dedicatio ecclesie aberdonensis" in black. The saints in the litanies include Columba, Machar, Ninian and Kentigern. The suffrages of the saints include Ninian, Cuthbert and Margaret of Scotland. There are numerous small miniatures and historiated initials, including Saints Ninian and Margaret of Scotland. Robert Blackadder became Bishop of Aberdeen in 1480, Bishop of Glasgow in 1483 and Archbishop of Glasgow in 1492. Ex-libris of Alexander Stewart, Archbishop of St Andrews (d. 1513), on fo.1. King James IV was appointed superior of Blackadder's last will and testament, and it would seem that he handed Blackadder's book of devotions to his son, who was killed at the Battle of Flodden. The name of Alexander, 5th Lord Livingston, is stamped on the binding. Fig. 10.

24. *The Playfair Hours.* French (Rouen), 1480s. 17.5 x 11.5 cms. Lent by the Victoria & Albert Museum, London, L.475-1918.

Rouen was an important town and a major centre of book production in the fifteenth century. Many Scots passed through its gates and presumably bought manuscripts and other items from the local workshops. The illuminated manuscript workshops produced books of hours according to the Use of Sarum (rather than the Use of Rouen) for English and Scottish customers. Calendars which included and gave prominence to Scottish saints were bound in the front of some of these books to meet the requirements of real or potential Scottish customers.

The calendar in the *Playfair Hours* contains two major feasts which are not standard in the Sarum calendar: the feast of St Kentigern, the patron saint of Glasgow (13 January), and the feast of St Ninian, the reputed apostle of the Picts (16 September). Other Scottish saints include Fillan of Strathfillan, Perthshire, an eighth century saint to whom Scots attributed their victory at Bannockburn in 1314 (9 January); Monan, the evangelist of Fife (1 March); Adrian (4 March); Baldred, a suffragan of Kentigern (6 March); the Cornish saint Constantine, who is said to have been martyred in Kintyre in 576 (9 March); and Kessog of Luss, Dumbarton, a sixth century saint martyred on the banks of Loch Lomond in 560. Nothing is known about the original owner.

The group of related Rouen books of hours with calendars containing Scottish saints includes Edinburgh University Library, Ms.43 (see below,

no. 25); the *Farmor Hours*, Koninklijke Bibliotheek, The Hague, Ms.133 D16; and the *Yester Hours*, Magdalene College, Cambridge, Pepys Library, Ms.1576.

25. Book of Hours. French (Rouen), late 15th century. 21.3 x 15.1 cms. Lent by Edinburgh University Library, Ms.43.

This manuscript is related to the *Playfair Hours* (see above, no. 24). The devotions conform to the Use of Sarum, indicating that they were intended for a customer living in the British Isles. A separate calendar with entries referring to Scottish saints is bound at the beginning of the book, enabling one to deduce that the finished product was either completed for a Scot or aimed at the Scottish market. The Scottish saints in the calendar include Fillan (9 January), Kentigern (13 January), Baldred (5 March), Patrick (17 March), Dongard (24 March) and Ninian (31 August and 16 September). There are no Scottish saints in the litanies. The manuscript is displayed open at fo.117 to show the miniature of the *Mass of St Gregory*. This was not an incident in the life of Pope Gregory the Great (c. 540-604), nor does it appear in the account of the saint's life in the *Golden Legend*. It is a late legend, probably evolved from Gregory's role in the development of the liturgy of the Mass and his belief in miracles and the potency of relics. The story tells how the saint, finding a disbeliever in his congregation, prayed for a sign and was rewarded by the appearance over the altar of the crucified Christ and the instruments of the Passion. The Real Presence of Christ in the sacrament was confirmed. Fig. 11.

26. Book of Hours. French, late 15th century. 15.5 x 11.5 cms. Lent by Emmanuel College Library, Cambridge, Ms.84. Written for Scottish use. The saints in the calendar include Ninian (31 August and 16 September) and Cuthbert (4 September). The saints in the suffrages include Eustace, Giles, Magnus, Margaret, Kentigern, Columba, Duthac and Ninian.

27. Model of the *Great Michael*. Scale 1:48. R. Paterson. Scottish (Lasswade), c. 1926. 112 x 130 x 53.3 cms. TY 1926.20.

The *Great Michael* was designed by a Frenchman, Jacques Terrel, and built under his supervision in the royal dockyard at Newhaven, near Edinburgh, between 1505 and 1511. She was the pride of James IV's navy, and a tremendous commitment in resources. The historian Robert Lindsay of Pitscottie (c. 1532-80) described her as "ane verrie monstruous great schip" which "tuik so meikle timber, that schoe wasted all the woodis in Fyfe except Falkland wood". He continues:

"many of the schipwrightis in Scotland wrought at hir, and wrichtis of uther countries had thair devyse at hir . . . This schip was twelff scoir footis lenth; threttie sax foott within the wallis: schoe was ten foot thik within the wallis of cutted risles of oak, so that no cannon could doe at hir . . ."

The total cost of the ship, including her extensive artillery, was in the region of £30,000—a tremendous sum for those days. The *Great Michael* was extremely expensive to maintain. Pitscottie notes that:

"schoe had thrie hunder marineris to governe hir; sixscoir guneris to use her artaillarie, and ane thousand men of warre, by captanes, skipperis and quarter maisteris".

These men required wages and also food: when the *Great Michael* went to sea, she carried 3,000 gallons of ale, 5,300 fish, 13,000 loaves and 200 stones of cheese.

The *Great Michael* was the equivalent of a dreadnought battleship or a Polaris submarine in the early sixteenth century, and much too powerful and expensive a capital ship for a relatively poor country such as Scotland. When war was declared between England and Scotland in 1513, the Scottish fleet was sent to aid the French, already at war with England. After the death of James IV at Flodden and the succession of a minor, there was no point in trying to maintain the *Great Michael*, and certainly not the resources. She was purchased by the French to replace the *Cordelière*, which had been destroyed at sea. The subsequent history of the *Great Michael* is not known, but it is believed that she was moored in Brest harbour.

28. Colour Photograph. The South Range of Falkland Palace. Two French master masons, Moses Martin and Nicholas Roy, worked on Falkland Palace between 1537 and 1541. Courtesy of the Royal Commission on the Ancient and Historical Monuments of Scotland, Edinburgh. Fig. 12.

29. *The Beaton Panels*. Oak. Scottish, c. 1540. 171 x 706 x 8.5 cms. Lent by the National Museum of Antiquities of Scotland, Edinburgh, L.1982.50.

The present arrangement of these panels dates from the seventeenth century when they were incorporated into the panelling of the dining-room at Balfour House, Fife—the home of the parents and descendants of Cardinal David Beaton, Archbishop of St Andrews (d. 1546). The first three panels are carved with representations of the *Annunciation*, the *Tree of Jesse* and the *Arma Christi*. The fourth panel has the Cardinal's arms above those of his parents and the fifth panel the Scottish Royal Arms. The sixth and seventh panels are carved with floral motifs, including thistles. The eighth panel is made up of roof bosses, including the royal arms and four Beaton shields.

The arms indicate that the panels were commissioned by Cardinal Beaton (see no. 30). It has long been assumed that they were assembled from the choir stalls formerly in Arbroath Abbey, of which Beaton was abbot. However there is no evidence of this and it seems to be unlikely on two grounds. Firstly, with the exception of the four cut-down tracery panels beneath the main panels, the panels are not in character, as one would expect of elements of choir stalls. Secondly, it is difficult to explain how they could have passed from Arbroath Abbey into the possession of the Beaton family. A more likely theory is that they came from St Andrews. The castle would seem a good possibility, and it is perhaps relevant that it was in the keeping of the Cardinal's nephew, the Laird of Balfour.

French influence is apparent in the scrolling bunches of grapes, while the main panels suggest connections with French printed book illustrations. The *Tree of Jesse* can be linked with treatments of the same subject in French books of hours. However the panels are very conservative for about 1540—the implied date. A French carver can be expected to have worked in a more *avant-garde*, Renaissance style. The panels would therefore appear to be the work of a Scottish carver with a limited knowledge of French art.

Note: *The Beaton Panels* are exhibited in the Main Hall, near the entrance to the exhibition.

30. Archibald Hay, *Pro Collegii Erectione* (Paris, 1538). Painted arms of Cardinal David Beaton (?1494-1546) with decoration in the Renaissance style. 21 x 15.5 cms. Lent by York Minster Library. The famous owner of this book served as ambassador to France in 1519, 1533 and 1539. He was made Bishop of Mirepoix in France in 1537, Cardinal in 1538, Archbishop of St Andrews in 1539, and Chancellor in 1543. Cardinal Beaton was the leader of the pro-French, pro-Papal party; his pro-French policies and persecution of protestants led to his murder on 29 May 1546.

31. John Major, *In Quatuor Evangelia Expositiones* (Paris, 1529). Illuminated ex-libris of William Stewart (1479-1545), Bishop of Aberdeen, with inscription in panel with Renaissance decoration. 34.5 x 23 cms. Lent by St Andrews University Library. John Major (1467-1550), the author of this work, was born at Gleghornie, East Lothian, and studied at Cambridge and Paris. He was professor of theology at Glasgow (1518) and St Andrews (1522) before returning to Paris (1525-33); he subsequently settled in St Andrews. His most important work was the *History of Greater Britain* (Paris, 1521). William Stewart, who owned this copy of *In Quatuor Evangelia*, became dean of Glasgow in 1527 and bishop of Aberdeen in 1532. He was responsible for building the library of King's College, Aberdeen.

32. *Missale Romanum*. Printed by Thielmann Kerver (fl.1497-1522), Paris, 1521. Illuminated ex-libris of Alexander Mylne (1474-1548), Abbot of Cambuskenneth, with inscription and vase of flowers. 34.5 x 24.5 cms. Lent by the Scottish Catholic Archives, Edinburgh (on deposit in the National Library of Scotland). Alexander Mylne was Canon of Dunkeld, Abbot of the Augustinian Abbey of Cambuskenneth, and first Lord President of the College of Justice (1532). He was the author of the *Lives of the Bishops of Dunkeld* and overseer of various religious and secular architectural projects. This missal was published in the same year that James, Bishop of Dunblane, consecrated the great altar, chapter house and two new cemeteries erected by Abbot Mylne at Cambuskenneth. A fascinating letter survives, dated 15 June 1522, from Mylne to the Abbot of the Augustinian monastery of St Victor in Paris, which reveals that Mylne was planning to send some novices to Paris for instruction.

33. *The Scone Antiphonary*. A large choirbook containing compositions by Robert Carver, Cornyshe, Dufay, Fayrfax, Lambe and Nesbett. Scottish (Scone Abbey, Perth). Carver's *Missa Pater creator omnium* (ff.4-6) is dated 1546. 39.5 x 30 cms. Lent by the National Library of Scotland, Edinburgh, Adv. Ms.5.1.15. The antiphonary is displayed open to show Dufay's *Missa L'homme armé* (ff.26v-42)—a rare instance of the copying of a Dufay Mass into an English or Scottish manuscript. Robert Carver was the greatest

Scottish composer of the sixteenth century. His *Missa L'homme armé* (ff.52v-66) is modelled on Dufay's Mass and is the only known English or Scottish example of a Mass based on a theme used by generations of continental composers.

SCOTS IN FRANCE

Many Scots visited France during the seventeenth century and returned with books, clothing and other luxury items.

34. *Robert, Lord Kerr, later 4th Earl and 1st Marquess of Lothian* (1636-1703). Oil on slate. Attributed to Abraham Raguineau (1623-c.1681). 22.9 x 17.8 cms. Lent by the Marquess of Lothian. Members of the Kerr family visited France during the seventeenth century. Robert, Lord Kerr, and his brother William resided in Paris and other towns in France in the 1650s, in the custody of their tutor, Michael Young. The first four books in this case are drawn from the family library.

35. Pierre de La Noue, *La Cavalerie Françoise et Italienne* (Lyons, 1620). 36 x 25 cms.

36. Claude Chastillon, *Topographie Francoise, ou, Representations de plusieurs villes, bourgs, chasteaux, maisons de plaisance, ruines & vestiges d'antiquitez du Royaume de France* (Paris, 1641). 44.5 x 31.5 cms.

37. Pierre Dan, *Le Tresor des Merveilles de la Maison Royale de Fontainebleau* (Paris, 1642). 35 x 25.4 cms. Robert and William Kerr and their tutor spent six days at Fontainebleau during their stay in Paris. The book is open at page 29 to show an engraving by Abraham Bosse (1602-76) of the "Maison Royalle de Fontaine Belleau".

38. Guillaume Girard, *Histoire de la Vie du Duc d'Espernon* (Paris, 1655). 40.5 x 28.5 cms. This is almost certainly the copy of the book which Robert and William Kerr purchased in Paris: "La vie du Duc d'Espernon in great paper—22 livres".

All four books come from the Newbattle Collection: the property of the National Library of Scotland, at present in the custody of the Marquess of Lothian.

39. Bound Volume of Engravings of Flowers, printed on vellum and hand-coloured in watercolours. 17th century. 33.7 x 22 cms. Lent by the National Library of Scotland, Edinburgh, Adv.Ms.23.1.8. Deleted inscriptions "Paris April 26 1670" and "Pa Moray" on the first and last folios. Acquired by Patrick Murray of Livingston during a botanical visit to France shortly before his death. Bought at the sale of Sir Robert Sibbald's library, 1723. This volume reflects the "specialist" interest of Scottish physicians, surgeons, medical botanists and gardeners in France during the seventeenth century. Fig. 16.

TABLEAU I

40. The Lennoxlove Toilet Service. Silver-gilt. French (Paris), 1661-77. 1954.8 & A-R.

The Lennoxlove toilet service was "discovered" at Lennoxlove, in East Lothian, shortly after the death of the 12th Lord Blantyre in 1900. Lennoxlove had been purchased by the executors of Frances Teresa Stuart (1647-1702), Duchess of Richmond and Lennox, for her cousin, Walter Stuart, in the early eighteenth century, and the service is believed to have been amongst the "plate, jewels, goods and chattels" which the Duchess bequeathed to her cousin. The tableau represents Frances Teresa Stuart, a celebrated beauty of the court of Charles II, being prepared for a ball by her maid. Most of the silver produced in France during Louis XIV's reign has been melted down, and only three other French seventeenth century toilet services have survived more or less intact. The Lennoxlove service is only surpassed by the larger service by Pierre Prévost (now at Chatsworth), which was owned by Queen Mary, the wife of William III. The fact that the articles were not a special commission but were assembled from stock indicates the extremely high quality of goldsmiths' work during the reign of the "Sun King". With the exception of the candlesticks, which appear to be by Pierre Masse, the service is by a goldsmith whose mark is interpreted as Pierre Flamand or Flament.

Details about the travelling chest and the seventeen articles of silver-gilt are set out below. In addition there are sixteen leather-covered boxes: the two candlesticks fit into one box. Cover, frontispiece and Fig. 18.

Item (silver-gilt unless otherwise stated)	Measurements in cms.	Ducal coronet and cypher	Maker's mark	Wardens' mark	Crowned "A" with three fleur de lys: identified as the mark of the tax farmer Vincent Fortier (12 October 1672-5 August 1677)
Travelling chest. Carcase of oak veneered in walnut with silver-gilt mounts.	36.5 x 81 x 47.5	✓ (applied)	[—]	[—]	[—]
Two candlesticks. Each with a detachable nozzle. Cast. Floral decoration. Not *en suite*.	With nozzle 13.2: without nozzle 12.6 x 11.2	✓ (engraved)	Crowned fleur de lys, two *grains*, and the initials "P" and [?] separated by two crossed maces.	"R" (30 December 1661-27 June 1663)	✓

Item (silver-gilt unless otherwise stated)	Measurements in cms.	Ducal coronet and cypher	Maker's mark	Wardens' mark	Crowned "A" with three fleur de lys: identified as the mark of the tax farmer Vincent Fortier (12 October 1672-5 August 1677)
Two large rectangular caskets. Cast, *repoussé* and chased floral decoration.	10.2 x 29.7 x 25	V (applied)	Crowned fleur de lys, two *grains*, and the initials "P" and "F" separated by a flame.	"X" (21 June 1666-8 June 1667)	"
Two large shaped salvers. Decoration as above.	6.9 x 28.3 x 21.3 6.2 x 28.3 x 21.5	" "	" "	" "	" "
Circular salver. Decoration as above.	6.5 x 27.4	"	"	"	"
Rectangular mirror surmounted by a ducal crown and the cypher in a tondo. Decoration as above.	55.5 x 54.5 x 6.5	"	"	"H" (16 July 1676-15 July 1677)	"
Rectangular casket with pin-cushion on the lid. Decoration as above.	10.6 x 19.3 x 13.2	"	"	Probably "I" (15 July 1677-18 June 1678)	"
Two large circular boxes. Cast and chased floral decoration.	8.5 x 13 8.5 x 12.8	" "	" "	"I" (see above) "R" (see above) or "B" (11 July 1670-16 June 1671)	" "
Two small circular boxes. Decoration as above.	3.9 x 8.3	" "	" "	Probably "I" (see above) [—]	" "
Large brush. Decoration as above.	23.8 x 14	—	"	[—]	"
Small brush. Decoration as above.	16 x 7.5	—	[—]	[—]	"
Two rectangular perfume bottles. Each with a sprinkler cap and a domed cover with a trefoil finial.	17.5 x 8.2 17 x 8.2	V (chased) "	Crowned fleur de lys, two *grains*, and the initials "P" and "F" separated by a flame.	[—] [—]	" "

Note: Marks on the Lennoxlove service. The above list only records clear marks. It is possible that other marks may be hidden from view or have been erased during the completion of the decoration. In addition to these sets of marks, there are also a number of impressions of a crown on some of the items by the goldsmith "PF". These are either discharge marks or the top part of the maker's mark: a few are clearly the latter.

41. *David Hume* (1711-76). Oil on canvas. Allan Ramsay (1713-84). Scottish (London), 1766. 76.2 x 63.5 cms. Lent by the Scottish National Portrait Gallery, Edinburgh, 1057. Fig. 22.

42. *Jean-Jacques Rousseau* (1712-78). Oil on canvas. Allan Ramsay (1713-84). Scottish (London), 1766. 75 x 64.8 cms. Lent by the National Gallery of Scotland, Edinburgh, 820. Fig. 25.

43. *David Hume* (1711-76). Pencil, red chalk and watercolour on paper. Louis Carrogis *dit* Carmontelle (1717-1806). French (Paris), c. 1763-66? 30 x 17.3 cms. Lent by the Scottish National Portrait Gallery, Edinburgh, 2238.

44. Correspondence between major figures of the French Enlightenment and the Scottish philosopher and historian David Hume (1711-76). Lent by the Royal Society of Edinburgh. Three selections of letters will be shown during the course of the exhibition.

45. *John, 5th Duke of Argyll* (1723-1806). Oil on canvas. François-Hubert Drouais (1727-75). French (Paris), 1763. 71 x 58.5 cms. Lent by the Duke of Argyll, Inveraray Castle. Painted during a visit to Paris in 1763, shortly after the signing of the peace treaty which ended the Seven Years War. Fig. 26.

46. *Elizabeth, Duchess of Argyll* (1723-90). Oil on canvas. François-Hubert Drouais (1727-75). French (Paris), 1763. 71 x 58.5 cms. Lent by the Duke of Argyll, Inveraray Castle. The companion to no. 45. Elizabeth, Duchess of Argyll, was a celebrated Irish beauty. She married the 6th Duke of Hamilton in February 1752. He died in January 1758, and Elizabeth married the future 5th Duke of Argyll in March 1759. In addition to being the wife of two Dukes, she was the mother of a further four: the 7th and 8th Dukes of Hamilton and the 6th and 7th Dukes of Argyll. Fig. 27.

Slide Programme on the Interior Decoration of Inveraray Castle. The programme concentrates on the painted decoration in the State Dining Room and Drawing or Tapestry Room by the French artists Guinand and Girard undertaken between c. 1784 and 1788. Figs. 28 and 29.

FRENCH ÉMIGRÉS

47. Two-handled Cup presented to Sir David Dundas, Baronet, by members of the French nobility. Silver-gilt. Jean-Baptiste-Claude Odiot. French (Paris), c. 1820. 51 cms. Lent anonymously.

Campana vase body set on a cubic plinth. Two scroll handles rise from Medusa masks with floral headbands. The vase is decorated with an anthemion scroll band, two medallions representing *Reconnaissance* and *Hospitalité* framed with applied laurel leaves, and leafage. The front of the plinth is engraved:

> "À SIR DAVID DUNDAS BARONNET.
> LES PRINCESSES.
> DE NOAILLES DE POIX.
> D'ALSACE-CHIMAY-D'HÉNIN.
> DE TALLEYRAND-PÉRIGORD-CHALAIS.
> LES MARQUISES.
> DE THUISY.
> DE SOMMERI.
> DE MONTAGU.
> LE DUC.
> DE GRAMMONT PAIR DE FRANCE.
> ET CAPITAINE DES GARDES DU CORPS DU ROI.
> LES MARQUIS.
> DE LALLY-TOLENDAL PAIR DE FRANCE
> ET MINISTRE D'ETAT.
> DE LA TOUR DU PIN PAIR DE FRANCE
> ET AMBASSADEUR À TURIN.
> DE CHABANNES PAIR DE FRANCE.
> DE THUISY MARECHAL DES CAMPS ET ARMEES DU ROI
> LE COMMANDEUR DE THUISY".

There were a number of Sir David Dundases living in the late eighteenth and early nineteenth centuries. The most eminent was General Dundas, G.C.B. (d. 1820). However, the description of the recipient of this cup as "Baronnet" suggests that the person in question was George III's medical attendant. This David Dundas was created a baronet on 22 May 1815; he died on 10 January 1826. His father was Ralph Dundas of Manour, co. Clackmannan, and his mother Mary, daughter of William Berry of Edinburgh.

48. Monstrance presented to St Mary's Roman Catholic Chapel (now St Mary's Cathedral), Broughton Street, Edinburgh, by Henri, Duc de Bordeaux, Comte de Chambord, the titular Henri V, King of France, to mark the occasion of his first communion on 2 February 1832. Silver-gilt. Maker's mark H^RJ? French (Paris), 1819-32. 75.8 x 36 x 16.5 cms. Lent by St Mary's Cathedral, Edinburgh.

A monstrance is an item of altar plate in which the Host (the consecrated bread, signifying the body of Christ) can be seen and venerated. This example takes the form of a radiant sun supported by an angel standing on a rectangular base with four feet. At the centre of the sun's rays is a circular,

glazed display unit in which the Host is placed. A cross surmounts the sun's rays. The heads of five cherubim decorate the central surround. The *Last Supper* and the *Agnus dei* are represented on the front and back of the base respectively. The monstrance is struck in a number of places with the first standard silver, restricted warranty, and large excise marks used in Paris from 1819 to 1838. The front of the base is engraved: "*Donné par Henri Comte de Chambord*/à la CHAPELLE CATHOLIQUE d'EDIMBOURG/le 2 Fevrier 1832".

The French royal family attended Mass at St Mary's during their exile in Scotland between 1830 and 1832, and a special royal pew was fitted out to the right of the altar. The eleven-year-old boy in whose name this monstrance was given was the posthumous son of Charles X's younger son, the Duc de Berri, who was assassinated in February 1820. When Charles X abdicated in August 1830, he transferred authority to his grandson; his elder son, the Duc d'Angoulême, resigned his rights to the throne at the same time. Henri arrived in Edinburgh with his grandfather on 20 October 1830 and departed with him on 18 September 1832. He returned to Scotland for a short visit in 1843, and died in 1883.

The monstrance is shown with its shaped, leather-covered case, which measures 81 x 41 x 20 cms.

49 & 50. Bronze Busts of Louis XVI and Marie-Antoinette presented to Father James Gillis by the Duchesse d'Angoulême, the wife of Charles X's elder son, in August 1832 shortly before her departure from Edinburgh. French (Paris), c. 1790? On loan from St Margaret's Convent of the Ursulines of Jesus, Edinburgh, to the Royal Scottish Museum, L.498.1 & 2.

King Louis XVI of France (1754-93). Bronze bust of Louis XVI mounted on a gilt bronze socle, a red marble drum and a square gilt bronze base. 30.7 x 11.3 x 11.6 cms.

Queen Marie-Antoinette of France (1755-93). Bronze bust of Marie-Antoinette mounted as above. 34.3 x 11.3 x 11.5 cms.

The fronts of the bases are engraved: "LOUIS XVI./King of France." and "MARIE ANTOINETTE." respectively. The left-hand sides are engraved: "*This Bust was saved from the sack of the/Tuileries, 10 Aug. 1792; & was presented to the/R.R.D^r. Gillis, by the Duchesse d'Angonteme*" (sic). The right-hand sides are engraved in similar fashion: "*Bequeathed by Bishop Gillis, to/S^t. Margaret's Convent, Edinburgh*".

Father James Gillis attended the seminary of St Nicholas in Paris between 1818 and 1823 and had become known to the French royal family before the fall of Charles X. He assisted the royal exiles when they came to Edinburgh in 1830. They provided him with letters of introduction and recommendations which would help him to raise funds in France and elsewhere for the foundation of St Margaret's Convent in Edinburgh: the first religious house to be founded in Scotland since the Reformation. The gift of the busts is of considerable interest and no small poignancy, for Marie Thérèse Charlotte (1778-1851), Duchesse d'Angoulême, was the only surviving child of Louis XVI and Marie-Antoinette. She gave Father Gillis what royalist sympathizers would consider to be images of her martyred mother and father. The Duchesse also presented the priest with locks of hair of members of the royal family. Father Gillis subsequently became a bishop; he died in 1864.

ALEXANDER, 10TH DUKE OF HAMILTON, AND THE HAMILTON PALACE COLLECTION

Further information on this section will be found in Chapter V.

51. *Alexander, 10th Duke of Hamilton* (1767-1852). Oil on canvas. Sir Henry Raeburn (1756-1823). Scottish (Edinburgh), early 19th century. 250 x 183 cms. Lent by Viscount Cowdray, Cowdray Park. Fig. 33.

52. The North Front of Hamilton Palace, built by Alexander, 10th Duke of Hamilton, after designs by the Glasgow architect David Hamilton (1768-1843). The *Glasgow Herald* noted on 7 May 1830: "This magnificent mansion, the principal seat of His Grace the Duke of Hamilton, is now fast advancing to its completion, and, when finished, will be not only by far the most splendid habitation in Scotland, but equal to any in the island". The original photograph was taken by Thomas Annan of Glasgow. Courtesy of Hamilton District Library.

53. Plan of Apartments in the North Block of Hamilton Palace. David Hamilton (1768-1843). Scottish (Glasgow), 1822. 50.5 x 40.8 cms. Lent by the Duke of Hamilton and Brandon, Lennoxlove. The plan of the proposed

146

apartments is on the reverse of a letter from the architect David Hamilton to the 10th Duke of Hamilton. The letter was written in Glasgow on 29 April 1822 and sent to the Duke in Paris.

54 & 55. Designs for the Entrance Hall of the North Block of Hamilton Palace. Charles Percier (1764-1838). French (Paris), c. 1827-29. Both mounts measure 56.3 x 42.3 cms. Lent by the Duke of Hamilton and Brandon, Lennoxlove. The 10th Duke appears to have commissioned Percier to design interiors for the principal rooms in the new north block of Hamilton Palace in 1827. He was probably inspired to employ Percier because the latter had been architect to his hero, Napoleon. Percier's designs were not carried out. Figs. 36 and 37.

56. Designs for the Tribune on the first floor of the North Block of Hamilton Palace. Charles Percier (1764-1838). French (Paris), c. 1827-29. 42 x 56.2 cms. Lent by the Duke of Hamilton and Brandon, Lennoxlove. The tribune was an ante-room between the Picture Gallery and the new Dining Room. Percier's designs were not carried out. Fig. 38.

57. Designs for the Dining Room on the first floor of the North Block of Hamilton Palace. Charles Percier (1764-1838). French (Paris), c. 1827-29. 42 x 29 cms. Lent by the Duke of Hamilton and Brandon, Lennoxlove. Percier's designs were not carried out.

Audio-Visual Programme. This ten minute programme examines Alexander, 10th Duke of Hamilton, as a builder and collector. It suggests that Alexander was inspired by the example of his contemporary, King George IV. The building of the north block of Hamilton Palace is seen against the background of George IV's major building projects at Carlton House, Brighton Pavilion, Buckingham Palace and Windsor Castle, and the French furniture acquired for Hamilton Palace against the great royal collection amassed by the king. The programme also investigates the Duke's fascination for the Emperor Napoleon. It discusses Alexander's acquisitions of works relating to Napoleon, his son's marriage into the imperial family, and the connections between the Emperor's re-burial and the Duke's arrangements for his own remains.

58. *The Emperor Napoleon in his Study in the Tuileries.* Oil on canvas. Jacques-Louis David (1748-1825). French (Paris), 1812. 203.9 x 125.1 cms. Lent by the National Gallery of Art, Washington, DC. Samuel H. Kress Collection, 1961.9.15. Commissioned by Alexander, 10th Duke of Hamilton, in 1811. Purchased after the Hamilton Palace sale of 1882 by the 5th Earl of Rosebery. Fig. 49.

TABLEAU II AND CASE

59. The Travelling Service of the Princess Pauline Borghese, bequeathed to Alexander, 10th Duke of Hamilton, in 1825. Silver-gilt, glass and other materials. Martin-Guillaume Biennais. French (Paris), c. 1803? Collection of the Duke of Hamilton, on loan to the Royal Scottish Museum, L.396.35.

This *nécessaire de voyage* or travelling service belonged to Napoleon's favourite sister, Pauline (1780-1825). An inscription on the edge of the chest reveals that it was supplied by Martin-Guillaume Biennais (1764-1843) while Napoleon was First Consul, that is before May 1804 when he became Emperor. The most likely date for the order would appear to be sometime during 1803, for in this year Pauline returned to France, purchased and redecorated the Hôtel de Charost in Paris (now the British Embassy) and married Prince Camillo Borghese. The two 'Bs' engraved on the shield on the lid of the chest suggest that the commission was connected with the marriage.

The 10th Duke became a friend of the Princess in Italy after her brother's final downfall and the service was bequeathed to him "as a mark of my friendship". It was probably collected during the Duke's visit to Italy in 1827. The tableau represents Alexander, then Marquess of Douglas, taking tea with the Princess Pauline in Rome in 1818. The chest, toilet and remaining items are displayed in the large case to the right. The photographs in the case show:

1. The chest with the interior lid lowered to form a writing surface; the compartments for stationery and papers are attached to the inside of the outer lid.

2. The service packed into the trays.

3. The combs neatly slotted into the back of the large mirror.

Biennais specialized in supplying *nécessaires* and this is one of his finest examples. It may be compared with the Emperor Napoleon's own service (now in the Musée Carnavalet in Paris) and with the slightly later service which the Emperor ordered, used briefly and then presented to Tzar Alexander I (now in the Musée du Louvre, Paris).

The majority of the more important pieces of silver-gilt were made by Marie-Joseph-Gabriel Genu (*maître* 1788, still working in 1806, d.1811 or before). They were produced in the period 1794-97 and then struck with the new marks introduced in 1798 (and in use until 1809). The forks and spoons were supplied by Pierre Benoît Lorillon, who provided Biennais with cutlery for many services. The *nécessaire* also includes items by other makers. All the items are listed below with the exception of a few small wooden stands and the silk liners intended to reduce the danger of articles becoming scratched. As the list reveals, a few pieces were added, either to replace broken or lost items or to meet other requirements. Fig. 50.

Item (silver-gilt unless otherwise stated)	Measurements in cms.	Engraved decoration	Maker's mark	Head of Apollo with the number 1 to the right*	Standard mark (silver unless otherwise stated)	Excise mark (large or medium work)
Mahogany chest with brass mounts; the shield on the lid engraved with a monogram consisting of two 'Bs'. The upper edge of the main part of the chest engraved: "*Biennais Orfevre du Premier Consul au Sᵗ. Honoré Nº 119 au Singe Violet à Paris*". Inside the lid is a detachable shield-shaped mirror. The interior can be lowered to form a writing surface. The inside of the actual lid is fitted with green morocco compartments for stationery and papers	18.8 x 57.3 x 40	—	—	—	—	—
Large rectangular wooden tray with shaped compartments for items: fits inside the above chest	6.2 x 54.3 x 36.7	—	—	—	—	—

* The general working theory is that the head of Apollo is an unofficial assay mark used before 1798. Two versions of the mark are known: one with the letter "P" to the left of the head of the god and the other with the number "1" to the right. The former is interpreted as the mark used in 1793-94 and the latter as the stamp employed between 1794-97.

Item (silver-gilt unless otherwise stated)	Measurements in cms.	Engraved decoration	Maker's mark	Head of Apollo with the number 1 to the right	Standard mark (silver unless otherwise stated)	Excise mark (large or medium work)
Circular wooden holder for plates: fits inside the above tray at the front	3.2 x 22.8	—	—	—	—	—
Shaped wooden container with shaped compartments for flatware and other items: fits on top of the above plate holder	5.1 x 33.1 x 24.2	—	—	—	—	—
Oval wooden container for the *écuelle* with two-part lid with shaped compartments for toilet and sewing items: fits inside the silver-gilt basin, which fits in the above tray	6.4 x 30.4 x 18.8	—	—	—	—	—
Rectangular wooden writing drawer, pulls out of the right-hand side of the chest. The edge engraved "*Biennais au singe Violet*". The upper surface is covered with red morocco. The top unlocks to reveal a compartment for papers. Fitted with a pen tray and a silver-gilt inkpot and pounce pot	3.1 x 40.3 x 38.2	—	—	—	—	—
Inkpot. Not removable. No marks visible	Approx. 3.6 x 3.6	[?]	[?]	[?]	[?]	[?]
Pounce pot. (Pounce is a fine powder of gum sandarach used to treat parchment or paper before or after writing.)	1.9 x 3.6 x 3.6	"P"	Genu	V	1st, 1798-1809	Medium, 1798-1809
Rectangular wooden money drawer, in the base of the chest to the left of the writing drawer	3 x 36.9 x 15.5	—	—	—	—	—
Three steel keys	5 x 2.7	—	—	—	—	—
	3.3 x 2	—	—	—	—	—
	3.3 x 1.9	—	—	—	—	—
Two steel tools for boring screw holes and screwing the chest down onto the floor or onto large pieces of furniture to prevent theft	7 x 5.7	—	—	—	—	—
	7.5 x 6.3	—	—	—	—	—
Oval teapot with detachable lid, ebony handle and ebony finial	11.5 x 26.7 x 10.3	"P" in wreath	Two: Genu and Biennais	V	1st, 1798-1809	Large, 1798-1809
Coffee pot with screw-on ebony handle	21 x 19 x 12.5	"	"	"	1st, 1798-1809	Large and medium, 1798-1809
Chocolate pot with lid and screw-on ebony handle	11.3 x 18.5 x 9.2	"	Genu	"	"	"
Oval tea caddy with detachable lid with pull ring	8.9 x 12.6 x 7.6	"	Two: Genu and Biennais	"	"	"
Milk jug	11.2 x 8.2 x 6.2	"	"	"	"	Medium, 1798-1809
Spirit-lamp	5.2 x 5	—	Genu	"	"	"
Tripod stand for spirit-lamp with screw-on ebony handle	9.5 x 15.5 x 8.7	—	"	"	"	"
Sugar tongs	1.5 x 10 x 3.3	—	Indecipherable: 3 letters, the first letter J, in a lozenge	—	2nd, 1798-1809	"
Tea strainer (lacking suspension wire)	2.2 x 4.7	"P"	—	—	—	—
Two cups with fluted sides and ebony handles	7.2 x 9.6 x 6.5	"P" in wreath	Genu	V	1st, 1798-1809	Large, 1798-1809
	7.2 x 9.5 x 6.6	"	"	"	"	"

Item (silver-gilt unless otherwise stated)	Measurements in cms.	Engraved decoration	Maker's mark	Head of Apollo with the number 1 to the right	Standard mark (silver unless otherwise stated)	Excise mark (large or medium work)
Cylindrical canister with pull-off lid	11 x 8.6	"	"	"	"	Large and medium, 1798-1809
"	10.7 x 5.6	"	"	"	"	Medium, 1798-1809
Cylindrical canister with two compartments and pull-off lid	7.4 x 6	"	"	"	"	"
Cylindrical canister with pull-off lid	7.8 x 4.2	"	"	"	"	"
Cylindrical canister with two compartments and pull-off lid	7.8 x 4.2	"	"	"	"	"
Cylindrical canister with one compartment and pierced pull-off lid	7.4 x 6	"	"	"	"	"
Two candlesticks with screw-on bases	11.8 x 8.6 / 11.8 x 8.5	" / "	" / "	[?] / "	" / "	Large, 1798-1809
Écuelle and cover with eagle finial	8.5 x 19.7 x 16.5	"	Biennais	V	"	Medium, 1798-1809
Six circular plates	1.9 x 21	"	5: Genu	"	"	Large, 1798-1809
		"	1: Biennais	[?]	"	Medium, 1798-1809
Two beakers	9.2 x 7.9	"	Biennais	—	1st, 1809-19	Medium, 1809-19
	8.9 x 7.4	"	"	"	"	"
Four dinner knives with steel blades and mother-of-pearl handles set with gilt shields	22 / 22 / 22 / 21.6	"P" / " / " / "	The blade stamped "AU SINGE VIOLET" / "	— / — / — / —	— / — / — / —	— / — / — / —
Four dessert knives with silver-gilt blades and mother-of-pearl handles set with gilt shields	20.8	"	Biennais	—	1st, 1798-1809	Medium, 1798-1809
	20.8	"	"	—	2nd, 1798-1809	"
	20.7	"	"	—	1st, 1798-1809	"
	20.5	"	"	—	"	"
Four forks	18.4	"P" in wreath	P. B. Lorillon	—	2nd, 1798-1809	Large, 1798-1809
	18.4	"	"	—	"	"
	18.4	"	"	—	"	"
	18.5	"	"	—	1st, 1798-1809	Medium, 1798-1809
Four spoons	19	"	"	—	"	"
	18.9	"	"	—	2nd, 1798-1809	Large, 1798-1809
	18.8	"	"	—	"	"
	18.7	"	"	—	[?]	[?]

Item (silver-gilt unless otherwise stated)	Measurements in cms.	Engraved decoration	Maker's mark	Head of Apollo with the number 1 to the right	Standard mark (silver unless otherwise stated)	Excise mark (large or medium work)
Two teaspoons	14.1 x 2.8	"	"	—	1st, 1798-1809	Medium, 1798-1809
	13.8 x 2.9	"	"	—	"	"
Oval box with two hinged lids and two separate compartments	2.2 x 10.3 x 6.2	"	Genu	⋁	"	"
Cut-glass tumbler	8.2 x 7	—	—	—	—	—
Chamber candlestick with detachable nozzle and handle	Stick and pan: 3.6 x 8.5 Handle: 13.6 x 2.2	"P" in wreath	Genu	⋁	1st, 1798-1809	Medium, 1798-1809
Mirror with stand and suspension ring (detaches from the lid of travelling chest)	34.5 x 30.2 x 1.4	—	—	—	—	—
Hand mirror with screw-on ebony handle	23.3 x 10.8 x 2.2	—	—	—	—	—
Oval basin	6.7 x 32.8 x 21.3	"P" in wreath	Genu	⋁	1st, 1798-1809	Large, 1798-1809
Ewer with cast swan on handle and screw-on foot	27.4 x 13.5 x 9.2	"	"	—	"	"
Two toothbrushes	13.6	"P"	Biennais	—	—	—
	13.5	"	"	—	—	—
Three spare toothbrush heads	4	—	—	—	—	—
Three tortoise-shell combs (stored in slots in the back of the large mirror)	Large teeth: 6.9 x 15.8	—	—	—	—	—
	Large and small teeth: 4 x 19.3	—	—	—	—	—
	Small teeth: 4.4 x 10.1	—	—	—	—	—
Two squat cylindrical or drum cut-glass bottles with silver-gilt screw-on caps	9.1 x 7	"P" in wreath	—	—	Restricted warranty, 1819-38	—
	8.8 x 6.8	"	—	—	"	—
Two rectangular cut-glass bottles with silver-gilt screw-on caps	10.7 x 4.9 x 4	"	—	—	—	—
	10.5 x 5.8 x 4.2	"	—	—	—	—
Two rectangular cut-glass jars with silver-gilt hinged lids	8.4 x 7.1 x 4.9	"	JM_DF in a lozenge	⋁	1st, 1798-1809	Medium, 1798-1809
	7.7 x 6.4 x 4.4	"	Indecipherable	"	"	"
Three small cut-glass flasks with silver-gilt screw-on caps. The last of the flasks is a replacement.	8.4 x 3.5 x 1.8	"	—	—	—	—
	8.2 x 3.5 x 1.8	"	—	—	—	—
	8.2 x 3.5 x 1.8	"	—	—	—	—
Funnel	4.5 x 3.6 x 3.1	"P"	—	—	Two very small in-decipherable marks	—
Larger nail file, steel with mother-of-pearl handle and gilt shield	15.6	"	—	—	—	—
Smaller nail file, steel with mother-of-pearl handle and gilt shield	14	"	—	—	—	—

Item (silver-gilt unless otherwise stated)	Measurements in cms.	Engraved decoration	Maker's mark	Head of Apollo with the number 1 to the right	Standard mark (silver unless otherwise stated)	Excise mark (large or medium work)
Nail brush	1.3 x 6.2 x 2.3	"	—	—	—	—
Tweezers with ear-pick at one end	7.9	"	—	—	Restricted warranty, 1798-1809	—
Seven manicure instruments, steel with mother-of-pearl handles and gilt shields	12.4	"	—	—	—	—
	12.4	"	—	—	—	—
	12.3	"	—	—	—	—
	12.2	"	—	—	—	—
	12.2	"	—	—	—	—
	12.2	"	—	—	—	—
	12.1	"	—	—	—	—
Spatula knife, silver-gilt with mother-of-pearl handle and silver-gilt shield	16.1	"	Biennais	—	1st, 1798-1809	Medium, 1798-1809
Eyebath	4.7 x 5 x 3.3	"	"	V	Restricted warranty, 1798-1809	—
Tongue scraper (?)	8.2 x 4	"P"	—	—	—	—
Hook	4	—	—	—	—	—
Bodkin	10.5	"P"	—	—	Restricted warranty, 1798-1809	—
Three scissors: steel and two-colour gold	10.2 x 3.5	"	P̂.L in a lozenge: Pierre Leplain?	—	3rd, gold, ?1798-1809	—
steel and gilt	15.2 x 4.3	—	"GAVET" and "E" below an oval device	—	—	—
steel	9.2 x 3.4	—	"GAVET"	—	—	—
Étui for needles, two-colour gold	8.7 x 1.6 x 1	"P"	Three letters: CorG [?] ?M in a lozenge	—	3rd, gold, 1798-1809	Medium, 1798-1809
Thimble, gold or gilt	2.4 x 1.7	"	—	—	—	—
Two cylindrical ivory containers, one containing spools of thread	10.9 x 3.2 / 10.7 x 3.1	—	—	—	—	—
Folding ivory measure	Folded: 9.4 Open: 59.5	—	—	—	—	—
Tambour chain stitch tool (?), mother-of-pearl	12.6 x 1.1	—	—	—	—	—
Penknife, steel with mother-of-pearl handle and gilt shields; four blades or tools	8.9 x 1.5	"P"	Device stamped on two blades	—	—	—
Folding steel corkscrew	Folded: 6.3 x 3.7 Open: 11.2 x 3.7	—	—	—	—	—
Dividers, gilt metal	18 x 4.3	"P"	—	—	—	—

Item (silver-gilt unless otherwise stated)	Measurements in cms.	Engraved decoration	Maker's mark	Head of Apollo with the number 1 to the right	Standard mark (silver unless otherwise stated)	Excise mark (large or medium work)
Multi-purpose tool, steel with ivory handle inset with two gilt stars	8.5 x 2.4	"	—	—	—	—
Tool, steel point with ivory handle inset with two gilt stars	9.7 x 2.4	"	—	—	—	—

Included in the tableau:

60. Two Single Chairs. Carved and gilded wood. Probably Italian, c.1800. 107.5 x 58.3 x 48.2 cms. Dunimarle Museum, Culross, Fife. Lent by the Trustees of the Mrs Magdalene Sharp Erskine Trust.

These two chairs are from a large collection of carved and gilded, Neo-classical furniture which was assembled by Sir James Erskine (1772-1825), 3rd Baronet of Torrie (see also nos. 62 and 63). Sir James was a professional soldier who began his career in 1788, became a Lieutenant-Colonel in 1794, a full Colonel in 1800 and acted as aide-de-camp to King George III between 1802 and 1804. He served under Wellington and was in Paris after the defeat of Napoleon. He eventually retired from the army with the rank of Lieutenant-General. Sir James was a collector and also an amateur artist. Part of his collection was bequeathed to Edinburgh University. Known as the Torrie Collection, it is generally on display in the Talbot Rice Arts Centre in the Old Quadrangle of the University of Edinburgh. The remainder of Sir James' collection is at Dunimarle Museum, along with other items acquired by his brother, John Drummond Erskine, and their sister, Magdalene Sharpe Erskine.

A catalogue of the Dunimarle Collection was prepared by Canon J. W. Harper, the Honorary Curator of the Dunimarle Museum, between 1912 and 1914. In this, Canon Harper records that Sir James purchased the gilt wood furniture and other related items. He specifically states that Sir James "got a suite of Napoleon's furniture. . .—The accounts for passing through the Customs are preserved among the print room papers", and he observes that Sir James "seems to have paid royally" for the furniture. Canon Harper also mentions a "receipt of the Custom-house charges for other Articles brought from Paris by Sir James Erskine in 1816" and it would seem likely that the gilt furniture was imported in the same year.

Canon Harper refers to "A list, preserved in the print room [which] notes that all this Suite was formerly the property of Cardinal Fesch, the uncle of Napoleon". He adds the information or personal belief that "The 2 Sofas and the two chairs [with acanthus-tailed griffins, see no. 62] appear to have been the property of the Cardinal, the others were Napoleon's—all the suite having passed through his hands".

The Canon notes that all the items are of Italian workmanship and mentions that the two chairs on display in this tableau, and the remaining six at Dunimarle, were formerly upholstered with "Basket of Flowers on pink tapestry". In his opinion, "This appears to have been the original Napoleonic Condition". See no. 63.

TABLEAU III

61. The Tea Service of the Emperor Napoleon I, purchased by Alexander, 10th Duke of Hamilton, probably in 1830. Silver-gilt, glass and other materials. Martin-Guillaume Biennais. French (Paris), 1810.

This great tea service was probably commissioned in connection with the Emperor Napoleon's marriage to his second wife, the Archduchess Marie-Louise of Austria, which took place in March-April 1810. It had almost certainly been delivered by mid August 1810, for General Duroc, Grand Marshal of the Palace, approved the bill of 40,000 francs on 20 August and the Comte Daru authorized payment a week later. The tableau shows the Emperor and Empress inspecting the new service.

Biennais was the head of the most important goldsmith and jewellery business in Paris during the Empire. He had begun to be patronized by Napoleon as early as 1796 and subsequently became the official goldsmith to the Emperor, employing around six hundred workers. Napoleon set aside 100,000 francs a year for silver and most of this was purchased from Biennais. Exceptionally large quantities of plate were acquired in 1810, in connection with Napoleon's second marriage, but the following year seems to have been an even busier and more profitable one for the imperial goldsmith. In 1811, the year of the birth of Napoleon's son, the King of Rome, Biennais supplied the imperial household with silver valued at no less than 720,199 francs. He was also responsible for producing large quantities of plate for the new aristocracy of France and for the courts of Austria, Russia, Würtemberg, Baden, Westphalia and Tuscany. He retired in 1819, selling his business to Jean-Charles Cahier, goldsmith to Charles X. Many of the pieces in this service are based on designs by the architect Charles Percier (1764-1838). The severe monumental forms and the sumptuous Neo-classical decoration exemplify the richness and magnificence of the French Empire style in its maturity. Some of the cutlery is by Pierre-Benoît Lorillon, whose work is also included in the *nécessaire de voyage* of the Princess Pauline Borghese (no. 59).

The service was sold by order of Charles X in May 1830 for 17,000 francs to "some foreigners", probably agents acting for the 10th Duke of Hamilton. It is clearly recorded in an inventory of plate made at Hamilton Palace on 17 January 1835.

The service is as it was when it was delivered to the Emperor Napoleon with the following exceptions.

A knife with steel blade and a mother-of-pearl caddy scoop are missing.

The two sugar tongs are engraved with the French Royal Arms, indicating that they are either replacements or have been re-engraved after the Restoration.

Four dozen pieces of cutlery have been added to the service. One dozen large spoons and one dozen large forks, which are not *en suite*, were made in the workshops of Biennais and Lorillon. They are marked for the period 1809-19 and appear from the numbers engraved on the handles to have formed part of a huge imperial service of cutlery. A dozen dessert spoons and a dozen dessert forks are by an unidentified maker. They are stamped for the period 1819-38 and were probably commissioned by the 10th Duke of Hamilton in the 1830s.

The items were delivered to the Emperor in two travelling chests. The articles in the first chest were sold from the Hamilton Collection in November 1919. They were acquired by M. Louis-Victor Puiforcat and remained in his collection until 1952, when they were donated to the Musée du Louvre by the Société des Amis du Louvre. The contents of the second chest were purchased by the Royal Scottish Museum in 1976 with assistance from the National Art-Collections Fund. The two halves of the service are reunited here for the first time since at least 1919. Figs. 52-55.

The items from chest one are lent by the Musée du Louvre, Paris.

The following information is taken from the *Catalogue of Silver in the Musée du Louvre and Musée du Cluny* published in Paris in 1958.

Item (all the items are of silver-gilt unless otherwise stated)	Measurements in cms.	Engraved decoration	Maker's mark	Head of Apollo	Standard mark (all silver)	Excise mark (large or medium work)
Urn. Urn in the form of an Etruscan vase with two handles formed by full-length winged, draped female figures holding wreaths above their heads and with two taps in the shape of dolphins. Set on a square foot and a circular pierced drum from which four winged lions project at right angles. Surmounted by a domed cover with an eagle finial. Decorated with bas-reliefs of Neptune and Amphitrite, the arms of the Emperor Napoleon I, bees and floral motifs. Engraved on the side of the foot: "BIENNAIS ORFÈVRE DE S.M. L'EMPEREUR ET ROI A PARIS".	80 x 45		Abel-Etienne Giroux	—	1st, 1809-19. Restricted warranty, after 1838	Medium, 1809-19
Teapot. Oval teapot with a spout in the shape of a swan's head and an ebony handle in the shape of a stylized dolphin. Decorated with a band of bas-relief representing winged maidens, the arms of the Emperor Napoleon I and bees, and with floral motifs.	18 x 32		Biennais	*V* with 1 to the right	"	"
Teapot stand for the above. Oval teapot stand set on six claw and pad feet and decorated with palmette and other floral motifs. Engraved on the side: "BIENNAIS ORFÈVRE DE S.M. L'EMPEREUR ET ROI A PARIS".	23.2 x 15.2	Arms of the Emperor Napoleon I	"	"	"	"
Teapot. Oval teapot as above but with slightly different profile, variations in the decoration and plainer ebony finial and handle.	16 x 30		"	"	"	"
Teapot stand for the above. Same as preceding stand. Engraved on the side; "BIENNAIS ORFÈVRE DE Lrs Més IMPÉRIALES ET ROYALES A PARIS".	23.2 x 15.7	Arms of the Emperor Napoleon I	"	"	"	"
Tea infuser. Ovoid, pierced tea infuser.	5 x 3.7					
Two tea strainers. Two circular, pierced tea strainers, with suspension wires.	2.2 x 5					
Tea caddy. Rectangular tea caddy with cut corners. The lid decorated with two winged maidens, the arms of the Emperor Napoleon I and floral motifs. The sides decorated with a band of bas-reliefs including a representation of the Roman wall painting known as the Aldobrandini Nuptials. The base engraved: "BIENNAIS ORFÈVRE DE Lrs Més IMPÉRIALES ET ROYALES".	14.5 x 15.5 x 8.7		Biennais	*V* with 1 to the right	1st, 1809-19 Restricted warranty, after 1838	
Milk jug. Ovoid milk jug in the shape of an ewer with a circular foot and ebony handle. Decorated with a band of bas-relief representing figures amidst scrolling acanthus foliage and the arms of the Emperor Napoleon I. Engraved on the side of the foot: "BIENNAIS ORFÈVRE DE S.M. L'EMPEREUR ET ROI A PARIS".	27 x 11		"	"	"	Medium, 1809-19

Item (all the items are of silver-gilt unless otherwise stated)	Measurements in cms.	Engraved decoration	Maker's mark	Head of Apollo	Standard mark (all silver)	Excise mark (large or medium work)
Coffee pot. Ovoid coffee pot with three feet and ebony handle. Decorated with a band of bas-relief representing winged maidens, the arms of the Emperor Napoleon I and bees, and with floral motifs.	31 x 12		”	”	”	”
Two butter dishes. Two oval butter dishes, each with four feet, with cut-glass interiors.	10. x 22.2 x 13					
Two butter knives with handles of sandal wood imitating bamboo.	27	Arms of the Emperor Napoleon I				
Glass bottle. Cylindrical cut-glass bottle with silver-gilt cover.	18 x 10	”				

CHEST TWO ROYAL SCOTTISH MUSEUM 1976.750. 1-167 and 1977. 190&A

Item	Measurements	Engraved decoration	Maker's mark	Head of Apollo	Standard mark	Excise mark
Travelling chest. Rectangular trunk of black leather with black mounts and leather straps. The interior fitted with shaped compartments for the punch bowl, sugar bowl, two double salts and twelve plates. Four removable trays: two shaped trays, the smaller fitting inside the larger, and one large rectangular tray with a narrower tray fitting inside it. All lined in red chamois. Later alterations to the two shaped trays. A black leather label on the interior of the lid printed in gold: "BIENNAIS, ORFÉVRE DE/L'EMPEREUR & ROI À PARIS". A brass plaque on the front of the chest engraved: *"His Grace the DUKE of HAMILTON & BRANDON N°2"*.	39.5 x 80.5 x 40.5	—	—	—	—	—
Steel key.	7.6	—	—	—	—	—
Punch bowl. Circular bowl with two handles above two bacchante heads supported on a bell-shaped foot set on a square base with four winged cloven feet. Decorated with figures of Neptune, seahorses and riders, the arms of the Emperor Napoleon I, and floral motifs. Engraved on the base on one side: "BIENNAIS/ORF^RE DE S.M./L'EMPEREUR ET ROI".	26.6 x 43.4 x 34.5	—	Biennais	*V* with P to the left	1st, 1809-19	Medium, 1809-19
Two punch ladles. Each ladle has an oval bowl with lip and a spirally twisted baleen handle with mother-of-pearl finial.	42.5 x 6.2	Arms of the Emperor Napoleon I	”	”	”	”

Item (all the items are of silver-gilt unless otherwise stated)	Measurements in cms.	Engraved decoration	Maker's mark	Head of Apollo	Standard mark (all silver)	Excise mark (large or medium work)
Sugar bowl and cover. Circular vase-shaped bowl with two handles terminating in four lions' heads supported on a bell-shaped foot set on a drum with six sphinxes on plinths projecting from it at right angles and on a wide circular base with slots for twelve coffee spoons, resting on six claw and pad feet. Surmounted by a slightly domed cover with a large cast eagle finial. The bowl decorated with figures of Cupid and Psyche, winged maidens with palm and oak or laurel branches and the arms of the Emperor Napoleon I; the drum with swans; and the base with crowned imperial eagles and bees. Floral and other motifs. Engraved on the inside of the cover and on the base: "*Biennais Orfevre de S.M. l'Empereur et Roi à Paris*".	32 x 26.4	—	"	"	1st and restricted warranty, 1809-19	"
Two pairs of sugar tongs. Each has shield-shaped ends and stems decorated on the outer sides with a line of anthemion and palmette motifs.	2.8 x 14.2 x 3.1	French Royal Arms	"	—	2nd, 1809-19	"
Two double salts. Each has a central altar on which stands a figure of Venus with a dolphin, with a scallop shell on either side of the altar. The altar is supported on the feet of two teams of seahorses and the far ends of the shells by swans. Set on a shaped base with six feet. Decorated with the arms of the Emperor Napoleon I and with floral motifs. Engraved on the base, in the centre: "*Biennais, Orfevre/de SS. MM. Imperiales/et Royales et de/S.M. le Roi de hollande/a Paris au Singe Violet/No 283*".	24 x 21.2 x 8	—	"	V with 1 to the right	1st, 1798-1809	Medium, 1798-1809. Medium census, 1809-19
Two salt shovels. Chased on the obverse with a mask between two cornucopia and on the reverse with a standing child and the arms of the Emperor Napoleon I.	10.9	—	P. B. Lorillon	—	1st, 1809-19	Medium, 1809-19
Twelve circular plates with concave borders and palmette rims. The backs stamped: "BIENNAIS".	2 x 22.2	Arms of the Emperor Napoleon I on the borders	Biennais	V 7: with P to the left 5: —	"	"
Two toast racks. Each with an oval base set on six claw feet with a central lifting bar and holding ring and twelve plain curved wire divisions, six on either side. Decorated with floral motifs. The bases stamped: "BIENNAIS".	14.5 x 25.1 x 11.7	Arms of the Emperor Napoleon I on the centre of the base	"	—	2nd, 1809-19	"
Twenty-three knives with steel blades. Originally 24. Each knife has a steel blade shaped *à la turque* and a flat, straight-edged silver-gilt handle chased on each side with a profile portrait of the Emperor Napoleon I, his arms and a crowned "N" reserved against plain panels with applied bees. The blades are stamped: "AU SINGE VIOLET". Not all the knives are struck with silver marks and the marks are very poor.	20, with variations	—	"	[?]	[?]	[?]

Item (all the items are of silver-gilt unless otherwise stated)	Measurements in cms.	Engraved decoration	Maker's mark	Head of Apollo	Standard mark (all silver)	Excise mark (large or medium work)
Twenty-four knives with silver-gilt blades. The shape and decoration as above. The blades of the majority of knives are marked. These marks are given on the right. There are also very poor marks, including Biennais' maker's mark, on the handles.	20, with variations	—	,,	—	1st, 1809-19	Medium, 1809-19
Twelve dessert spoons. Each with pointed oval bowl, flat stem and rounded upturned end. Chased with arabesques and a peacock on the obverse and a standing female figure and the arms of the Emperor Napoleon I on the reverse.	19.2, with variations	—	Lorillon	—	,,	,,
Twelve dessert forks. Each with four curved prongs. The decoration as above.	18.8, with variations	—	,,	—	,,	,,
Twenty-four coffee spoons. Each with pointed oval bowl, flat stem and rounded upturned end. Chased with a mask between two cornucopia on the obverse and a standing child and the arms of the Emperor Napoleon I on the reverse.	14.5, with variations	—	,,	—	,,	,,
The following items have been added to the original service.						
Twelve spoons. Each with pointed oval bowl and fiddle and thread pattern stems. The arms of the Emperor Napoleon I chased on the reverse. The sides of the handles are engraved with numbers. Most are worn and open to different readings. The highest clear numbers are 785 and 850.	21.6, with variations	—	7: Biennais 5: Lorillon	—	,,	Large, 1809-19
Twelve forks. Each with four curved prongs and fiddle and thread pattern stems. The decoration as above. The sides of the handles are engraved with the following numbers: 152 or 159, 188?, 224, 234, 273, 372, 415, 422, 471, 477 and 745.	21.5, with variations	—	7: Lorillon 5: Biennais	—	,,	,,
Twelve dessert spoons. Each with pointed oval bowl, flat stem and rounded upturned end. Chased with arabesques and a peacock on the obverse and a standing female figure and the arms of the Emperor Napoleon I on the reverse.	19.2, with variations	—	Maker unidentified	—	1st, 1819-38	Large, 1819-38
Twelve dessert forks. Each with four curved prongs, flat stem and rounded upturned end. The decoration as above.	18.7, with variations	—	,,	—	,,	,,

62. Armchair with arm-rests supported by acanthus-tailed griffins. Carved and gilded wood. Probably Italian, c.1800. 110 x 75.5 x 58 cms. Incised on the underside: "1". Dunimarle Museum, Culross, Fife. Lent by the Trustees of the Mrs Magdalene Sharpe Erskine Trust.

This is one of two chairs of the same design at Dunimarle Museum which were acquired, along with other items of carved and gilded, Neo-classical furniture, by Sir James Erskine (1772-1825), 3rd Baronet of Torrie (see also nos. 60 and 63).

The florid character of the carved arm-rest supports suggests that the two chairs are of Italian workmanship and this seems to be borne out by the lack of French maker's marks and by the existence of a drawing of a settee of similar design, signed "*Fratelli Santi*", in the Cooper-Hewitt Museum, New York (1938.88.559). Further corroboration is to be found in the catalogue of the Dunimarle Museum prepared by Canon J. W. Harper between 1912 and 1914.

The chair on display here and its companion at Dunimarle are part of a very large suite of palace furniture which is now dispersed. Four three-back settees, ten armchairs, eight single chairs and two firescreens from the suite are today in the Lady Lever Art Gallery, Port Sunlight; a four-back settee, eight armchairs and six single chairs are in the Royal Pavilion, Brighton; and a further three armchairs and four single chairs are at Beningbrough Hall, near York. Other examples are also recorded.

The suite is generally associated with Cardinal Giuseppe or Joseph Fesch (1763-1839) who was the step-brother of Napoleon's mother. Napoleon advanced his step-uncle, and Fesch enjoyed the distinction of holding the Archbishopric of Paris concurrently with that of Lyons. He was made Cardinal in 1803 and served as ambassador to the Holy See. The Cardinal was one of the great collectors of his day and items from his enormous collection subsequently entered the Vatican and other principal European collections.

Fesch owned or occupied a number of houses and palaces. In all probability these chairs and the other items from the suite would have graced one of his Paris residences. He lived in a house in the Rue de Mont-Blanc but also built a large mansion to designs by Napoleon's architect Fontaine. One or more sales of Fesch's possessions took place in Paris in 1815-16 and such a sale would be the most obvious source for the two chairs and of some of the other items of gilt furniture now at Dunimarle. However, it is possible that they were acquired from another sale or source. It is interesting to note that Sir James Erskine appears to have purchased items from one of the royal palaces. Canon Harper reveals that he bought the six X-shaped stools now at Dunimarle. These are stamped as having been in the Tuileries Palace during the Restoration period and were presumably acquired at a sale of redundant Napoleonic furniture and fittings authorized by Louis XVIII.

Many of the items from the Cardinal Fesch suite came to Scotland or were owned by Scots. The eight armchairs and six single chairs now in the Royal Pavilion, Brighton, were at Abercairny Abbey, Perthshire, until the mid 1950s, while the chairs at Beningbrough Hall were formerly owned by the Duke of Atholl and his family. Members of all these families were involved in the defeat of Napoleon and visited Paris shortly after Waterloo. Fig. 65.

63. Armchair with arm-rests supported by winged lions. Carved and gilded wood. Probably Italian, c.1800. 115 x 71.7 x 60.2 cms. Dunimarle Museum, Culross, Fife. Lent by the Trustees of the Mrs Magdalene Sharpe Erskine Trust.

This is one of six chairs of the same design at Dunimarle Museum which were acquired, along with other items of carved and gilded, Neo-classical furniture, by Sir James Erskine (1772-1825), 3rd Baronet of Torrie, probably in 1815 or 1816 (see also nos. 60 and 62). This furniture is associated with Cardinal Fesch and the Emperor Napoleon in the catalogue of the Dunimarle Collection prepared by Canon J. W. Harper between 1912 and 1914. In the entry relating to the six chairs, Canon Harper states "These chairs were Napoleons". He mentions that, like the rest of the furniture, they were made in Italy. The chairs appear to be *en suite* with the single chairs shown in the second tableau (no. 60). They were also formerly "Upholstered with pink tapestry, with design of a Basket of Flowers".

64-67. Photographs of the Exterior and Interior of the Hamilton Mausoleum, built by Alexander, 10th Duke of Hamilton, close to Hamilton Palace, and of the Egyptian sarcophagus in which he is interred.

The 10th Duke of Hamilton's intense pride in his family and exalted view of his own status increased as he grew older. A further possible cause for self-esteem was added in 1830 when a skeleton, rumoured to be that of a child, was discovered in the wall of a chamber at Edinburgh Castle. The writer of the Duke's obituary in the *Gentleman's Magazine* in October 1852 records that the Duke was "ready, if not anxious, some time since, to give credence to a conjecture that the remains of an infant found buried in a hollow of the wall in the old apartments of Edinburgh Castle, were those of the real King Jamie [James VI and I], the child of Queen Mary [Mary Queen of Scots]. Under that conviction, the Duke would at once conclude that he was himself the true heir to the throne of Scotland, the old Regent Arran, first Duke of Chatelherault, having been . . . the heir presumptive at that period".

The Duke determined to be buried in regal or imperial style. David Hamilton prepared several schemes for a mausoleum in 1841, but he was a dying man by February 1842, and the Duke turned to H. E. Goodridge of Bath, who had been employed by the Duke's father-in-law, William Beckford, and had been recruited to work on the interior of Hamilton Palace. Goodridge's proposals and attitude did not please the Duke and in 1848 David Bryce was requested to submit designs. These were essentially a development of Hamilton's scheme for a Roman mausoleum emulating the tombs of Caecilla Metella and the Emperor Hadrian. The crypt had already been built, and construction work, presumably on the chapel and podium, was begun in July 1848. The project was still incomplete, however, at the time of the Duke's funeral in September 1852.

On 4 September 1852 Alexander was placed in an Egyptian green schist or basalt sarcophagus, on a pedestal opposite the entrance to the mausoleum. It is sometimes stated that he acquired this sarcophagus especially for his remains, but this does not seem to have been the case. What appears to have happened is that the Duke arranged to buy a sarcophagus for the British Museum, of which he was a trustee, while he was in Paris in 1836. The other trustees and the museum staff thought that he had managed to secure the sarcophagus of the priestess Ankhnesneferibre which they had been negotiating to purchase, for a small sum, and were dreadfully disappointed to discover, when the crate was opened in September 1836, that the Duke had in fact only purchased a green schist anthropoid coffin. There was some annoyance and recrimination, and Alexander offered to keep the sarcophagus and meet all expenses. The trustees agreed to this proposal with enthusiasm, and the sarcophagus was transported to the Duke's house in Portman Square and later sent up to Hamilton. The cost of the sarcophagus apparently came to £632.8s.2d. It is not clear when the Duke decided that his new acquisition would serve as a suitable receptacle for his "porcelain clay". At the time of his death, the sarcophagus was believed to have been made for a queen or a princess, and this association with royalty almost certainly influenced the "very Duke of very Dukes". Subsequent research has revealed the sarcophagus to date from the Ptolemaic period and to have contained a lady named Ithoros.

It would seem possible that the Duke's decision to build a mausoleum and to be buried in a sarcophagus was influenced, at least in part, by the magnificent treatment afforded to his hero Napoleon's remains in 1840. On 1 May 1840 Louis Philippe announced to his ministers that he consented to the return of Napoleon's body to France. The Invalides was selected as the most suitable site for the tomb, and a mission was dispatched to St Helena to bring back the great soldier. A truly spectacular funeral was staged on 15 December 1840. There was much discussion about the design of the shrine, a scheme for a sunken well or crypt was approved, and construction work eventually got under way in 1843. It may be just coincidence, but on 31 December 1840, a fortnight after Napoleon's funeral, the Duke's factor is to be found writing to the architects William Burn and David Hamilton on the subject of a proposed mausoleum at Hamilton Palace. Furthermore, the Duke's decision to be buried in a sarcophagus can be related to the fact that Napoleon had been placed, in 1840, in a coffin in the shape of an ancient sarcophagus, made of ebony polished till it looked like black marble. Later, when the crypt in the Church of the Invalides was finished, he was to be entombed in the great sarcophagus of porphyry designed by Visconti.

The possible Napoleonic connections should not, however, distract attention from the Egyptian elements in the Duke's disposal of his mortal remains. The writer of the Duke's obituary in the *Gentleman's Magazine* clearly did not approve. He writes of the "insane pride" which led the Duke to make such arrangements for his corpse. "His body underwent the process of embalming, a process which even royalty has of late years judged proper to decline." The

Duke had in fact commissioned Thomas Joseph Pettigrew, "Mummy Pettigrew", to embalm him. Pettigrew had been examining mummies since 1820; his *History of Egyptian Mummies* had appeared in 1834 and he had become famous for his public demonstrations of "unrolling" mummies. He duly performed the necessary operations, assisted by his own son and a Mr Squibb, and also acted as chief ritualist at the funeral. The obsequies, described in *The Times* (7 September 1852), included ceremonies modelled on Egyptian practices, or at least what Pettigrew understood or made of them.

Unfortunately, the 10th Duke was not allowed to rest in peace like some latter-day Pharaoh or his hero Napoleon. During the First World War a seam of coal was allowed to be mined beneath the mausoleum and in 1921 the ducal trustees decided that the building was no longer safe. The remains of the majority of the Hamiltons were removed to Bent Cemetery, Hamilton. Still in his Egyptian sarcophagus, Alexander was lowered into a mass grave in the local burial ground.

68. *The Emperor Napoleon apotheosized.* Marble. Bertel Thorvaldsen (1770-1844). Danish (Rome), c. 1830. 99.9 cms. Lent by the Thorvaldsen Museum, Copenhagen, 850. A number of versions of Napoleon apotheosized as emperor were produced in Thorvaldsen's workshop in Rome. In February 1846 a bust of Napoleon by Thorvaldsen was brought to Hamilton Palace and placed in the tribune, or ante-room, on the first floor next to the dining-room which contained the portrait of Napoleon by David. The date suggests that the work had been acquired from the estate of Alexander Murray of Broughton, Kirkcudbrightshire (d. 1845), who had commissioned a bust of Napoleon from Thorvaldsen in 1829. The Hamilton Palace bust was sold in the great sale of 1882, when it was purchased by J. B. Greenshields of Kerse, Lanarkshire. It would seem likely that the Hamilton Palace bust is the version now in the Thorvaldsen Museum. The latter appears to be identical to the bust illustrated in the Hamilton Palace Collection sale catalogue, with the exception of (subsequent) damage. Furthermore, the version in the Thorvaldsen Museum seems to have a convincing provenance. It is stated to have been bought at a sale at Sotheby's, in London in 1916, by M. Bacri of Paris, who sold it to M. Thionville, also of Paris. It was acquired, in Paris in 1918, by Valdemar Glückstadt, Consul General, of Copenhagen, and purchased at the sale of his collection, in Copenhagen in 1923, by Mr Bruun, of Copenhagen, whose daughter sold it to the Museum in 1929. The other main contender, the bust in the Art Gallery, Auckland, New Zealand, is definitely not the work illustrated in the Hamilton Palace sale catalogue. Fig. 56.

FRENCH FURNITURE

69. Colour Photograph. Cabinet. Veneered with marquetry of stained and natural woods, turtleshell and metals. The figures are of wood, painted to resemble patinated and gilded bronze. Gilt bronze mounts. Attributed to André-Charles Boulle (1642-1732). French (Paris), 1670-80. 225 x 139 x 67.5 cms. Collection of the Duke of Buccleuch and Queensberry, Drumlanrig Castle, Thornhill, Dumfriesshire. Almost certainly a French royal commission. The cabinet was formerly in Dalkeith Palace, which was rebuilt in the early 18th century by Anne, Duchess of Buccleuch and widow of the Duke of Monmouth. It is said to have been presented by Louis XIV to Charles II and given to Charles' eldest natural son, Monmouth (d. 1685). The cabinet is illustrated in Fig. 57. The subject-matter is discussed briefly in the caption.

70. Colour Photograph. Cabinet. Veneered with natural and stained woods, turtleshell and metals. The figures are of wood and gilt. Gilt bronze mounts. Attributed to André-Charles Boulle. French (Paris), c. 1670. 192 x 114 x 54 cms. Collection of the Duke of Buccleuch and Queensberry, Drumlanrig Castle. This cabinet is also from Dalkeith Palace and is associated with Anne, Duchess of Buccleuch, and her husband. Fig. 58. Further details appear in the caption.

71. Commode. Two drawers. Marquetry decoration. Gilt bronze mounts. Marble top. Adrien Faizelot-Delorme (*maître* 1748, retired 1783). French (Paris), c. 1760. 84 x 90 x 44 cms. Lent by the Earl and Countess of Rosebery, Dalmeny House, near Edinburgh. Delorme practised both as a manufacturer and as a dealer.
 This piece is displayed out of chronological sequence to demonstrate how French furniture is constructed and marked. Further information appears on the panel beside the exhibit.

72. Commode. Marquetry decoration. Gilt bronze mounts. Marble top. French (Paris), 1745-49? 91.5 x 141.7 x 65.1 cms. Lent by the Duke of Buccleuch and Queensberry, Bowhill, near Selkirk. Commodes such as this have almost invariably been attributed to the great *ébéniste* Charles Cressent (1685-1768). However, there were other makers besides Cressent producing commodes of this type (as, for example, Antoine-Robert Gaudreau). One of the mounts appears to be struck with a mark. Between 1745 and 1749 taxes were levied on works made in various materials, and it is possible that this mark may have been made with a 1745-49 tax punch.

73. Armchair (*fauteuil*). One of a dozen. Pierre Bara (*maître* 1758). French (Paris), c. 1765. 102 x 76 x 63 cms. Lent by the Earl and Countess of Mansfield, Scone Palace, near Perth. Bara had close business contacts with the *tapissier* Planqué, and Planqué may have provided the superb needlework panels with which this set of chairs is upholstered. The subject-matter of the panels includes figures in mythological, medieval and Chinese costume, fabulous beasts and chinoiseries. The frames were repaired and re-gilded in 1885; the panels were also cleaned at this time.

74. Armchair (*fauteuil*). French (Paris), c. 1770. 92.5 x 68 x 52 cms. Lent by the Duke of Buccleuch and Queensberry, Bowhill.

75. Armchair (*fauteuil*). From a set upholstered with panels illustrating La Fontaine's *Fables*. French (Paris), c. 1775. 101.5 x 75.5 x 62 cms. Lent by the Duke of Roxburghe, Floors Castle, Kelso.

76. Commode from the bedchamber of the Comtesse d'Artois at Versailles. Marquetry decoration. Gilt bronze mounts. Sarrancolin marble top. Gilles Joubert (1689-1775). French (Paris), 1773. 92. 5 x 146.5 x 65 cms. Lent by the Duke of Roxburghe, Floors Castle, Kelso. The back of the commode is inscribed "*du N° 2718*". The French royal inventories reveal that this was one of many items of furniture supplied by Joubert for the apartment of Comte and Comtesse d'Artois at Versailles around the time of their marriage. It was, in fact, delivered on 8 November 1773, eight days before the wedding. Fig. 64.

77. Bed Table. In two parts. The lower part is formed by four cabriole legs with a single drawer set in the frieze. The upper part can be lifted off and also has four legs, which normally fit against the main feet. The upper part opens to reveal a compartmented interior with an adjustable mirror in the centre section. Floral marquetry decoration. Gilt bronze mounts. French (Paris), c. 1770. 76.2 x 60.9 x 35.6 cms. Lent by the National Trust for Scotland, from Brodie Castle, Morayshire. Ex-Collection of Elizabeth, Duchess of Gordon (d. 1864), wife of the fifth and last Duke of Gordon.

78. Dressing Table. The top is decorated in marquetry with a scene of figures in front of a *château*. A pull-out centre panel is inlaid with a portrait of a man in 16th century costume, who may be Francis I. Gilt bronze mounts. French (Paris), c. 1775. 72 x 79.5 x 46.5 cms. Lent by the Earl and Countess of Mansfield, Scone Palace. Like many items with high quality panels of marquetry this dressing or mechanical table is associated with Charles Topino (b. 1742, *maître* 1773, d. 1803), who produced and dealt in marquetry panels.

79. Small Lean-to Secretaire (*bonheur du jour*). Marquetry decoration, including a seascape on the lid. Gilt bronze mounts. French (Paris), c. 1775. 99 x 98 x 56 cms. Lent by the Duke of Buccleuch and Queensberry, Drumlanrig Castle. Like the last item, this piece is also associated with Charles Topino.

80. Cylinder Bureau. Veneered in exotic woods and set with painted panels imitating oriental lacquer. Gilt bronze mounts. Marble top. Roger Vandercruse, called Lacroix (b. 1728, *maître* 1755, d. 1799). French (Paris), c. 1780. 109.5 x 81 x 53.5 cms. Lent by the Earl and Countess of Rosebery, Dalmeny House.

81. Commode. Three short drawers in the frieze and two deep drawers below. Marquetry decoration. Gilt bronze mounts. Breccia marble top. Léonard Boudin (b. 1735, *maître* 1761, d. 1804). French (Paris), c. 1780. 88 x 81 x 50 cms. Lent by the National Trust for Scotland, from Brodick Castle, Isle of Arran.

82. Writing and Work Table from the Château of Marly. Marquetry decoration. Gilt bronze mounts. Jean-Henri Riesener (b. 1734, *maître* 1768, d. 1806). French (Paris), c. 1781. 77 x 50.5 x 38.5 cms. Lent by the Earl and Countess of Mansfield, Scone Palace. Delivered to the Château of Marly in 1781. For further information see Chapter V. Fig. 61.

83. Commode. Straight front containing a fitted secretaire drawer above two others, flanked by concave sides, each with two shelves. Veneer decoration. Gilt bronze mounts. Siena marble top. Attributed to Adam Weisweiler (b. 1744, maître 1778, d. 1820), French (Paris), c. 1790. 103 x 140 x 56 cms. Lent by the National Trust for Scotland, from Hill of Tarvit, Cupar, Fife. F. B. Sharp Collection.

84. Drop-front Secretaire. One of a pair. Plain black lacquer decoration. Gilt bronze mounts. Marble top. Attributed to Adam Weisweiler. French (Paris), late 18th-early 19th century. 124.5 x 68.5 x 35.5 cms. Lent by the Earl and Countess of Rosebery, Dalmeny House.

85. Cabinet. One of a pair. Marquetry decoration. French (Paris), c. 1848. 127 x 92 x 45 cms. Lent by the Duke of Atholl, Blair Castle, Blair Atholl, Perthshire. Stated to have been acquired in 1848, the year which saw the downfall of Louis Philippe, the election of Louis Napoleon to the presidency of France, and, as part of the troubles, a strike by the furniture makers in the capital.

FRENCH 19th CENTURY PORTRAIT SCULPTURES

86. *The Marquess of Stafford and future 3rd Duke of Sutherland in Highland costume.* Bronze. The side of the base engraved: "EXECUTE EN BRONZE PAR VITTOZ SUR LE MODÈLE DE JEAN · FEUCHÈRE. PARIS 1837". Jean-Jacques Feuchère (1807-52). Cast at the Vittoz foundry. French (Paris), 1837. 134 x 62 x 46 cms. Collection of the Countess of Sutherland, Dunrobin Castle. Lent by the Sutherland Trust. The sitter was George Granville William Leveson-Gower, Marquess of Stafford, the eldest son of the 2nd Duke of Sutherland. He was born on 19 December 1828, became 3rd Duke in 1861, and died in 1892. The bronze was exhibited at the Paris Salon of 1838 and was at Stafford House, London, by 1846. It was subsequently brought up to Dunrobin Castle, Golspie, Sutherland, where it is normally to be seen in the entrance hall, in a niche facing the main doorway. Fig. 67.

87 & 88. *Lords Albert and Ronald Leveson-Gower.* Bronzes. The backs of the bases signed and dated: "CARRIER. 1852". Albert-Ernest Carrier-Belleuse (1824-87). French, 1852. *Lord Ronald* (left): 43 x 21 x 18.3 cms; *Lord Albert* (right): 43 x 18 x 18.3 cms. Collection of the Countess of Sutherland, Dunrobin Castle. Lent by the Sutherland Trust. The French sculptor Carrier-Belleuse arrived at the ceramic factory of Minton in Stoke-on-Trent in 1850. Two years later he modelled these two statuettes of the 2nd Duke of Sutherland's third and fourth sons, Lord Albert (1843-74) and Lord Ronald (1845-1916). They were produced in bronze and in Parian porcelain. A pair of Parian statuettes, which are a good deal smaller than the Dunrobin bronzes, is at Osborne House on the Isle of Wight. Carrier-Belleuse undertook a full-length statuette and a bust of the boys' sister, Constance, in 1854, two years after her marriage to the future 1st Duke of Westminster. Fig. 68.

89. *Arthur St Clair Anstruther Thomson.* Marble. The base signed and dated: "DALOU 1877". Aimé Jules Dalou (1838-1902). French (London), 1877. 114 x 40 x 40 cms. 1984.120.

Arthur St Clair Anstruther Thomson was the youngest son of John Anstruther Thomson, Master of the Pytchely, Atherstone and Fife hounds, and Maria Hamilton Gray, the daughter of the historian Caroline Johnstone and the Rev. John Hamilton Gray, the rural dean at Bolsover Castle, Derbyshire. Arthur was born in Edinburgh in 1872 and died in 1902; he is buried in Dunedin, New Zealand.

The sculptor Dalou was a staunch republican with decidedly left-wing sympathies. He became involved with the Paris Commune and was appointed an adjunct curator of the Louvre. When the uprising was put down, he had to flee into exile. He came to England in July 1871 where his friend Alphonse Legros, then Professor at the Slade, introduced him to possible patrons. Dalou returned to France in April 1880.

This sculpture appears to be connected with a visit which Maurice Dreyfous, Dalou's close friend, executor and biographer, noted Dalou paid to Scotland in 1877. It seems to have been commissioned as a pendant to a marble statue of Maria Hamilton Gray as Psyche, carried out by the Scottish sculptor Lawrence MacDonald in Rome in 1839.

During his English period Dalou had concentrated upon working in terracotta and only two other marbles are known from these years: *Hush-a-Bye* (a mother seated on a rocking chair nursing her child) made for the Duke of Westminster, dated 1875 and exhibited at the Royal Academy in 1876, and *Charity* (a female figure with small children) commissioned by the

Broad Street Ward, London, in 1877 to surmount a public drinking fountain near the Royal Exchange. Unfortunately *Charity* was ruined by the weather and was replaced by a bronze cast in 1896 or 1897.

Dalou's energies in later years were taken up with his colossal *Triumph of the Republic* for the Place de la Nation in Paris, commissioned in 1879, unveiled as a plaster in 1889 and in final bronze form in 1899. In these last two decades he became one of the most prolific, and arguably most successful, monument makers in France. Fig. 70.

FRENCH MEDIEVAL ANTIQUITIES

The second half of the nineteenth century saw a growth of interest in medieval antiquities. One of the principal collectors in Scotland was Sir Thomas David Gibson Carmichael, who became Lord Carmichael of Skirling. A slightly later collector was Sir William Burrell. Carmichael's collection is now dispersed, but Burrell's is still intact, and important French medieval enamels, ivories, sculptures, tapestries and stained glass may be seen in the Burrell Collection, in Glasgow. The two tapestries exhibited here serve as reminders of the collecting of French and other medieval works of art by Scots.

90. Tapestry. Verdure with four thistle plants growing vertically almost the entire height of the tapestry; stylized clouds at the very top. Wool. Franco-Flemish, late 15th-early 16th century. 264.1 x 246.3 cms. Lent by the Burrell Collection, Glasgow Museums and Art Galleries, 46.108. The term "verdure" describes tapestries which represent flowers, plants and trees. A closely related hanging from the same model, and possibly part of the same set, is in the Museum of Decorative Art in Copenhagen. Another fragment, without the stylized clouds, is in a French private collection. In the early seventeenth century André Favin recorded that Peter II, Duke of Bourbon (d. 1503), ordered a set of thistle tapestries to be made in remembrance of his great grandfather, Louis II, Duke of Bourbon. In the middle of the fourteenth century Louis had founded the Order of Hope. Knights of this order bore a blue strap with buckle and tongue bearing the word "Espérance" in gold. The set of tapestries ordered by Peter II apparently had white thistle heads and blue borders which alluded to "la ceinture d'espérance" in the devise and coat of arms of the founder. The Burrell tapestry has thistle heads woven in whitish wool and blue-green borders, and it is possible that it formed part of the set commissioned by Peter.

91. Tapestry. *Triumph of Death over Chastity*. Wool and silk. Flemish (Brussels), early 16th century. 351 x 305 cms. Lent by the Burrell Collection, Glasgow Museums and Art Galleries, 46.128. In the top left, the winged figure of Time cuts down victims with a scythe. To the right, Death is personified by a flying female figure swathed in a shroud, who pierces the arm of a peasant with a lance. Below them, Chastity lies trampled beneath the feet of the three Fates. The figure between the Fate in the centre and the Fate on the right may represent sickness or the plague. The tapestry illustrates one of the Triumphs described by the Italian poet Petrarch in his poem *I Trionfi*. It is usually the third of a set of five Triumphs beginning with the Triumph of Love and ending with the Triumph of Eternity. Another version of this tapestry is in the Château d'Azay-le-Rideau in France. One of the two versions may have formed part of a set of Triumphs acquired by Isabella the Catholic from a Flemish merchant who had settled in Medina del Campo.

THE CULT OF NAPOLEON

A number of Scottish families besides the Dukes of Hamilton acquired works of art and other items which relate to the Emperor Napoleon and his family. The exhibits shown here are but a small selection from the wealth of Napoleonic material still preserved in Scotland.

92. Miniature of Napoleon. Signed on the right; "*Jsabey*". Jean-Baptiste Isabey (1767-1855). French (Paris), c. 1800-4? 6 x 3 x 1 cms. Lent anonymously. Isabey was a miniature and watercolour painter. A pupil of Giradet and Claudot in Nancy, he arrived in Paris in 1785 and was accepted into David's studio the following year. Much in demand during the *ancien régime* and the Revolution, Isabey enjoyed even greater success after Napoleon came to power. He became drawing master to Joséphine's children and later to the Empress Marie-Louise.

93. Plate. Circular plate painted in enamels in the centre with an oval portrait of the Empress Joséphine. Gilded ground with the initials "J" (for Joséphine) on the left border and "N" (for Napoleon) on the right border. The base marked in red enamel "*M. Imp.le/de Sevres/7*" and inscribed "*Peint à la Manufacture Imp.le, de sevres/par J.B.* [*I*]*sabey.Aout.1807*". Jean-Baptiste Isabey. French (Sèvres), 1807. 3.3 x 23.5 cms. Lent anonymously. For information on Isabey see the preceding entry. A piece of paper attached to the base of the plate records: "*Part of a service belonging to the Emperor Napoleon used by him at S.t Helena—given to General Bertrand after his death & left to me by G.en Bertrand's daughter—M.me Thayar. G de Lavalette.*" Bertrand was Grand Marshal of Napoleon's household in exile. In the first codicil to his will, signed on 16 April 1821, the Emperor left "to Counts Bertrand and Montholon and to Marchand the money, jewellery, silver, porcelain, furniture, books, weapons and in general everything that has belonged to me on the isle of St Helena". In the eighth codicil, dated 27 April, he bequeathed "to Countess Bertrand and Countess Montholon half of my set of Sèvres porcelain".

94. Bowl and Stand. Circular bowl and circular stand. Porcelain with applied biscuit porcelain decoration including medallions with profile busts of the Emperor Napoleon and members of the imperial family, on gilded grounds. French (Sèvres), early 1810s. Bowl: 9.5 x 19.5 cms; stand: 2 x 34.2 cms. Lent anonymously. The bowl bears a medallion of Napoleon's son, Joseph-Charles-Francis, King of Rome, who was born in March 1811.

95. Death Mask of the Emperor Napoleon. Bronze. Inscribed: "NAPOLEON EMP.ET ROI SOUSCRIPTION D.R ANTOMMARCHI 1833" on a medallion under the chin; "D.R.E ANTOMMARCHI" on the left side; and "FONDU PAR L. RICHARD ET QUESNEL A PARIS" on the right side. French (Paris), 1833. 17.5 x 14 x 35 cms. Lent anonymously. François Antommarchi was a Corsican dissecting-room assistant whom Cardinal Fesch sent to St Helena in 1819 to act as Napoleon's doctor. He claimed to have made the death mask of Napoleon after the Emperor's demise on 5 May 1821. However, it is now thought that it was an English doctor, Dr Burton, who made the mould and that Antommarchi carried this off and signed it. Antommarchi subsequently capitalized on his time at Longwood: he wrote a book entitled *Les deniers moments de Napoleon* and in 1833 sold the rights to reproduce the death mask to two Parisian founders, Richard and Quesnel. There was some disappointment that the death mask did not correspond with the then fashionable science of phrenology: no trace could be found of the "bumps of genius".

Thorvaldsen's bust of the *Emperor Napoleon apotheosized* (no. 68) is said to be based in part on the death mask. The cast is shown alongside the Thorvaldsen sculpture to allow comparison.

MEDIEVAL LIMOGES ENAMELS

96. Ciborium. *Champlevé* enamel on copper. Circular bowl of copper *repoussé*, *champlevé*, chased, engraved, enamelled and gilded, covered with a diaper of intersecting lines. Three tiers of demi-figures: eight angels within half-lozenges in the top row; eight saints within lozenges in the centre; and eight angels in half-lozenges in the bottom row. The heads applied separately. Set with glass pastes and semi-precious stones. Foot of gilded copper with pierced decoration representing three human figures in short tunics alternating with fantastic hybrid bird-animals in scrolling foliage. Lacking a domed lid. Attributed to the Magister Alpais. French (Limoges), early 13th century. 16 x 13.8 cms. 1966.452. A ciborium is a vessel used for the reservation of the Eucharist. This is one of only half-a-dozen surviving examples and is very close to a complete ciborium, with a domed lid, which is signed by the Magister Alpais. This signed piece was in the Abbey of Montmajor in the diocese of Arles and is now in the Musée du Louvre, Paris. A legal document of 1216 refers to a certain J. Alpais and the name also appears on several lists of benefactors of the Abbey of Saint Martial in Limoges. The bowl and foot of the ciborium in the Royal Scottish Museum came from two continental collections and were auctioned separately by Sotheby's in the 1960s. Fig. 74.

97. Reliquary Casket. *Champlevé* enamel on copper. Rectangular casket with pitched roof, cresting and gabled ends, on four rectangular feet. Door in the back. Originally eight plaques attached to a wooden core: seven remain, the eighth (on the back to the left of the door) is lacking. The plaques *champlevé*, chased, engraved, enamelled and gilded. The heads applied separately. French (Limoges), c. 1225. 19 x 21.8 x 9.5 cms. 1884.44.56. The two plaques on the front represent the *Journey of the Magi* (roof) and the *Adoration of the Magi* (side). The gable-ends are each decorated with a standing saint holding a book and the three plaques on the back with quatrefoils contained in roundels. Ex-Castellani Collection. Fig. 75.

98. Gemellion. *Champlevé* enamel on copper. Shallow circular bowl with a spout attached to the side. *Champlevé*, chased, engraved, enamelled and gilded. The spout cast to represent the head of an animal. French (Limoges), mid 13th century. 25.2 x 3.2 cms. 1877.20.86. A gemellion (from *gemellus*, twin) is one of a pair of bowls used for washing hands on ritual or ceremonial occasions. This example was for pouring. Gemellions were made in comparatively large numbers at Limoges, and were distributed quite widely throughout Europe. About 230 are known to have survived. Ex-Collections of Prince Soltykoff and Robert Napier. Fig. 76.

PAINTED LIMOGES ENAMELS

99. Plaque. Rectangular plaque of copper painted in grisaille enamel with the *Virgin and Child* on a black ground and gilded. Signed in white on the step beneath the Virgin and Child: ".LL.1540". Léonard Limosin (c. 1505-75/77). French (Limoges), 1540. 22.3 x 13.1 cms. 1877.20.87. The composition reflects the influence of Italian art in France during the 1530s and 40s.

100. Plaque. Rectangular plaque of copper painted in grisaille enamel with the *Adoration of the Magi* on a black ground and gilded. French (Limoges), third quarter of the 16th century. 9.1 x 15.2 cms. 1948.146.

101. Triptych. Ten plaques of copper painted in grisaille enamel on a black ground and gilded set in an ebonized and gilded wooden frame. The three main rectangular plaques show scenes from the *Life of St John the Baptist*. The main left- and right-hand plaques signed in gilt letters bottom right: ".I.R.". Probably a member of the Reymond family, Jean or Joseph. French (Limoges), late 16th-early 17th century. 35.7 x 20.4 (closed): 28.2 (open) x 5.7 cms. 1876.29.4. The left-hand wing shows the *Baptism of Christ* by St John in the River Jordan, the centre panel *St John Preaching*, and the right-hand wing the *Decollation* or *Beheading of St John*. God the Father is represented in the act of blessing in the lunette above the main central panel. The work is based on triptychs with the same scenes by M. D. Pape.

102. Plaque. One of a pair. Rectangular plaque of copper, the top now rounded, painted in coloured enamels with the head of *Christ* in an oval on a black ground and gilded. Floral decoration. Enamelled foils. Inscribed in gilt letters across the base "[. . .]*fili david*". Signed in gilt letters bottom right: "I [. . .]" with a fleur de lys between the letters. Jean I or Jean II Limosin. French (Limoges), first quarter of the 17th century. 8.3 x 6.8 cms. 1877.20.89. The other plaque depicts the Virgin Mary (see following entry).

103. Plaque. One of a pair. Rectangular plaque of copper painted in coloured enamels with the head of the *Virgin Mary* in an oval on a black ground and gilded. Floral decoration. Enamelled foils. An inscription and possible signature at the base of the plaque have been destroyed. Jean I or Jean II Limosin. French (Limoges), first quarter of the 17th century. 8.6 x 6.7 cms. 1877.20.90. The other plaque depicts Christ (see preceding entry).

104. Plaque. Convex rectangular plaque of copper painted in coloured enamels with a depiction, in an oval, of *St Charles Borromeo* (1538-84) worshipping a crucifix on a black ground and gilded. Raised enamel ornamentation in the corners. Inscribed across the base in black letters: "S. CHARLES BORROMEE". Signed in gilt letters in the centre beneath the oval: "B. N". Probably a member of the Nouailher family. French (Limoges), 17th century. 13.7 x 10.8 cms. 1896.332. Cardinal Borromeo was Archbishop of Milan and one of the major figures of the Counter Reformation; he was canonized in 1610.

105. Plaque. Rectangular plaque of copper with rounded top painted in coloured enamels with the *Coronation of the Virgin* on a black ground and gilded. French (Limoges), late 16th century. 8.4 x 6.7 cms. 1890.918.

106. Plaque. Rectangular plaque of copper with rounded top painted in coloured enamels with the *Crucifixion* on a black ground and gilded. French (Limoges), 17th century. 8.3 x 6.5 cms. 1870.16.38.

107. Dish. Circular dish of copper painted in grisaille enamel with the *Wedding Banquet of Cupid and Psyche* on a black ground and gilded. The reverse painted in grisaille enamel with two heads in profile facing left on a black ground and gilded. Attributed to Léonard Limosin (c. 1505-75/77). French (Limoges), c. 1560. 44.3 x 4 cms. 1885.33. The gods are shown seated

at table on clouds above Mount Olympus. Jupiter is represented in the centre holding a thunderbolt. Cupid and Psyche are depicted together on the right in front of the table. The story of Cupid and Psyche is contained in the *Metamorphoses* of the second century African writer Lucius Apuleius, which is sometimes given the modern title *The Golden Ass*. The Italian humanist Poggio Bracciolini discovered a manuscript of the work in 1427, and it was published in Rome in 1469, only four years after printing had been introduced into Italy. The *Metamorphoses* enjoyed great popularity during the Renaissance. It was translated into Italian by Boiardo (1494, printed 1518), into French by Michel (1522) and into English by Adlington (1566). Raphael prepared designs illustrating the legend for the decoration of Peruzzi's loggia in the Villa Farnesina in Rome. The scheme, carried out by his assistants, was probably begun in 1517 and appears to have been completed by the end of 1518. The composition on this plate is based on the central part of the *Wedding Feast of Cupid and Psyche* in the Villa Farnesina. A pupil of Marcantonio Raimondi produced an engraving after the fresco. The scene on this plate is copied, with variations, from an engraving by the Master of the Die. The print is number 31 in the series of 32 engravings of the story of Psyche according to Apuleius by the Master of the Die and Agostino Veneziano after drawings by the Flemish artist Michiel Coxie, "the Raphael of the North". A dish depicting the same subject in the Walters Art Gallery, Baltimore, is signed "LL" for Léonard Limosin. A third dish of the same subject is in the Widener Collection in the National Gallery of Art, Washington, DC. It had been assigned to Jean III Penicaud but is now attributed to Léonard Limosin. The dish in the Royal Scottish Museum is from the Collection of Andrew Fountaine of Narford Hall, Norfolk (sale 16 June, 1884, lot 161). Fig. 77.

108. Plaque. Oval plaque of copper painted in grisaille enamel with the head of a man in Roman costume wearing a laurel wreath facing left on a black ground and gilded. Inscribed in gilt letters: "IMPERATOR NERO". French (Limoges), mid-late 16th century. 19.6 x 14.7 cms. 1880.57.3. After an engraving by Marcantonio Raimondi. The Emperor Nero reigned 54-68 AD.

109. Plate. Circular plate of copper painted in grisaille enamel with a scene from the story of Psyche on a black ground and gilded. The base decorated in grisaille enamel with the heads of four putti on a black ground and gilded. Possibly from the workshop of Jean Court *dit* Vigier. French (Limoges), c. 1560. 24.2 x 2.9 cms. 1868.35.1. After engraving number 14 in the series of 32 engravings of the story of Psyche by the Master of the Die.

110. Plaque. Oval plaque of copper painted in coloured enamels with the goddess Diana hunting, with a stag and a rabbit being pursued by five dogs, and a naked woman being dragged down into hell by two devils. Enamelled foils. Inscribed in gilt letters around the side: "POTESTAS★PARVBIQVE★". French (Limoges), late 16th century. 11.3 x 8.6 cms. 1868.35.2. An allegory, possibly not unconnected with Diane de Poitiers (1499-1566), mistress of Henri II.

111. Plate. Circular plate of copper painted in coloured enamels with a scene of sheep-shearing and the sign of the zodiac for July on a black ground and gilded. Inscribed in gilt letters: "IVLIET". Enamelled foils. The reverse painted in coloured enamels with the head of a man in Roman costume wearing a laurel wreath facing left and gilded. Inscribed in gilt letters: "SER GALBA". French (Limoges), late 16th century. 24.7 x 1.6 cms. 1877.20.88. The depictions of the labour of the month and of the Emperor Galba are after engravings. The Emperor Servius Galba reigned 68-69 AD.

112. Pair of Candlesticks. Candlesticks of copper, each with a stem with a six-cusp section above a circular drip pan and a broad circular foot. Painted in grisaille enamel with scenes of the hunt on a black ground and gilded. The feet signed "I.L" and the bases inscribed "·Laudin·Emaillieur·/·a·Limoges/ ·I·L·". Jacques Laudin I (c. 1627-95). French (Limoges), mid-late 17th century. 23 x 19 cms. From the Mentmore Towers sale. 1977.199 & A.

113. Dish. Shaped two-handled dish of copper with six-cusp section and hexagonal base painted in coloured enamels and gilded. The base of the interior decorated with a female figure in classical dress with a hooded bird of prey perched on her left hand and the inner wall with foliage and birds. The base decorated with buildings and trees. French, 17th century. 15.8 x 4 cms. 1872.25.11. One handle missing.

114. Dish. Circular two-handled dish of copper painted in coloured enamels and gilded. The base of the interior decorated with St Peter repenting with the cock behind his shoulder on the right. Six shaped divisions on the inner wall decorated with eagles alternating with flowers. A landscape painted on the base. French, 17th century. 15.8 x 4 cms. 1888.184. One handle missing.

FRENCH CERAMICS

115. Ewer. Earthenware stamped and inlaid with coloured clays and glazed. French (Saint-Porchaire), c. 1540. 34.6 x 10.8 cms. 1975.466. This dating follows the old classification. Work presently underway on Saint-Porchaire ware suggests a somewhat later dating, c. 1550-60 or possibly even slightly later. Ex-Collection of Horace Walpole at Strawberry Hill. Fig. 78.

116. Dish. Circular dish depicting *Joseph's Brothers before Joseph in Egypt*. Tin-glazed earthenware painted in colours. Inscribed on the back: "*Dieci fratelli/dalla fame chaciato/in egitto a Giusepe nēgo/avanti/*GENES XLII". French (Lyons), c. 1585. 6.7 x 44 cms. 1963.36. The scene is copied from an engraving by the Lyons illustrator Bernard Salomon. The attribution of this dish presents a problem. The style of decoration is very close to that found on maiolica produced in Urbino in northern Italy and the piece is inscribed in Italian. Not too much can be made of the fact that the composition is after an engraving by the *Lyonnais* Salomon: his work was widely distributed and was certainly known to decorators working in Urbino and elsewhere in Italy. The tentative attribution of the dish to Lyons is based on the strong links between the faience workshops of Lyons and the maiolica industry of Urbino and on the apparent relationship of the dish to two other dishes decorated with the same scene, now in the British Museum, London, and the Metropolitan Museum, New York, which were almost certainly produced in Lyons. The former is inscribed on the back "*1582 ... LEON*", while the latter bears the French inscription "*Les frères de Joseph venus a luy en Egypte au Genese LXIII*". Fig. 79.

117. Plaque. Rectangular plaque showing the *Christchild and St Joseph*. Earthenware moulded and covered with coloured glazes. Wooden frame. French (Bernard Palissy or a follower), mid 16th-17th century. 26.7 x 23 x 3.6 cms. 1872.2.5.

118. Dish. Oval dish with a representation of the *Baptism of Christ*. Earthenware moulded and covered with coloured glazes. French (Bernard Palissy or a follower), mid 16th-17th century. 4.1 x 25.6 x 30.9 cms. 1891.42.

119. Dish. Oval dish with three-dimensional representations of fish, crustaceans, a snake, lizards and toads. Earthenware moulded and modelled and covered with coloured glazes. French (Bernard Palissy or a follower), mid 16th-17th century. 7.6 x 53.5 x 40.2 cms. 1880.1.

120. Bottle. Tin-glazed earthenware painted in white on a blue ground. Floral decoration. French (Nevers), 1650-80. 26.9 x 13.5 cms. 1887.610.

121. Pilgrim's Bottle. Tin-glazed earthenware painted in white, yellow and orange on a blue ground. Floral decoration. French (Nevers), 1660-80. 30 x 19.3 x 11.3 cms. 1877.20.24.

122. Plate. Circular plate. *Rayonnant* ware. Tin-glazed earthenware painted in blue with flowers and foliage. French (Rouen), early 18th century. 4.3 x 56.5 cms. 1887.604.

123. Plate. Circular plate. Tin-glazed earthenware painted in blue and purple-brown with Chinese scenes. Mark: "*Giey*" above three crossed Cs above "/..." on the base. French (Gien, factory of Geoffrey Guérin et Cie), 1873. 5.9 x 55.8 cms. 1873.92.2.

124. Cooler. Tin-glazed earthenware painted in colours with flowers. French (Rouen), c. 1720-40. 16.2 x 25.6 x 21.7 cms. 1887.605.

125. Jug. Tin-glazed earthenware painted in colours. Coat of arms and swags. French (Bordeaux), c. 1740. 22.5 x 19.2 x 16 cms. 1960.403.

126. Plate. Circular plate. Tin-glazed earthenware painted in colours with birds, a butterfly and flowers. Mark: "T" painted in blue on the base. French (Rouen), c.1750-60. 3 x 24.7cms. 1878.13.3.

127. Coffee Pot. Tin-glazed earthenware moulded and painted in colours with flowers on a yellow ground. French (Moustiers), c.1760-70. 25.2 x 16.9 x 12.5 cms. 1962.123 & A.

128. Tureen, Cover and Stand. Tin-glazed earthenware painted in enamel colours. Handle of cover modelled in the form of fish and shells. Coat of arms. Mark: *L.* painted in black on the cover. French (Marseilles, probably made in the factory of Jean-Joseph Larchier), c.1770. 24.5 x 43.2 x 26.7 cms. 1879.48 & A-B.

129. Figure of a Boar. Porcelain. Undecorated. French (probably Saint Cloud), c.1735. 16.6 x 19.9 x 13.2 cms. 1980.674.

130. Figure of a Sleeping Boy. Porcelain. Undecorated. Mark: "P" impressed

on the base. French (Vincennes), c.1755. 8.2 x 14.5 x 6 cms. 1973.1. Perhaps from a model by Louis-Félix de la Rue, after a design by François Duquesnay ("Il Fiammingo").

131. Figure of a Boy playing Bagpipes. Biscuit porcelain. Mark: "F" incised on the base. French (Sèvres), c.1755-60. 22.7 x 10.6 x 8.6 cms. 1965.1047. From a model perhaps by Jean Baptiste Fernex after a glazed model by Blondeau after François Boucher.

132. Group. A Boy and Girl disputing over grapes (*La Chamaille des Raisins*). Biscuit porcelain. French (Niderviller), c.1780. 14.3 x 15.9 x 11.7 cms. 168.116. After a model by Paul-Louis Cyfflé.

133. Group. *The Darning Girl*. Tin-glazed earthenware. Undecorated. French (St Clement), late 18th century. 24 x 16.2 cms. 1923. 272. After a model originally made for the Luneville factory by Paul-Louis Cyfflé.

134. Group. A Boy in a tub watching a Boy and a Girl embracing. Tin-glazed earthenware. Undecorated. French (St Clement(?)), late 18th century. 17 x 19.6 x 14.2 cms. 1931.68.

135. Tea Service. Porcelain, enamelled, painted with portraits of members of the imperial family and gilded. French, c.1860. 1985.281 & A-KK. The service consists of the following pieces.

Item	Measurements	Subject
Circular tray	2.8 x 50 cms.	Emperor Napoleon (1769-1821)
Milk jug	13.5 x 15.1 x 9 cms.	Empress Joséphine (1763-1814), first wife of Napoleon (married 9 March 1796; marriage annulled 1809)
Teapot	21.8 x 23.2 x 12 cms.	Empress Marie-Louise (1791-1847), second wife of Napoleon (married 1-2 April 1810)
Sugar bowl	16 x 16.6 x 11.4 cms.	King of Rome (1811-32), Napoleon's son by Marie-Louise
Six plates	2.7 x 23.8 cms.	*Top row, left:* Madame Letizia Bonaparte (c.1751-1836), mother of the Emperor Napoleon (her second son); gave birth to thirteen children, of whom eight survived (five boys and three girls)
		Right: Elisa Bacciochi (1777-1820), first sister of Napoleon; married Capt. Felix Bacciochi (1797); made Princess of Lucca and of Piombino
		Middle row, left: Pauline Borghese (1780-1825), second sister of Napoleon; married General Leclerc (d.1802) and Prince Camillo Borghese (1803); made Duchess of Guastalla
		Right: Caroline Murat (1782-1839), third sister of Napoleon; married Joachim Murat (1800); made King and Queen of Naples
		Bottom row, left: Hortense Bonaparte (1783-1837), daughter of the Empress Joséphine by her first marriage to Viscount Alexandre de Beauharnais; married Napoleon's third brother Louis (1802); made King and Queen of Holland
		Right: Princess of Saxony
Twelve cups	6.5 x 8.5 x 6.4 cms.	*Top row, left to right:* Joseph Bonaparte (1768-1844), first brother of Napoleon; made King of Spain

Item	Measurements	Subject
		Lucien Bonaparte (1775-1840), second brother of Napoleon; made Prince of Canino
		Louis Bonaparte (1778-1846), third brother of Napoleon; made King of Holland
		Jerome Bonaparte (1784-1860), fourth brother of Napoleon; made King of Westphalia
		Eugène de Beauharnais (1781-1824), son of the Empress Joséphine by her first marriage; created Viceroy of Italy
		Joachim Murat (1767-1815), first aide-de-camp to Napoleon in Italy and the most dashing cavalry leader of the age; married Napoleon's third sister Caroline (1800); created Marshal of the Empire, Grand Admiral, Grand Duke of Berg and Cleves and King of Naples
		Bottom row, left to right: Duchesse d'Albuféra, niece of Joseph Bonaparte's wife; married the future Marshal Suchet (1808), who was made Duke of Albuféra after the Conquest of Valencia (1812)
		Madame Ealien
		Duchesse de Frioul
		Madamoiselle Mars
		Madame Juliette Récamier (1777-1849), the wife of a wealthy Paris banker and the reigning beauty of the Consulate and early Empire; later exiled from Paris by Napoleon
		Madame de Staël (1766-1817), daughter of the Swiss financier Necker, who became Director of the French Treasury in 1776; novelist and writer; at first a supporter and then a critic of Napoleon; exiled from Paris by Napoleon
Twelve saucers	2.7 x 13.2 cms.	Trophies

The base of the pieces are inscribed in red or black enamel: *M.Imp./de SèvreS* (the mark used at the Sèvres factory in 1804, the first year of the First Empire). The bases also bear the decorator's initials "*È.h*" for Jules-Eugène Humbert, who was active at the Sèvres factory between 1851 and 1870. The portraits themselves are signed: "*d'Humbert,/Sèvres*".

FRENCH AND FRENCH-STYLE GOLD BOXES FROM THE JAMES CATHCART WHITE BEQUEST

136. Snuffbox. Oval box with eight panels of moss-agate mounted *à cage* in gold. Unidentified maker's mark incorporating what appear to be an "r" and a "b". French (Paris), 1731-32. 2.5 x 5.2 x 4.4 cms. 1943.182. Fig. 71 (L).

137. Snuffbox. Elongated oval box of gold of four colours. Decorated with chased sunbursts overlaid with trophies in relief. Aymé-Antoine Chollet. French (Paris), 1761-62. 3 x 8.7 x 4.1 cms. 1943.174. Fig. 71 (K).

138. Snuffbox. Oval box of gold of three colours. Chased decoration. The lid set with an oval enamel miniature of a seventeenth century comtesse,

Jean-Marie Tiron. French (Paris), 1766-67. 3.6 x 8.9 x 4.4 cms. 1943.152. Fig. 71 (B).

139. Scent Flask. Flattened pear-shape flask of gold of four colours. Chased floral decoration in relief. Finial of stopper composed of two lyres placed back to back and draped with chased flowers and foliage. Possibly Pierre Cerneau. French (Paris), 1766-67. 10 x 4.7 x 1.5 cms. 1943.173. Fig. 71 (H).

140. Snuffbox. Rectangular box with cut corners of mother-of-pearl and malachite mounted à cage in gold of three colours. The lid and sides set with enamel miniatures. On the lid: an oval miniature of Venus and Cupid with an altar of love to the left. On the sides: oval and circular miniatures of Cupid presenting a posy of roses to a girl with a lamb, eating a bunch of grapes, lying asleep across the back of a dog, and holding a posy of roses above a lamb. Possibly Louis Cousin or Louis Gallois. French (Paris), 1771-72. 3 x 6.5 x 5 cms. 1943.148. Ex-Hawkins Collection. Fig. 71 (D).

141. Snuffbox. Rectangular box with cut corners of gold of three colours. Chased trophies in relief and engine-turned decoration. The front of the bezel engraved: "DU PETIT DUNKERKE". Jean-Baptiste-Maurice Juin. French (Paris), 1772-73. 2.6 x 7.8 x 4 cms. 1943.172. Fig. 71 (E). The Petit Dunkerque was a café particularly admired by Voltaire.

142. Snuffbox. Oval box with six gouache miniature views of coast scenes under glass mounted à cage in gold of two colours. Mathieu Coiny. French (Paris), 1774-75. 2.5 x 5.9 cms. 1943.164 & A. Ex-Hawkins Collection. Fig. 71 (F). The miniatures are attributed to van Blarenberghe.

143. Snuffbox. Oval box of gold and enamel. The lid set with an oval enamel miniature of Mucius Scaevola before Lars Porsena. The panels enamelled over engine-turned decoration. Pierre-Denis Hoart. French (Paris), 1774-75. 3.4 x 8.3 x 6.2 cms. 1943.141. Fig. 71 (I).

144. Eyeglass. Shaped eyeglass of gold of two colours and enamel. The panels enamelled over engine-turned decoration. Diminishing lens. Pierre-Denis Hoart. French (Paris), 1775-76. 9.1 x 3.8 x 0.8 cms. 1943.168. Fig. 71 (J).

145. Snuffbox. Oval box of gold of three colours and enamel. The lid set with an oval enamel miniature of a shepherdess and an old man standing beside a fountain with the sea, a ship and a classical ruin in the background. The panels enamelled over engine-turned decoration. Charles Le Bastier. French (Paris), 1776-77. 3.2 x 7.9 x 5.6 cms. 1943.145.

146. Snuffbox. Oval box of gold and enamel. The lid set with an oval enamel miniature of a woman and child seated and a man standing with hat in hand on the right. All three figures are dressed in seventeenth century costume. The panels enamelled over engine-turned decoration. Possibly Charles Dueil. French (Paris), 1777-78. 3.1 x 7.9 x 5.9 cms. 1943.144. Fig. 71 (C). The miniature is a detail in reverse from the painting La conversation espagnole by Carle Vanloo (1705-65) and is taken from an engraving.

147. Bonbonnière. Circular box of gold of three colours. Chased and engine-turned decoration. Charles Ouizille. French (Paris), 1778-79. 1.9 x 4.6 cms. 1943.183 & A. Fig. 71 (N).

148. Snuffbox. Oval box of gold and enamel. The lid set with a circular enamel miniature of a woman standing and a man kneeling to the right of an altar of love, over which hovers a putto. The panels enamelled over engine-turned decoration. "Pearls" of opalescent enamel. Illegible maker's mark. French (Paris), 1780-81. 2.5 x 7 x 5.2 cms. 1943.143. Fig. 71 (M).

149. Bonbonnière. Circular box with six miniatures under opalescent glass mounted à cage in gold. The lid and base have picturesque landscapes and the sides trees. Pierre-Claude Pottiers. French (Paris), 1780-81. 2.3 x 6.9 cms. 1943.166 & A.

150. Bonbonnière. Circular box of gold of two colours. Engine-turned decoration. Auguste-Gaspard Turmine. French (Paris), 1782-83. 1.9 x 4.8 cms. 1943.179 & A. Fig. 71 (A).

151. Buîte à Bonbono. Oval box with three panels of rock crystal mounted à cage in gold. Chased and decorated with enamel. Illegible maker's mark. French (Paris), 1781-83. 2.6 x 7 x 5.1 cms. 1943.171.

152. Snuffbox. Oblong box with semi-circular ends of gold of three colours. Chased and engine-turned decoration. Philippe Le Bourlier. French (Paris), 1785. 2.5 x 10 x 3.1 cms. 1943.176. Fig. 71 (G).

153. Bonbonnière. Circular box of gold of three colours. Chased and engine-turned decoration. Maker's mark "JLR", the device not clear. French (Paris), 1785. 2.2 x 6 cms. 1943.180 & A.

154. Snuffbox. Rectangular box with rounded corners of gold. Chased and engine-turned decoration. The lid set with an oval enamel miniature of Louis XIV. Augustin-André Héguin. French (Paris), 1798-1809. 1.8 x 6.8 x 4.8 cms. 1943.154.

155. Snuffbox. Rectangular box with rounded corners of gold and enamel. The lid decorated in champlevé and painted enamels with an arrangement of flowers and foliage reserved on an opaque black ground. The base has a formal, symmetrical arrangement of scrolls, stylized flowers and leaves in champeleré enamel also reserved on a black ground. Maker's mark "JD". French (Paris), 1819-38. 1.2 x 6.6 x 3.8 cms. 1943.191.

156. Snuffbox or Bonbonnière. Circular box. The lid and body are of glass mounted à cage in gold. The lid is flat, the sides bombé and the base convex. Applied to the centre of the lid is a carnelian cameo of Henri IV of France (1589-1610) in profile facing right. Probably French, 19th century. 2.4 x 5.4 cms. 1943.190.

157. Snuffbox. Oval box of gold and enamel. The lid set with an oval enamel miniature of two women and a man in Roman costume standing in an architectural setting. Maker's mark "NCQ". Imitation Paris marks. Probably Swiss, late 18th century. 3.3 x 7.5 x 5.6 cms. 1943.142. Ex-Hawkins Collection.

158. Snuffbox. Oval box of gold and enamel. The lid set with an oval enamel miniature of Calypso, two nymphs and Cupid. The panels enamelled over engine-turned decoration. "Pearls" of white enamel. Probably Swiss, late 18th century. 2.5 x 8.5 x 6.2 cms. 1943.146. The miniature depicts a scene from Fénelon's Les Aventures de Télémaque, in which Cupid enflames the hearts of Calypso and the nymphs. It is based on an engraving by Jean-Baptiste Tilliard after a drawing by Charles Monnot. This was one of a set of engravings first published in 1773 and then used to illustrate an edition of Fénelon's work published in Paris in 1785.

159. Snuffbox. Oval box of gold and enamel. The lid set with an oval enamel miniature of a queen or goddess with a female attendant and a negro page on the left and a man in Roman costume on the right. The panels enamelled over engine-turned decoration. "Pearls" of white enamel. Maker's mark "JF" over "T" couronné. Imitation Paris marks. Probably Swiss, late 18th century. 3 x 8.2 x 6.1 cms. 1943.147. The miniature may depict Dido and Aeneas.

160. Bonbonnière. Circular box of gold, enamel and pearls. The lid set with a circular enamel miniature of an altar of love, on which stands Cupid, with a woman holding a wreath and another woman kneeling on the right. The panels enamelled over engine-turned decoration. Illegible maker's mark beneath a crown. Probably Swiss, late 18th century. 2.1 x 7.1 cms. 1943.149 & A. Ex-Lampson Collection.

161. Bonbonnière. Circular box of gold and enamel. The lid set with a small circular enamel miniature of a woman kneeling to the right of an altar of love. The panels enamelled over engine-turned decoration. "Pearls" of white enamel. Unidentified maker's mark. Probably Swiss, late 18th century. 1.6 x 7 cms. 1943.150 & A.

162. Snuffbox. Rectangular box with cut corners of gold and enamel. The lid enamelled with a view of a coastline, shipping and fisherfolk. The base and sides enamelled over engine-turned decoration. Rémond, Lamy, Mercier et Compagnie. Swiss (Geneva), early 19th century. 1.9 x 8.6 x 6 cms. 1943.163.

163. Snuffbox. Oval box of gold and enamel. The oval panels on the lid and base and the four rectangular panels on the side wall painted in purple with harbour scenes. Illegible maker's mark. Imitation Paris marks. Probably Swiss, late 18th century. 2.5 x 6.4 x 4.8 cms. 1943.165.

164. Snuffbox. Oval box of gold, enamel and pearls. The panels enamelled over engine-turned decoration. Illegible maker's mark. Probably Swiss, late 18th century. 2.4 x 6.7 x 4.9 cms. 1943.167. Ex-Hawkins Collection.

165. Madame Victoire de France (1733-99). Marble. The socle inscribed "VASSE FECIT". Louis-Claude Vassé (1716-72). French (Paris), 1763. 71 x 48 x 28 cms. 1983.575. Victoire-Louise-Marie-Thérèse was the fifth daughter of King Louis XV and Queen Marie Leczinska. The sculptor Vassé trained under his father, the sculptor and decorator François-Antoine Vassé (1681-1736), and under Edme Bouchardon before studying in Rome from 1740 to 1745. He exhibited at the Salons from 1748 until the year before his death, becoming a full member of the Academy in 1751. This example of his work is related to a sketch of an identical, or near identical, bust in the artist Gabriel de Saint-Aubin's copy of the catalogue of the Salon of 1761. The present theory

is that it is the Salon piece with the date of final completion carved on the socle. Fig. 80.

FRENCH FABRICS

166. Dress Fabric. Deep brick red corded silk ground with a large exotic fruit and flower design in white and green silk and silver threads. French, c. 1726-28. 134 x 53 cms. 1977.254. Ex-Haddington Collection. Probably bought by Rachel, wife of Charles, Lord Binning, elder son of the 6th Earl of Haddington, on the continent. A dress of the same fabric, re-made in the 1740s, is in the National Museum of Antiquities of Scotland, Edinburgh.

167. Dress Fabric. Cream silk satin brocaded in coloured silks and silver thread with sprays of peonies and other flowers with rocks, in the Chinese style. French, c. 1730. 117 x 56.2 cms. 1966.863. Ex-Haddington Collection. Probably bought by Rachel, wife of Charles, Lord Binning, on the continent.

168. Furnishing Fabric. Cream silk satin brocaded in colours with a design of a lamb tied to a rose bush with a set of bagpipes beside it. French (Lyons), c. 1780. 99.5 x 54.5 cms. 1978.394. Designed by Philippe de Lesalle for the sheep farm of Marie-Antoinette at Rambouillet.

169. Furnishing Fabric. Dark red silk satin with a design of busts on plinths with serpents below and an arch above, done in light and dark cream. French, c. 1785. 185 x 62 cms. 1978.397.

FRENCH FURNITURE

170. Drop-front Secretaire. Upright rectangular drop-front secretaire with a drawer in the frieze, drop-front and two doors. Carcase of oak covered with veneer and trellis marquetry of tulipwood, kingwood and holly decorated with gilt bronze studs. Gilt bronze mounts. White marble top. The back stamped "G⁰ BENEMAN" and inscribed "₀₀₃₀". Guillaume Benneman (maître 1785-d.after 1811). French (Paris), c. 1790. 146 x 99 x 40.2 cms. 1985.313. Benneman replaced Riesener as the accredited court ébéniste in 1785 and from then on he was actively employed in supplying furniture for the royal residences. The secretaire is closely related to the work of Gilles Joubert. The marquetry is similar to that found on a secretaire by Benneman from the Cabinet-intérieur of Louis XVI at Compiègne, now in the Wrightsman Collection, New York.

171. Drop-front Secretaire. Louis XVI-style upright rectangular drop-front secretaire with drop-front above four drawers. Carcase of oak covered with amboyna and ebony veneers and floral marquetry decoration. Gilt bronze mounts. White marble top. French (Paris), period of Louis Philippe (1830-48). 130.4 x 73.9 x 38.4 cms. 1937.713. The back bears the stencilled inscriptions "CHARTAUX" and "₆₉₉".

172. Card Table. Louis XVI-style card table with shaped, folding top on four fluted, tapering legs. The rear portion made to pull out to form a drawer and a "rest" for the back half of the table top. Carcase of softwood veneered and decorated with lozenge or diamond pattern marquetry. Gilt bronze mounts. French (Paris), period of Louis Philippe (1830-48). 74.5 x 86.2 x 43 cms. 1941.42.

173. Tea Service in the Neo-classical style, consisting of tray, urn with spirit lamp, drip basin, teapot, coffee pot, milk jug and sugar bowl. Silver-gilt, wood and ivory. A. Risler and Carré. French (Paris), late 19th century. 1914.1240 & A-F. Inscribed on the bases: "A. RISLER & CARRÉ PARIS". Struck with the maker's mark "R & C", the mark used in Paris on first standard silver from 1 May 1838, and the restricted warranty punch employed from 1 April 1879 on items intended for export. Tray: 4.1 x 87 x 57 cms.; urn with spirit lamp: 44.5 x 18.5 x 23 cms.; drip basin: 5.7 x 13.2 cms.; teapot: 18.5 x 23 cms.; coffee pot: 23.3 x 17 cms.; milk jug: 14.8 x 12.2 cms.; sugar bowl: 14.7 x 15.5 cms.

174. Cups and Saucers from a Boxed Set for Six People. The cups porcelain, enamelled, painted with portraits of members of the imperial family and gilded, the handle rings and saucers silver-gilt. French, late 19th century. Cups: 6.2 x 6 cms.; saucers: 13 x 1.4 cms.; ring handles: 7.2 x 9 x 6.2 cms. 1985.282.A,B,D,E,G-J and M-P. The bases of the cups inscribed in red enamel: "M.Impᵉ/de SèvreS" (the Sèvres factory mark for 1804, the first year of the First Empire). Only four cups are displayed here: they depict, from left to right, the Emperor Napoleon; his third sister, Caroline; his son, the King of Rome; and his first wife, the Empress Joséphine's daughter, Hortense, by her previous marriage. The two cups not on exhibition show the Emperor's second sister, the Princess Pauline Borghese, and his second wife, the Empress Marie-Louise. For further information on these individuals see no. 135. The saucers are struck with the maker's mark "u." separated by an X-shaped device and the punch used on first standard silver intended for export introduced on 1 April 1879. The handle rings are without a maker's mark but bear the same export mark as the saucers.

FRENCH GLASS

175. Dish. Heart-shaped dish. Clear glass with gilt metal mounts. French, c. 1850-75. 2.4 x 8.2 x 8.3 cms. 1958.111.

176. Dish. Circular dish. Clear glass with gilt metal mounts. French, c. 1850-75. 2.4 x 8.4 cms. 1958.109.

177. Box. Circular box. Clear glass with silver mounts. Engraved silver or metal foil sealed between two thicknesses of glass. French, mid 19th century. 4.4 x 14.1 cms. 277&A. Acquired in 1858 and said to be Grichois.

178. Tazza. Clear glass painted in enamel colours with flowers in the Chinese style. Mark: "Brocard/[?]/23 R. Bertrand/Paris" painted in red enamel on the base. French (Paris, glasshouse of Joseph Brocard), c. 1878. 9.1 x 32.3 cms. 1878.41.1.

179. Vase. Clear pale amber glass acid-etched and painted in enamel colours and gilded. Arabesque decoration. Mark: "E.Gallé/Nancy" diamond engraved on the base. French (Nancy, glasshouse of Emile Gallé), c. 1890. 24.5 x 21.6 x 15.3 cms. 1934.307.

180. Vase. Clear pale amber glass painted in enamel colours and gilded. Decorated with two scenes of a horseman and two armed men fighting amidst scrolled foliage. Mark: "Emile Gallé/à/Nancy" painted in red enamel on the base. French (Nancy, glasshouse of Emile Gallé), c. 1890. 18.6 x 13.5 x 6.8 cms. 1892.518.

181. Vase. Purplish-white glass flashed with purple, acid-etched with floral decoration. Mark: "Gallé" in relief on the side. Printed label on the base: "EMILE GALLÉ, NANCY PARIS". French (Nancy, glasshouse of Emile Gallé), c. 1890. 6.3 x 3.6 cms. 1960.217.

182. Vase. Clear purple ("amethyst") glass, streaked and crackled. Printed label on the base: "ROSSEAU-LEVEILLE, 5 ru d HAUSSMANN". French (Paris, glasshouse of Eugène Rosseau and E. Leveillé), c. 1890. 10.9 x 13 cms. 1892.521.

183. Jug. Clear colourless and green glass acid-etched and painted in gilt. Bands of cinquefoil decoration. "Mark: "Daum/‡Nancy" painted in gilt on the base. French (Nancy, glasshouse of Daum frères), early 20th century. 24.5 x 19.8 x 7.3 cms. 1958.157.

184. Vase. Semi-opaque pâte de verre moulded with flowers in low relief. Marks: "G. ARGY-ROSSEAU" in intaglio on the side and "1271" impressed on the base. French (Meslay-le-Vidame, glasshouse of Gabriel Argy-Rosseau) c. 1910-30. 14.1 x 8.8 cms. 1963.418.

185. Vase. Clear glass moulded with acanthus leaf decoration in relief. Mark: "R LALIQUE" wheel-engraved on the base. French (Wingen-sur-Moder, glasshouse of René Lalique), c. 1925-30. 22.7 x 21.4 cms. 1958.217.

186. Vase. "Opaline" glass moulded with decoration of berries and leaves on vertical bands. Mark: "Sabino/France" diamond-engraved on the base. French (Paris(?), by Marius-Ernest Sabino), c. 1930. 22.7 x 19.6 cms. 1983.787.